THE MOTHER
OF BLACK HOLLYWOOD

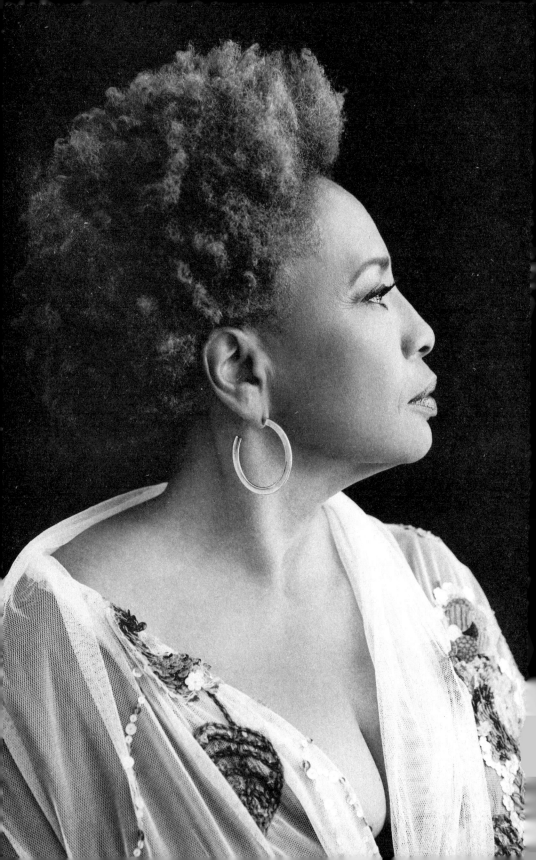

THE MOTHER

OF

BLACK HOLLYWOOD

—————— · A MEMOIR · ——————

JENIFER LEWIS

WITH MALAIKA ADERO

Amistad

AN IMPRINT OF HARPERCOLLINSPUBLISHERS

HarperCollins books may be purchased for educational, business, or sales promotional use. For information, please email the Special Markets Department at SPsales@harpercollins.com.

Grateful acknowledgment is made for permission
to reprint from the following:
"Incident," by Countee Cullen. Originally printed in *Color.*
Courtesy of Amistad Research Center, New Orleans, LA.
"Climb Ev'ry Mountain" by Richard Rodgers
and Oscar Hammerstein II.
Copyright © 1959 by Richard Rodgers and Oscar Hammerstein II.
Copyright Renewed.
WILLIAMSON MUSIC owner of publication and
allied rights throughout the World.
International Copyright Secured. All Rights Reserved.
Used by Permission.
"Love Goddess," written by Marc Shaiman.
Courtesy of Marc Shaiman.
"Pussy Bone," written by Marc Shaiman.
Courtesy of Marc Shaiman.
FIRST EDITION

Designed by Suet Chong

Frontispiece by Maarten de Boer

All photographs courtesy of the author unless otherwise indicated.

Library of Congress Cataloging-in-Publication Data has been applied for.

ISBN 978-0-06-241040-5
ISBN 978-0-06-283919-0 (B&N Signed Edition)

17 18 19 20 21 DIX/LSC 10 9 8 7 6

To Julia Walker, who saved my life . . .
and then saved her own.

"Your playing small does not serve the world. Who are you not to be great?"

—Nelson Mandela

CONTENTS

THE MOTHER
OF BLACK HOLLYWOOD

PROLOGUE

Dorothy Mae Lewis was not a woman to mess with. One day, when I was about six, I held Mama's hand as we walked home from Miss Woods's store, where Mama had bought a bottle of Coca-Cola. Well, out of nowhere, her boyfriend, Jelly Bean, pulled up in his station wagon and called out for my mother, "Hey, Dorothy! C'mere."

Now, my mother was pretty much the queen of Kinloch, Missouri, and the one thing you did not do was summon her to do anything, anywhere, at anytime. My mother ignored Jelly Bean.

He said, "Dorothy, you hear me talkin' to you?"

She said, "Go on somewhere else, Jelly. Cain't you see I'm with my baby?"

Jelly Bean then made the biggest mistake of his life. He pulled the car over to where Mama and I stood, reached out of the window, grabbed Mama's right arm, and said, "You gonna talk to me right now, Dorothy."

I was still holding Mama's left hand tightly, aware of the time bomb that was about to explode. What I can tell you now is that it was all over in five seconds.

It ended with Jelly Bean speeding away and a trail of blood that led to the corner where the station wagon had taken a sharp right and disappeared. And as small as Kinloch was, we never saw Jelly Bean again. And y'all wanna wonder where I get it from.

ONE

BLACK-ISH TO GREENISH

After two weeks of intensely working out, I had lost not one fucking pound! Yet, ready or not, there I was, my first day on the set of *black-ish*. The show is what every actor dreams of—a prime-time hit on a national network. My first scene was with Morpheus from *The Matrix*—of course, I mean Laurence Fishburne, the brilliant actor who plays my ex-husband, Pops.

I was about to deliver my initial line. One would think that this moment would be fun, easy, even fabulous. I mean, after all, I had been doing television for what seemed like a hundred years—from *The Fresh Prince of Bel-Air* to *Murphy Brown*, from *In Living Color* to *Friends*, and on and on. But ten

years had passed since I had worked consistently on the small screen.

Once again, the gods of television had summoned me back. Back to bring the Jenifer Lewis magic. Back to deliver the take-no-prisoners attitude and deep, rich tone that made mine one of the most recognizable voices in Hollywood. But I'll be damned if now, at the moment of truth, I could remember one line of the script I had studied.

After 259 episodic television shows, 63 movies, and four Broadway shows, the great Jenifer Lewis could not remember one fucking line. I was a nervous wreck. No one on the *black-ish* set besides me knew it, though.

I asked for a moment and grabbed my script. As I sat down and put on my glasses, I knew I would be forgiven for the pause. After all, I was new to the set and the rest of the cast had already shot several episodes together.

Come on, Jenny, you can do this. I was not about to disappoint all these people—the cast and crew, the writers, the producers, and ABC/Disney, who had hired me without a single audition. To better focus, I took three deep breaths, finally got all the lines in my head, then whispered, *Come on, Jenny, get up. Get your ass up and deliver.*

In the days before, like a fool, I had read the Facebook comments about the announcement that I would be on *black-ish*—"Awww, shit, here come Jenifer Lewis!" "She my play-auntie y'all." "That's right. They got the Mother of Black Hollywood." OMG, she's fabulous. She's this. She's that. Now I felt like I had to live up to all that love. I couldn't let it shake me.

I had to shut down all the internal noise and get in the moment of my character, Ruby Johnson. *C'mon, pull yourself together, Miss Bachelor's Degree in Theater Arts!* I'd studied Stanislavski, Feldenkrais—and with the great Uta Hagen no less. Where did Ruby come from and what is her objective in this scene?

I had been working on Ruby. I wanted her to be a whole person—warm, grounded, smart, quirky, and very, very funny. A woman who loves her son (perhaps a bit too much), never cuts her daughter-in-law any slack, and who loves her grandbabies above all else.

And, of course, Ruby had to be fabulous! So again like another fool I'd said yes to the four-inch pumps—completely forgetting what they would do to my ever-present, aching plantar fasciitis. I stood there feeling fat. My right knee was throbbing. I felt old.

What was I doing here anyway? My thoughts flashed back to a few months earlier—when I had seriously considered retiring. I decided to treat myself to a much-needed vacation and jetted off to Europe to have some fun and ponder my life—not only my career, but also the fact that at age fifty-seven I was still single. Despite being engaged four times, I had never made it to the altar. Of course, I kept the rings.

I was off to Athens, where I boarded the *Seven Seas*, an exclusive luxury cruise ship. For three weeks it was just me, myself, and I, a little barefoot colored girl from poverty-stricken Kinloch, Missouri.

I had worn one of my huge straw hats, expensive dark shades (trying to be incog-Negro), and a muumuu. I ex-

tended my passport and ticket to the young steward. He then stretched his neck and peered under my hat. Even though he was Italian, he proceeded to do an Irish jig, and with no care for his job security, screeched in front of all the first-class passengers, "Jackie's back!" He was referring to the title of the 1999 Lifetime movie in which I had starred.

News spread through the ship that a celebrity was on board. There was a knock at my door. It was my butler (yes, that barefoot little colored girl had a butler!), informing me I was invited to dine at the captain's table. Though I hadn't planned on it, I admit I enjoyed the celebrity treatment.

I basked in my luxury suite and lounged on my private balcony as we made our way around the Aegean, the Mediterranean, and the Adriatic, but my joy was tempered by the decision before me—to retire or not to retire. I still bristled from the recent disappointment of not being chosen for several roles I had wanted. I didn't get *Orange Is the New Black*, but my dear friend Lorraine Toussaint did. I didn't get *Getting On*, but my dear friend Niecy Nash did. I hated the fact that after forty years in the business, I still even had to audition. And damn, could it possibly be true that as a singer, I had never even recorded an album? On top of all that, I had just broken off another engagement. Okay, okay. Now I'm doing what my therapist, Rachel, would call "garbage collecting." *Stop bitching, Jenny!*

We soon arrived in Katakolon, Greece, the site of the original Olympics nearly three thousand years ago. I went to the fields where the games had been played. What impressed me most was the excavation of still-intact hovels and looming

columns. There was a walk of shame where they carved the names of the athletes who had cheated. I was grateful that my name wasn't there because though I've always been athletic, I was one cheating ass when I was a kid!

A few days later, in Montenegro, we visited several magnificent wineries. Winding through the twisting roads, we had to take a sudden detour. There had been an accident up ahead and someone had been killed. A grim reminder of how so very fragile we are and how precious life is.

As the *Seven Seas* approached the Croatian city of Dubrovnik, the view of the orange-roofed Old Town took my breath away. I visited the Church of St. Francis, where some local women were singing folk songs in the courtyard. I admired their beautiful harmonies, and when they beckoned me forward, I joined them. Actually, I just barged in and sang baritone! They good-naturedly allowed me to arrange them like the Supremes, drawing on poses I had been taught by Michael Bennett himself during rehearsals for the workshop production of *Dreamgirls*.

On a small boat from Dubrovnik back to the *Seven Seas*, there was an older Caucasian American man who took it upon himself to extra notice me—a middle-aged black woman traveling alone on a VIP ship. He knew that if I was in fact alone, I had paid $9,000 more than he had (the nasty little single-occupancy fee).

For some ungodly reason, this man yelled over the boat's motor: "So where'd you get your money?" I turned slowly. Would he ask a white man this question? Was this mofo implying a black woman shouldn't have money? I was *this* close

to pushing him overboard. No doubt, the old Jenifer Lewis would have cussed him out in a rage-fueled tirade. But as a person with bipolar disorder who'd spent seventeen years in therapy, I had finally learned to control my rage and was grateful for the behavioral skills and medication that give me that control. I took three deep breaths and decided not to slap the shit out of him. Instead, I said, "Oh, you didn't know? I own the *Seven Seas*." His much-too-young wife, naively believing my statement, chimed in with a high-pitched "Oh, really?" I returned the "Oh, really" in the deep, low pitch Bette Davis used responding to Joan Crawford in the movie *Whatever Happened to Baby Jane?* "Oh, really." The mike had been dropped on the shores of Dubrovnik. Another war had been won. And not a single life had been taken.

The next stop in Croatia was the island of Hvar, where I swam at a rocky beach. I was very thankful that my friend Deborah Dean Davis had told me to bring special shoes for the stony beaches. A nice couple from Germany watched my belongings as I swam. Afterward, they invited me to have a drink. The friendliness of the people of Hvar put me in a peaceful mind-set. I felt ready to spend my final night at sea contemplating whether or not to retire.

Later, on my balcony under a big fat moon, I had a frank conversation with myself. *What are you gonna do, kid?* Could I really face another "Thank you, Miss Lewis. Next!" or "We're looking for a Jenifer Lewis type, not the real thing!" Fuck show business. Did I really want to continue watching myself age on a five-story-tall movie screen?

I was blessed to have already realized so many wonderful

dreams: an electrifying standing ovation at Carnegie Hall when I sang with the New York Pops orchestra; performing for royalty in Monaco; headlining in *Hello, Dolly!* at the esteemed 5th Avenue Theatre in Seattle; and, of course, working with great actors—everyone from Denzel Washington and Meryl Streep to Tom Hanks, Taraji P. Henson, and Matt Damon. I had *sooooo* many *amaaazing* memories to retire with.

But wait. Be honest, Jenny. Is there anything else? Anything??? Shit. There *is* one more dream. I have wanted it all my life. A one-woman show on Broadway—like the great ones who had paved the way—the likes of Lily Tomlin, Whoopi Goldberg, Elaine Stritch, and Anna Deavere Smith to name a few.

And maybe one or two other as-yet-unrealized dreams. Like I still hadn't played Mama Rose in *Gypsy*. (My friend Marc Shaiman joked that the black version of *Gypsy* would be titled *Nipsy*. Asshole.)

I guess I could live without playing Mama Rose. But without that one-woman show, I know in fact when I reach those Pearly Gates, St. Peter's first words to me would be, "What happened with the one-woman show? Get your unheavenly ass on back down there and get that Tony!"

How do I make it happen? A one-woman show on Broadway starring Jenifer Lewis? Jenifer who? Dear God, what an undertaking. People recognize me, but frankly, plenty of them don't even know my name. Why would Broadway backers be willing to invest millions of dollars in me? Well, I'll just have to become more famous. And there's one sure way of doing that (besides a sex tape): prime-time network TV.

I leaned on the rail and gazed at the perfection of the moon, the stars, and the Adriatic Sea. I howled up at that big fat moon true to the alpha wolf who runs through my veins: "I'm JeniferMothaFuckinLewis! I *am* the *show* in show business!" Who was I trying to kid? To retire from show business would be to retire from the act of breathing. I closed my eyes and said a silent prayer. Yes, a prime-time show. A show that's top quality. In a role that recognizes my talent and experience; where I can show my chops and make people laugh, think, and cry. I wanted to work with great actors and writers I admired and could grow with. Now listen, God, I don't want to be the lead in the show; I don't want to work that hard anymore. Oh, and this is the most important thing: please let the show shoot close to home (don't even let me get started about the LA traffic!). I blew a soft kiss to the moon, smiled, and took my ass to bed.

Two days later, I touched down at LAX and was picked up by my dear friend and manager, Julia Walker. She allowed me to go on and on about my vacation. "Girl, I had a fabulous time. I hiked up the ancient city walls of Dubrovnik. In Montenegro, there was an unimaginable rainbow over the limestone cliffs in the Bay of Kotor. I'll show you the picture later. And listen, Ju, there are these two islands just off Venice, right? The first one, Murano, is where they do a fabulous glass-blowing demonstration. On the second one, Burano, they make wonderful lace. Oh, and honey, I met this French boy in Athens up at the Acropolis. He was staring at my cleavage, but he was all hot and sweaty and you know I didn't have

time for a Parisian. It would have made for a good story, but it just was not going to happen. He was real cute, though.

"In Corfu, your girl almost went hungry because my credit card wouldn't swipe through at the food stand, so I deliberately showed that guy my cleavage and he let me have a turkey and goat cheese sandwich for free. And *girrrrl*, the food on the ship was incredible. I was so undisciplined, I ate like anybody's and everybody's pig. The chef was a *Fresh Prince* fan and would make me anything I wanted. And the desserts were stupid. I must have put on at least ten pounds. Thank God I've got two months to get in shape before the Human Rights Campaign honors me in St. Louis."

As we rode down Sepulveda to get on the heinous 405 Freeway, I saw a huge billboard for the new ABC show *black-ish* and asked, "Oh, how is that show doing?" Julia didn't respond. When I turned to look at her, she had a silly, sweet smile on her face. "I was giving you a moment before I told you. They called. They want you to play Anthony Anderson's mother. They want you for *black-ish*!"

I said, "Well, *black-ish* better have some greenish!"

Yeah, that quip was a good one, but underneath, I was thinking, *Damn, I didn't expect my Adriatic prayer to happen* this *fast!* It had only been two nights ago when I was speaking to God. I guess I'll be kissing the moon more often.

Julia continued, "And you're booked to start in two weeks."

I fell into a dead panic. "Bitch, are you insane? Did I mention I ate fried cheese every fucking day? And chocolate, and

butter-drenched escargots, and crème brûlée for breakfast? That camera's gonna put another ten pounds on my ass. And oh my God, it's all high definition these days, so everyone watching can see every pore and wrinkle."

It had been eight years since I had played Lana Hawkins on *Strong Medicine*, the hit Lifetime television drama. My memory had gotten worse, and I was going to have to learn lines, lines, lines. Not to mention my knees now had names— Arthur and Ritis Jackson. Shit. I needed at least six months to get ready.

Look, was I excited to get back to steady work? Yes. Was I appreciative? Yes. But I was really scared at the same time. *Come on, Jenny, time to slay.*

When I arrived home, I kissed and played with my bichon frise, Butters (named for the character on *South Park*), and collapsed from jet lag. Lying on my bed, my mind was racing. *You got two weeks, Missy!* I got out of bed, flew downstairs to my gym, and mounted the elliptical. I did forty-five minutes of cardio. Then it was on to the weights and sixty squats. *Come on, Jenny!* The next morning I rode my bike seven miles, thinking about the time I had joined Weight Watchers. I went once, sang all them big mamas a blues song (after all, they were a captive audience), and never went back. I had to get serious; I needed a regimen. I made an arrangement for my niece Michiko to start training me every day. I wanted to look like I had twenty years earlier on *The Fresh Prince*, when I was beautiful from *every* camera angle.

But, like I said, I had not lost one fucking pound by the

time, two weeks later, when I drove my big black S5 Mercedes through the gates of one of the most beautiful and historic movie lots in the world—the Walt Disney Studios.

The security guard at the gate shouted, "Hey, Flo! Hey, Mama Odie!" Disney is a home away from home for me. I am more famous here than at any other studio. And most Disney employees, from security guards to the chefs in the commissary, are huge fans of Disney animations; they know every movie, actor, and voice.

I smiled at the security guard as I fantasized that I was the great Gloria Swanson playing Norma Desmond in the movie *Sunset Boulevard* when she returns to Paramount, the studio she had made famous. In my fantasy, I wanted the guard *not* to recognize me so that, like Norma Desmond, I could say to him, "Open the gate and watch your manners, because without me, there would be no Disney studio."

I pulled into the parking space marked "Jenifer Lewis" in front of Stage Four, thinking, *Wow, you've come a long way, baby!* Still in my Norma Desmond fantasy, I thought, *Oh my God, will anyone remember me?*

The answer, thank goodness, was yes, yes, and yes. They came and they came and they came. I was encircled by the cast and crew welcoming me, smiling and gushing. After all my years in show business, I had worked with damn near every one of them in some capacity or another: wardrobe, makeup, set designers, the drivers, the assistant directors. Even the dialogue coach was my dear friend Iona Morris, a talented actress and director. I knew and loved them all.

And on they came—embracing, reminiscing: "Hey, Jenifer, remember when Tupac had all them girls in his trailer on the set of *Poetic Justice*? Remember me? I was the stunt coordinator when you clocked Jim Carrey with that rubber skillet on *In Living Color*. We're so excited you're here. We've been waiting." It wasn't only about show business. One crew member said, "Hey, Jenifer, my brother loves you. When he saw you on *Oprah* talking about having bipolar, he went and took care of himself."

Even the executives from the front offices came down to the *black-ish* set to welcome me. I was lit up.

I had of course worked with the oh-so-very-talented Tracee Ellis Ross on *Girlfriends* and *Five*, a wonderful Lifetime movie that Alicia Keys had directed. I knew Anthony Anderson's brilliant and funny work in everything from *Law & Order* to *Hustle & Flow* to *Barbershop*. Of course, there was Laurence Fishburne, who had not only played Ike Turner, the son-in-law to my Tina Turner's mama in *What's Love Got to Do with It*, but whose body of work was beyond impressive, including some of the most important films of our time, from *Apocalypse Now* to *Boyz n the Hood* and all of the *Matrix* films. I was thrilled to reconnect with Kenya Barris, the creator of *black-ish*, who was just a young writer when we'd first met on *Girlfriends*. I dub him "Genius."

Following the warm welcome, it was time for the usual television routine: two hours in the makeup and hair trailer. And, of course, the last-minute rushing. There's always so much hurry up and wait. I sat in my dressing room, miked for sound, zipped into Ruby's clothes—only to wait.

All the waiting gave me way too much time to fret. *Would I fit in?* The rest of the cast was already a family. I was only a guest star at that point. I would have to gauge and get in sync with their rhythm. *Could I do it?* Finally a knock at the door. "They're ready for you now, Miss Lewis."

I entered the soundstage trying to look cool. After a few preliminaries, including my last-minute pause to look at my script, shooting began. Now fully confident in my lines I stepped onto my blue tape-mark, opposite Laurence. The set was "put on a bell," signaling all cast and crew to fall silent.

The first AD shouted, "Rolling!" I inhaled, shoulders back and spine straight. I felt the entire company lean in, smiling expectantly as all eyes fell on me, the mother of black Hollywood, the veteran of nearly three hundred productions, the woman they hired without auditioning.

The director shouted, "Action!"

I exhaled, thinking of that kiss I'd blown to the full moon over the Adriatic.

I go inside. I become Ruby Johnson. I deliver my first line. Within seconds, I hear the sound I'd been listening for all my life—the rising, swelling lion's roar as dozens of people collapse in laughter and applause.

And the bitch is back.

TWO

SHOULDERS BACK, TITTIES FIRST

I am a born entertainer. Even as a little girl, I dreamed of being a star. I would be an entertainer had I been born a hundred years earlier or later. Had I been born a unicorn or even been born on Neptune, I would be somewhere singing in somebody's universe, filled with music and fire.

I started early: I was five years old when I went to Miss Vera and asked to sing a solo in the annual church program called "The Old Ship of Zion." About ten choir members started in the back of the church, singing a song as they moved one by one down the center aisle. After they reached the choir stand, they "boarded the ship," in recognition of the vessel in the Bible that carried believers to the Promised Land. When the

last soloist had reached the stand, the entire choir sang "'Tis the Old Ship of Zion." I asked Miss Vera if I could sing a song called "Oh, Lord, You've Brought Me a Mighty Long Way."

Miss Vera said, "Jenny, you're only five years old, honey."

I said, "But that's the one I listen to on my pink close 'n play record player."

The day of the program, there I stood in the back of the church, in my black patent leather shoes and folded-over lace socks. I had on a blue skirt and a white blouse, the standard choir uniform. I knew this was my moment, and I was totally prepared to show out. My mama, aunts and uncles and cousins, as well as the deacons and the mothers of the church, the entire congregation—all had their eyes on me.

Miss Vera played a glissando on the organ to give me my note. I leaned back and did an exaggerated backbend in an effort to fill my little lungs. Gradually returning to an upright position, I slowly released my first note, "Ohhhh—" and held it for what seemed an entire minute. "Oh . . . oh . . . oh . . . Lord, you brought meeeee a miiiighty looooong waaay."

I grabbed the side of the back pew, steadying myself in dramatic fashion. "They said I couldn't maaaaake it, but you brought meeeee. Jesus, you brought meeee a mi-hi-ty loooong waaaay."

I knew I had them all in the palm of my hand when I heard my aunts Katherine, Louise, Rosetta, Jean, Shirley, Gloria, Janice, Mary, Margaret, and even my own mama shouting, "Sing, Jenny! Go 'head on, sing, baby!"

I two-stepped down the aisle past five more pews to the spot where an usher, Sister Lorraine Parks, stood erect wait-

ing to catch anyone who got the Holy Spirit and fell out (love me some black church, y'all!). I grabbed Miss Parks's fan from her hand, leaned against her, and fanned myself furiously, singing, "sum–um–bod–yy help meee."

Then going limp, I bent over and sucked in a huge breath so I could growl the next phrase as I heard pastors do in their sermons: "Grrrzzyuh yassss, Lawd, a mii-hiii-ty luh-onng waaaay!" One of the deacons jumped up and guided me aboard the "ship." When I turned around at the stand-ing microphone, I really cut loose. I leaned the mike over like James Brown. I waved it around like Sarah Vaughn. Then I did a little praise dance like I had seen Sister Moten do every Sunday morning to show off her new clothes. When I saw Sis-ter Ethel Miller snatch her big, big hat off her head and throw it in the air, well that was it. I riffed one more time, "Thank ya, Lord. Thank ya, Jesus."

My solo flowed from my five-year-old self with force and feeling so great the entire congregation of First Baptist Church in Kinloch, Missouri, exploded in a standing ovation. I knocked them out doing my best imitation of the great gos-pel artist Dorothy Love Coates singing with the Gospel Har-monettes. In that moment, my destiny as a singer was sealed. Though we were there to praise God, I loved that I was getting some praise, too. I plugged my mouth with my thumb and stood there a bit cross-eyed. I felt steeped in love and secure in the knowledge that I was indeed a child of God.

My family didn't have much money for extras, but mu-sic was a constant presence in our home. We were all good singers. And between Mama and my older siblings, I spent

hours listening to the greatest of the greats in gospel, jazz, and popular music. Mahalia, Ella, Aretha, B.B. King, Ramsey Lewis and, for comic relief, there was lots of Moms Mabley! I felt a profound soul connection with them all.

As I grew up, my burning desire to be a star flourished. I told any and everybody who would listen that I was going to be famous. And baby, I was real serious about it. I'd grab my hairbrush, stand in front of a mirror, and "Aretha Franklin" your ass all day. I studied and imitated the old classic Hollywood movies, especially musicals, that came on the late, late show. I watched with fierce intensity, reveling in the magic of multitalented superstars such as Judy Garland, Ethel Merman, and Sammy Davis Jr. I identified with these twentieth-century greats—with Bette Davis, with Tallulah Bankhead. Their flair. Their power. As a kid, I sought to emulate Hattie McDaniel's timing in *Gone With the Wind* and Danny Kaye's mastery of tongue twisters.

When I got a little older, the whole town anticipated my monthly talent shows. I had bothered Father Siebert over and over to let me use the Catholic school basement. I worried that poor man (who was Kinloch's sole white resident) so much, one day he just said, "Anything you want, Jenny." I cut up brown paper bags to make signs and in black Magic Marker I wrote: "Jenifer Lewis Sings. 7:00 pm Saturday, 35 cents." I taped the signs to telephone poles all over town and, baby, you couldn't get in for the crowd! People would come all dressed up. The talent shows became so popular, folks would barbecue outside in the parking lot and sell rib tip

sandwiches, pigs' feet, and hot dogs, with orange and cream sodas. It was *the* Saturday night event in Kinloch.

I would sing songs by Aretha, Fontella Bass, and Gladys Knight with my cousins as my Pips. Years later, my cousin Ronnie reminded me that I never paid my Pips. I would just run out with all the cash at the end of the show. Let's just say I didn't deny it. These talent shows—starring me, of course—allowed me to practice for the time I, like Dionne Warwick or Nancy Wilson, would make my grand entrance on *The Ed Sullivan Show*.

I could see myself in a class with these greatest of the greats because I felt that my gift, my talent, my ability to entertain was so innate, so powerful, so evident, that God had given me something special. Judge me if you must, but it was my reality. Call it delusional, call it grandiosity. Call it what you will, but it was my dream—and it kept me going through some dark times.

I used what I learned from these legends in many of my most popular roles. When I played Will Smith's Aunt Helen on *The Fresh Prince of Bel-Air* I mixed in shades of Pearl Bailey. In the *Cars* animations, my character, Flo, is a mix of Edward G. Robinson's nasality, Mae West's sass, and Lauren Bacall's sultriness. In my scene with Denzel Washington in *The Preacher's Wife* when we're talking outside in the cold, my character is pure Bette Davis. In the sit-com *Girlfriends*, Tony's drunk mother is Lucille Ball, and the sorceress Mama Odie in *The Princess and the Frog* is straight-up Moms Mabley.

The point is, that I am aware that I stand on the shoulders

of many great entertainers. I still study the greats. It's what keeps my game on point. I do not consider it boastful to say I am a great entertainer. Look, it's just a fact: I can sing you a song and tell you a story. I can make you dance and shout. I can hold you in the palm of my hand and make you feel alive. I can get you weak in the knees, catch you, say I'm sorry, and then rock you to sleep. But above all things, I can make you laugh, and I mean laugh your ass all the way off! Apparently, the only thing I *can't* do is stop talking about myself!

On May 25, 1979, I headed to New York City, having graduated the day before with a degree in Theater Arts from Webster University, just outside of St. Louis. Finally, I was leaving St. Louis for good and pursuing my destiny. Finally, I was taking my shot at fame and stardom.

My whole family, six siblings and my mother, came to the airport to send me off. St. Louis to New York, TWA nonstop! I used my graduation money to fly first class—it just felt appropriate. On other trips to New York for auditions I had seen and envied the grandness of first class. Now it was my turn to recline, sip champagne, and smoke my Virginia Slims.

Lambert International Airport was a hub for Trans World Airlines, and Kinloch was right under the flight path. Looking through my first-class window, I felt a twinge of irony as the plane roared over Kinloch and I gazed down on the narrow streets and small houses of my childhood and then turned my attention toward the future—and the fulfillment of my lifelong dreams.

In my mind, I was unstoppable. My freshly minted degree certified me as a classically trained actress. I believed I could sing like nobody else and felt that although I wasn't the best dancer, my presence on stage was riveting. I roared into New York confident, thirsty. *What's next, bitches?* If it's got anything to do with performing, or with being funny or fabulous—I'm your girl. If it's got anything to do with Shakespeare, Ibsen, Molière, or Chekhov—I'm your girl. Oh, and by the way, watch me kick my foot above my head then slam it to the floor in a full split! And if you're not feeling me, just tell me what note, what key, and how fast or slow you want it. How many Hula-Hoops around my neck?

I hit New York prepared to conquer, to win, to slay. And why not? All my life I had been hailed for my abilities, made to feel special, singled out. As a kid, I was a born leader, the alpha of the pack. In high school, I ruled as class president and captain of the cheerleading squad. At Webster, I had dominated the theater department. I was a stand-out even in my first professional job, when I took a sabbatical during sophomore year to tour the country performing in a vaudeville-style revue, *Baggy Pants*.

I got off that plane at LaGuardia with ten thousand songs in my heart, envisioning my life unfolding before me. I was hell-bent on first conquering Broadway, figuring Hollywood would come later. Black Broadway was at its height. The late 1970s had seen a string of successful African American–themed shows such as *The Wiz*; *Ain't Misbehavin'*; *Don't Bother Me, I Can't Cope*; and *Bubbling Brown Sugar*.

I was a Midwestern girl who found New York City thrill-

ing, but absolutely overwhelming. I had been there a couple of times before, but for only a few days. I mean I was street smart and knew how to watch my back, but still it was a huge culture shock. Nobody spoke to each other. In my hometown, I was used to saying good morning to total strangers, but New Yorkers didn't even make eye contact.

Wherever I went in the city, I felt surrounded by twenty million people. I remember standing in the shopping mall beneath the World Trade Center and feeling the sensation of an oncoming stampede, an earth tremor. I said aloud, "What the fuck is that?" The guy at the newsstand nearby heard me and calmly said, "Rush hour, lady." Mouth agape, I flattened myself against the wall as thousands of commuters surged past to board their trains on the levels below.

From day one in the Big Apple, I was swept into the whirlwind life of an aspiring actress, driven by my dream. Shoulders back, titties first. Every day, rushing to auditions all over Manhattan and one or two dance classes at Frank Hatchett's famous studio at Broadway and 55th Street.

I had won a voice scholarship funded by the actor Richard Kiley, the "Man of La Mancha" himself. The scholarship provided vocal lessons with Ray Smolover, whose genius as a voice teacher was well known in the theater community. Ray taught me how to keep my vocal apparatus healthy and flexible; his lessons have sustained me to this very day.

In fact, I have lost my voice only twice. The first time was in 1984 when I got pissy drunk singing and carrying on until the wee hours at a bar in Cologne, Germany, and had to miss the next day's matinee. The second time I lost my voice was

during my first week performing on Broadway in *Hairspray* in 2008. I thought I would take a lovely walk through my old stomping ground—Central Park. The park was gorgeous. It was springtime and the trees and flowers were in high bloom. From Columbus Circle, I walked to the boathouse, stopping to admire every variety of tree, stone, child, street artist, and horse-drawn carriage. Just plain skippy-happy! As I walked through Sheep Meadow, my thoughts went back to that horrible day, years earlier when I didn't get cast in *Saturday Night Live* and collapsed in sorrow in the cool meadow grass. I smiled a bit, thinking how meaningless rejection becomes as the years roll by.

By the time I reached the boathouse, I realized my throat had constricted. What the flying fuck was I thinking? *Jenny, you have allergies this time of year!* I hacked mucus out of my throat all the way back to Columbus Circle, because taxis were no longer able to go through the park. My vocal cords were strained, but I went on to the theater anyway, knowing that my voice would come. Surely, it would come.

It did not.

I made my entrance on the stage, opened my mouth to sing, and no sound came out. Silence. Everything went into slow motion. I pushed for the notes. Praying, I lowered the register an octave.

Nothing. Nothing. Nothing.

There I stood, the great Jenifer Lewis, voiceless in front of fourteen hundred people in the Neil Simon Theatre. To add insult to injury, as I coughed and gasped through this train wreck of a performance, a woman front row center turned

slightly to her excited son, who looked to be about ten years old and who was clearly gay. Without taking her eyes off me, the woman said to her son in a voice that was quite audible over the music, "This is *not* how it's supposed to be."

Thank God it was the end of Act I. The curtain came down, I ran up the concrete staircase in that old theater, fell into my dressing room, and sobbed uncontrollably. To add more insult to injury, Marc Shaiman, *Hairspray*'s co-lyricist and composer, had been in the back of the house and witnessed the entire catastrophe. He walked into my dressing room and said, "Your contract says three months, not three performances." It was a brilliant line, but I was in no mood to laugh with my best friend. Asshole.

When I first hit town, fresh from college, I was sobered by the competition, especially in dance class. Y'all, they came from the four corners of the nation and they were the best—the motherfuckers of the motherfuckers. They danced like Shakafuckingzulu's children; like kings and queens. They were long and they were graceful—the Adonises and Aphrodites of Juilliard, Alvin Ailey, and Carnegie Mellon. They strode across the dance floor like Thomson's gazelles on the Serengeti. They stared at themselves in the wall mirrors like they owned the world. They walked in first position. They wore tights to show their perfectly formed muscles. They were beautiful, gods almost.

I felt doubt, concern. Okay, I was fucking losing it and called my mother, sobbing, from a pay phone behind the

Lunt-Fontanne Theatre on 46th Street: "Mama, Mama, everybody wants to be a star up here in New York!" Who knew all these other people were gonna be here, chasing the same dream as me? "Oh my God. It's all too big, Mama," I wailed. "There are so many of them and they're all so good." Part of me wanted to give up and run home. But quit? Me? Fortunately, the bigger part of me knew I was on the right track.

One of my first auditions was for an out-of-town production of *Daddy Goodness*, starring Clifton Davis. It was a musical based on a play by Richard Wright, the brilliant author of *Native Son*. At the audition I met Sheryl Lee Ralph, the wonderful actress and activist, who remains a good friend. At age twenty, Sheryl was strikingly beautiful. And she still is today at age ninety-three! After the audition we went off together to Howard Johnson's in Times Square to kill time before contacting our answering services for what we just *knew* would be a call-back. I ate apple pie à la mode. Sheryl ate a banana split. Neither of us got the gig, but we bonded that day, vowing that we'd become stars on Broadway and in the movies. Years later, I was one of Sheryl's bridesmaids when she married her eighth husband (okay, it was her second husband!).

I was living temporarily with my college boyfriend, Miguel, and his mother in Brooklyn, in their fourth-floor walk-up above a karate dojo on the corner of Flatbush Avenue and St. Marks. Miguel was, perhaps, to this day, the one true love of my life. We had been together during my first two years at Webster, but it was off and on because my love life in college had a lot of moving parts.

But I always found my way back to Miguel. He was born

and raised in the Dominican Republic. He was a brilliant man who held two master's degrees, and when we met, Miguel was at Webster working on his PhD—in math no less! I loved Miguel for his intelligence and his delicious accent, especially the way he said my name: *Yenifer.* He was about ten years older than me but a very healthy man. And ladies, I do mean *very* healthy. I recall how his skin tone blended with mine—together we were a beautiful caramel macchiato. Miguel was the first vegetarian I'd ever met. I found him fascinating.

Once he got his PhD, Miguel went back to live with his family in New York City while I finished my last two years of college. We maintained a long-distance relationship, and I stayed with him a few times during my junior and senior years when I went to New York for auditions.

After we'd been a couple for some time, Miguel said something that stayed with me: "Yenifer," he said, "joo have theez great ability to get zee attenshoon of zee people, but den, joo say no-thing." I thought, "So what? I am an entertainer, not a teacher."

Miguel's mother, Andrea, did not speak much English, but she treated me like a daughter and sure could cook her ass off. She made plantains and *concón*, a traditional Dominican dish of the delicious crust of rice scraped off the bottom of the rice pot. If you've ever had *concón*, you understand why thinking about it still makes my mouth water after all these years!

Miguel and I went into Manhattan a lot. He'd play chess in Washington Square Park. I loved that he won most of his games, being a genius and all. But with my short attention

span, it was tough for me to sit and watch something as boring as chess, so I would wander off and go watch the street artists in the middle of the square. I liked their raw, natural style. It was there that I first met Phyllis Yvonne Stickney, who later played my daughter Alline in *What's Love Got to Do with It*. She was so captivating, talking politics in her red, black, and green turban. I have always been attracted to intelligent people. I find them fascinating because I just didn't pay as much attention in school as I ought to have; if it wasn't about music or movies, I really didn't see what it had to do with me.

Many of my outings with Miguel were punctuated with a visit to Mamoun's, the falafel joint on MacDougal Street that has become a Greenwich Village institution. We'd stand in line arm-in-arm, pressing against each other, laughing and talking as we waited our turn to squeeze into the hole in the wall for our delicious falafels drenched in tahini sauce. The few sticky tables were usually taken, so once we'd ordered and paid, we would sit on the bench out front, stuffing our faces and wiping tahini from the corners of each other's mouths. Once, Miguel noticed the cook who had served us leaning against the building smoking a cigarette. Disgusted that a smoker had touched his food, Miguel threw what remained of his falafel in the trash. I loved that Miguel kept his body pure (and I made a note to continue hiding my nicotine habit from him!). We had a beautiful, loving relationship, but we fought a lot, mostly because Miguel wanted to marry me.

I couldn't marry him or anyone else. I had already taken a husband—New York City itself. We were the perfect couple. I've always been dramatic, and New York matched my "extra-

ness." The city was extreme, and so was I. Everything about New York seemed over the top like me. Y'all know I'm loud. The entire city seemed to vibrate at my frequency, propelling me to reach for more, more, more! This was the relationship I wanted—though I loved Miguel deeply, his proposal didn't stand a chance.

Through the decades, New York City has remained a magical, fascinating adventure for me. The people, the conversations! For instance, nearly thirty years after I first arrived in New York, I was sitting in the lobby of the Public Theater, studying my ass off for my role playing opposite Meryl Streep in *Mother Courage and Her Children*. A young black man, who I think was a summer intern, approached me in the lobby. Without saying so much as "Excuse me," he sat down next to me in a huff and growled, "Why do black women get so mad when they see us walking down the street with a white girl?"

I slowly turned toward this handsome, ebony boy and said, "Do you really want to know the answer to that question?"

He said, "Yeah, I really want to know. I get sick of that shit."

I said, "Well, it might have something to do with this. For decades, black men were lynched, often for allegedly looking at a white woman. Our mothers' mothers cut the black bodies of their sons and husbands down from the trees. But we black women did something we didn't have to do before we buried them. First, we washed their bodies." I let my words sink in and continued.

"So, little boy, when you see a black woman walking down

the street, you tilt your hat and acknowledge her existence. If only for the fact that first, we washed you. And next time you sit down next to me, you say, 'Excuse me, Miss Lewis.' Now get the fuck on where you're going. I'm studying Brecht, little boy."

About two years later, I was again living in the city temporarily, this time during my run as "Motormouth Maybelle," the black mother character in *Hairspray*. I was provided a nice one-bedroom apartment with a great view on the twenty-eighth floor of a high-rise that had a pool on the lower level. It was all very movie star on Broadway, if you know what I mean.

Every day of that sweltering hot summer seemed to serve up at least one quintessential New York experience. I'll never forget the day I rode the Circle Line tour boat past an astounding public art exhibit where they had erected a waterfall underneath the Brooklyn Bridge. Another memory of that New York summer is the reaction of the passengers when I rode the N Train between shows in my Motormouth makeup, which of course was shocking up close in that garish light. And, I will definitely never forget the time I decided to do my own laundry and inadvertently found new meaning in the phrase "separate the whites."

Although any sane person who was singing and dancing in eight shows a week would have someone else handle her wash, I'm a clean freak and find it highly disturbing to stare at a load of dirty clothes. So, I decided to truck on down to the third-floor laundry room and do it myself. I separated the whites into a basket and used pillowcases for darks and light colors.

I stood in my sweats and house shoes at a bank of four elevators, waiting in the middle. When an elevator door opened to the far left, I scooped up the basket, ran over, and plopped it in the door's path to keep it open. I asked the older couple in the elevator to wait a second while I grabbed the other two bags. I ran to get them, but as I turned back, I heard the woman say loudly: "We're not waiting for *you*." With that, she kicked my laundry basket out of the elevator, its contents spilling out onto the floor.

I began to rumble like the Northridge earthquake of 1994. Truth be told, I was overdue for a phone session with my therapist, Rachel, and was carrying a lot of pent-up anxiety. When I saw the basket fly out of the elevators, I launched my body between the elevator doors in one rage-fueled leap to stop them from closing. Then, while keeping my eyes on the couple's eyes, I knelt down, and ever so slowly placed my whites, one by one, back into the basket. White sock by white sock. White towel by white towel. White crotch-less panty by white crotch-less panty. When finished, I straightened up, stepped into the elevator, and let the door close. I pushed "3," turned to face the white couple, and in a normal, even tone of voice, said, "Well, that was rude." The woman snapped back. "Look, we're in a hur . . ." Before she got the entire statement out of her mouth, I was about a half-inch from her nose. Drawing on vocal cords that had been reaching the back row of the theater, I roared, "Shut the fuck up. You lost the right to speak when you kicked my shit."

The old man stepped toward me as if to reach out and

protect the woman. But if there was a first blow to deliver, it wasn't coming from me. I never strike first. I had sense enough to remember that there are cameras on elevators. The man stepped toward me. I turned my head and with eyes blazing, and through clenched teeth, I said, "Don't you move." He went rigid. I continued in a low, level tone. "You lost your right to do anything when you let her kick my shit."

Ooooh baby, that was just the introduction to my diatribe!

"What are you people made of?" I shouted, my voice amplified in the small cabin. "After the Holocaust, after 9/11, after the Middle Passage . . ." I realized they didn't know what the Middle Passage even was. That made me madder, so I really went in. "Have you no souls? Have you not heard of the Brotherhood of Mankind?!" I berated them for the duration of the twenty-five-floor descent, probably for close to a minute. I'm sure it felt like hours for the couple, who stood stiffly, their eyes wide. At one point the elevator stopped and the doors opened. A young, executive-type Asian woman stepped forward, but sensing the tension, quickly retreated, whispering, "I'll wait for the next one."

As we reached the third floor, I yelled, "And, another thing!" The doors opened right on time as I gathered my laundry and cheerfully exited the elevator with, "Now, y'all have a nice day."

Later I learned that the couple reported me to the concierge, describing me as a "crazy maid." But the joke was on them. The staff knew and loved me and figured out for them-

selves what had taken place. They told me that particular couple treated everyone disrespectfully as a matter of course.

Before leaving for the evening's performance, I found an anonymous note taped to my door that read: "The couple who were racist toward you this morning are in suite number 2908. Handle your business, Miss Lewis." It felt good to have the support of the building staff, but I decided to let it go. You've got to choose your battles, and I had a show to do.

That night on stage in *Hairspray*, I sang my asssss off performing "I Know Where I've Been," the showstopper about the Civil Rights Movement, thinking about racism, segregation, and my own experience that day having to "separate the whites"!

DON'T TELL MAMA

About a week after I first arrived in the Big Apple, Miguel left for the Dominican Republic to care for his sick grandmother. That was fine with me because I was feeling a bit cramped by his requests for marriage. Miguel's departure spurred me to say goodbye to his mom's apartment and move into a small one-bedroom with Mark Alton Brown and Robert (Bobby) Cesario. Mark and Bobby were friends from Webster University whom I met during my first week there. I'd walked into the busy dining hall sporting Afro puffs and a checkered pantsuit and spied two men sitting together. I sashayed over to where they were seated and without so much as introducing myself, I leaned over and put my elbows on their table so my face was level with theirs. "Which man in this cafeteria do you think I slept with last

night?" I asked, glancing around the crowded hall, allowing my gaze to land on Miguel.

Both Mark and Bobby fell in love with me in that moment. At the same time, they fell in love with each other. For the next two years at Webster and then throughout our lives, the three of us have been thick as thieves.

Mark and Bobby were already juniors when we met at college and they had moved to New York City about two years before I arrived. Like me, Mark and Bobby had showbiz aspirations. But when I moved in, Mark was scooping ice cream at Häagen-Dazs and Bobby was pounding the pavement for acting jobs.

I'd been living at Mark and Bobby's place on Broadway and 101st Street for just a couple of days when I decided to hike the thirty or so blocks downtown to one of my favorite places for a cheap delicious meal. The Upper West Side of the late 1970s was a gritty neighborhood rich with an abundance of dive bars, diners, and coffee shops. At Gray's Papaya on the corner of 72nd Street and Broadway, I could get a couple of hot dogs slathered in mustard and a little relish along with a sweet, fruity beverage for around two dollars.

It was late evening. I stood on the filthy street corner jamming the second hot dog into my mouth and suddenly recognized a face in the stream walking by. It was Danny Holgate, the music supervisor for *Eubie!*, the hit show of the 1978–79 Broadway season. The previous November, I had flown to New York during my senior year to audition for the *Eubie!* national tour. At the audition, Danny had accompanied me as

I sang "Everything's Coming Up Roses" from *Gypsy*. I was so green it didn't occur to me to sing a "black" song or even a song by the show's namesake, Eubie Blake!

"Everything's coming up roses, for me and for *youuuuuuuuu*," I'd belted the iconic song, finishing the audition in a full backbend and holding the final note so long that Danny was forced to look around the upright piano to see when I'd finally release it. I didn't get the gig.

I pushed myself into Danny's path in front of Gray's Papaya as I wiped my mouth with a damp yellow-stained napkin. "Danny! Danny! Remember me? Hi, Danny, it's me, Jenifer Lewis—you don't remember me, but I auditioned . . ." He interrupted me, "Oh yeah, you're the one that did that backbend." (Obviously, I'd made an impression.) "I think they need somebody in the show right now," Danny continued. "C'mon, walk with me. I'm going to pick up some Chinese food." I was nervous because I had mustard smeared on my blouse and he was a big, important person in the theater world.

Well, timing is everything. Turned out *Eubie!* was looking for a replacement for a wonderful actress named Gina Taylor. Long story short, on June 5, 1979, exactly eleven days after graduating from college, I made my Broadway debut in *Eubie!* at the Ambassador Theatre.

Broadway! I had never doubted that I would perform on the Great White Way. (No joke here, folks. That one's too easy!) Mark Brown told me he cried when he saw my name on the marquee at the Ambassador because he knew I had dreamed of this my whole life. "It only took you eleven days,

Jenifer." I felt pride, amazement. But I also was keenly aware of the 8,030 days that had brought me there. (Yes, I did the math!)

Eubie! was a revue honoring the work of James Hubert Blake, the first African American to write, direct, and star in a musical on Broadway. The acclaimed musical revue starred Gregory Hines and Maurice Hines.

I barely remember my first *Eubie!* performance. I stood in the wings awaiting my cue, a little nervous but definitely not scared. My only concern was that I not disappoint my fellow cast members. I wanted them to see me as their peer. Suddenly I was on stage, singing and dancing in a hit show with some of the most talented entertainers on Broadway. After I sang my featured song, "If You've Never Been Vamped by a Brownskin, You've Never Been Vamped at All," I barely heard the applause. It was the faces of my castmates that told me I had done well.

I had stepped into a new world, the world of my dreams. I was the baby in the cast, but I felt safe with the veterans. I knew they were rooting for me. Even though I was not creating the role, I found ways to make it my own. Like, if the choreography called for two steps, I might take two and a half. Nothing to disturb my fellow actors; just a little something to put my stamp on it!

I was attracted to Gregory Hines (who wasn't?), and we flirted a bit, but mostly just became friends. He was a big prankster. Once, as we performed a sophisticated Blake-Sissle song called "A Million Little Cupids in the Sky," in which the choreography called for Gregory to hold me with my back to

his front, I felt an enormous lump pressing against my ass as we swayed and dipped. I barely held my giggles as I realized Gregory was sporting a pair of rolled-up socks in his pants!

Performing in my first Broadway show was fun, but it was intense, requiring me to focus my entire being on my performance. Most days, I would wake up around three in the afternoon, eat, stretch, and in order to open my lungs power-walk to the theater. After warm-up and vocalizing, I was on stage and life began. Everything fell into place for me once the conductor raised his baton. It was exhilarating: the music, the dancing, the response of the audience. Nothing else existed when I was standing in front of that many people. I could feel the energy from their eyes, hear the thump of their heartbeats. In these moments, I could read their souls and sense their innermost emotions. When you are good, you will deliver precisely the right performance for the audience at hand. In turn, the audience will deliver your reward—applause and adulation. Whew!

It felt exciting to become part of the black Broadway community. There was always the show after the show, and I soon found myself hanging out with towering figures of the theater—the likes of Hinton Battle, Ethel Beatty, Nell Carter (who at first was not having my young, Afro-wearing ass!), Armelia McQueen, Vivian Reed, Ken Page, Marion Ramsey, André De Shields, and on and on. Initially I would "eggshell" around these grand idols, but usually within ten minutes I'd have them all laughing.

We "gypsies," meaning anyone who has been on Broadway, especially in the chorus, had our own world, our own

language. "Chile, you peed all over that stage!" meant your performance was incredible. And if you were truly extraordinary, well then, "Girl, you turned that shit out!" We spoke only of show business, quoting old movies, singing in piano bars, and telling jokes. I felt embraced, a rightful part of the crowd even though one or two dismissed me as just the newest sweet young thang. Believe me, I have never been sweet and there was not a damn thang young about my talent.

Case in point: I understudied Alaina Reed (remember Olivia from *Sesame Street*?) on two spirited Blake songs: "Roll, Jordan, Roll" and "My Handy Man Ain't Handy No More." When Alaina was out for a few performances, I took the stage in her role. Later, she returned to backstage gossip that I had gotten standing ovations singing "her" songs. She didn't speak to me for a week! Now, up to this point Alaina had been cool; she had even invited me to her place in Harlem for collards and cornbread. So my feelings were hurt. Okay, not that hurt, but y'all, this was not *All About Eve*! I wasn't trying to take her part. Okay, maybe I was. So sue me.

Making that steady Broadway money in *Eubie!* allowed me to leave Mark and Bobby's place and move into my first apartment. In mid-September I rented a cute studio in the La Premiere, a new building on the corner of 55th Street and Broadway. It was a great location, right in the heart of the theater district with the Applejack Diner conveniently located a few steps around the corner (we are talking ten-minute delivery, y'all). Rent was $450 per month. I loved telling people that I lived in a "luxury high-rise," but failed to mention I was on the lowest floor in the smallest apartment. It was fun

to take my friends to the rooftop, where there was an incredible panoramic view. You could look down on the Winter Garden Theatre, Times Square, and the Hudson River, and to the north was a partial view of my beloved Central Park. Nobody could tell me I wasn't right where I was supposed to be.

But let's not forget that New York City can be a nasty two-faced monster, too. It will serve you diamonds with dirt, caviar with shit, pleasure with pain. I learned this firsthand after I'd been living in the city a few years and the *New York Times* crowned me the "reigning queen of high camp cabaret" for my one-woman show, *How I Spent My Summer Vacation*, which was selling out every night at Don't Tell Mama, the hottest cabaret in Manhattan.

As a result of the show's success, I was selected by the *New York Daily News* to be a Wingo Girl. There I was in a full-page picture, cheesing it up in my *Vacation* costume of a white bikini, fishnets, and white sunglasses.

Nearly one million New Yorkers bought the *Daily News* that day. I awoke around noon to the phone ringing and John, the doorman, buzzing up to say Western Union was coming up with a telegram and that there were two bouquets waiting for me at the front desk. I opened the door smiling, as I took the telegram. I had worked hard to make *Vacation* a success and felt on top of the world.

I lit a scented candle that I kept on the bed stand next to my open Bible and went into my small bathroom to run a steaming aromatherapy bath. As I bent over to tap two drops of essential peppermint oil into the water, my little Maltese, Genta, jumped up and bumped my elbow, causing

me to dump in half the bottle. I was quickly overwhelmed by peppermint fumes in the thick steam, and when I opened the bathroom door, the pungent fog filled my entire little studio apartment.

Just then, John buzzed again to say a delivery guy had a package for me. "Okay, send him up."

I opened the door to a young man holding an envelope with "Don't Tell Mama" in childish handwriting across the front. He looked quickly to his left and right and within seconds was inside my apartment holding a kitchen knife to my throat.

As I stood in paralysis, the cloud of peppermint fumes took quick effect on the man, causing him to wince and blink, clearly taken aback as his senses were invaded.

"What do you want?"

"You know what I want."

Genta started jumping up happily on him.

"Put the dog in the bathroom."

"Do you mind if I cut the water off?"

"Yeah, cut if off."

I did so and then closed the door, leaving Genta in the bathroom, worrying she would become sick from the smell. By now, the peppermint fumes were overpowering the room. He put the wooden-handled knife back at my throat and led me to the window.

"Are you expecting anybody?"

"My boyfriend is on his way over."

"Close the blinds."

As I reached for the blinds, like so many assault victims, I thought, *Is this really happening to ME? Dear God, what have I*

done to deserve this? I couldn't think of a thing I had done to warrant this moment. Then all the stuff I had been reading about past life regression kicked in and suddenly the image was clear as day for me. In a previous life, I had cut off this boy's head in one swoosh with a medieval sword. Now his soul had returned to take revenge.

Shock descended and everything went into slow motion as I closed the blinds.

"Take your clothes off."

I did so, feeling as though I were moving through cement.

"Get on the bed. On your back."

I followed his directions and then watched as he pushed his dark polyester pants down his legs to his shoes.

He lay down on top of me, putting his head on my shoulder and holding the knife in his left hand. In an almost gentle way, he slowly rocked back and forth. Not rough. Not urgent. He struggled quietly to get his huge penis hard. We both seemed to be miscast actors in a horrible movie scene. He seemed unsure, as if he was new at this. The thick peppermint aroma surrounding us was almost calming. When I turned my head to the right, I saw our reflection in the mirror next to the bed. The young man almost seemed to have forgotten me as he tugged at his limp flesh. In the mirror, I saw his left hand relax briefly, silently dropping the knife on the bedspread.

My right arm was free, and I put my hand around the knife handle without him realizing it. As I raised my arm to plunge the knife into the man's back, the stainless-steel blade flashed the glare of the candle flame at my eye. I stopped my

hand in midair. It was like the reflected candle sparked deep knowledge in my soul. Suddenly I was clear that violence was not the answer; I wanted to see neither my blood nor his on my bedspread.

I dropped the knife on the bed and undertook the greatest performance of my life. In a low, even tone, I asked, "What is your name?"

"James."

"Can I tell you something, James?"

"What?"

"You smell that medicine?"

He raised up on his hands, blinking his eyes against the invasive scent.

"Yeah, what is that?"

"I'm sick, and that's the medicine I have to soak in every day."

"What's wrong with you?"

I paraphrased something my mother had said to me about a friend's illness: "It's a disease, and they don't know what it is. I was raped."

"You were raped? Where?"

"Down over on 10th Avenue."

"What were you doing on 10th Avenue?"

"Walking my dog."

This was believable to him. He looked me in the eyes for the first time.

"Look, if you go inside of me you are going to get sick. Let me get you off. I have Vaseline in the bathroom."

"Uh, yeah. Okay."

He rolled off me. I got up and started toward the bathroom.

"Stop."

I thought, *Damn. He's snapped and this is it.* But when I turned around, the young man was sitting on the bed with his head in his hands. Crying. He looked at me.

"Put your clothes back on."

I quickly complied as he continued to speak.

"I shouldn't be doing this shit! Especially to a sister. They locked me up for some shit I didn't do! I just got out."

Suddenly I saw how skinny, fragile, and vulnerable this kid was. I realized I could probably kick his ass. Instead I sat down next to him and put my arm around his shoulder.

"I'm sorry that happened to you, James. You see this Bible? I have this here to help me through hard times. I will help you, James. Let me give you my number, and you can call me."

I walked to the kitchenette and got a paper and pencil. From the nightclub, I had $400 in tens and twenties on the counter. He easily could have taken it, but he wasn't looking for money. He was looking to hurt because he had been hurt. I well understood emotional pain. I gave him the paper with a telephone number on it.

"You should go, James. My boyfriend is coming. G'on now. I won't tell. I won't."

James looked at my piano and spoke like a little boy.

"You play piano?"

"Yeah, but you gotta go now."

"I'm sorry. I know you are gonna tell, but I just want you to know I am sorry."

He was not evil. He was just fucked up.

He left, and I stood still for a moment, then quickly opened the bathroom door. As Genta jumped into my arms, I fell to my knees and fainted.

When I came to, I thanked God for my life. Sweet Bobby came over immediately and that afternoon he and Mark took me to the stationhouse to report the assault. The detective said, "Miss Lewis, you will suffer some emotional stress over this. But keep this in the front of your mind, only one in three million women can talk her way out of rape, especially once the door closes.

When I called Thomas, my boyfriend at the time, he couldn't handle it. "Don't walk me through it."

I couldn't tell Mama or my siblings. I was too far from home and knew they'd be worried sick. The next day I fled to Boston. I was sure Temi and June, two friends about twenty years my senior, would give me the love and security I needed. I knew and trusted those divas. They had had so much therapy over the years, they knew exactly how to help me heal. I was tormented by "what ifs." June said, "You have a right to your thoughts. Have them all, feel them all, so you can get up and keep going."

They dragged me to a lake in Brookline, and I found solace in the beauty of New England in the fall. There's nothing like the bond between women during a crisis. They comforted me and reminded me of my own power. After a couple of days I felt better, although I continued to look over my shoulder

for months. But the show must go on. My beloved New York, despite it all, was still my city.

I had been performing in *Eubie!* for several months, when one late September day, I arrived at the Ambassador at half-hour and saw Gregory Hines and all the other cast members standing around the call board looking gloomy. They told me the show was closing October 7th, just two weeks away. I was so young and new to showbiz that I didn't realize that Broadway shows even closed. "Excuse me? We're closing? Well, now what do we do?" I remember how Maurice Hines just looked at me. Clearly, he couldn't believe my naiveté. Here were the great Hines brothers, and I was standing there with my big Afro wondering, "What do we do now? Where's the next show?"

The female lead in *Eubie!* was Terry Burrell. She and her sister Deborah Burrell, both extremely talented performers, were about my age, and I became close friends with them. I heard Terry say, "Me and my sister Debbie, we're doing a club act." I knew what that was, and I asked them, "Can I do it, too?" Terry said, "Why don't you open for us?" I didn't really know what that meant, but as long as there was a stage, I was ready. Thus I entered the world of cabaret in New York City. Terry and Debbie had a gig at the Bushes, a tiny nightclub, where I sat at a little white piano and sang Sam Cooke's "You Send Me" and two other songs. The Burrell sisters were fabulous, but on the first night I realized I wanted to be the star, not an opening act. I was the opening act only twice more—for the singing group Gal-

lagher and stand-up comic Jackie Mason. After that I made a rule—nobody goes on after Jenifer Lewis (said with humility, of course).

I did the Bushes for a few weeks, but with no other major gig in the wings, I began to fret as my finances dwindled. A gypsy friend suggested I check with the Actors Fund, a charitable organization that would give a few bucks to an out-of-work actor like me. The folks at the Fund were real nice and hardly asked any questions. I walked out of the office with $40 that would at least cover my food for the next week or so. But I was wishing it was $4,000.

Walking back home through Times Square, my attention was caught by a handful of people crowded around a small makeshift, cardboard table. The eyes of the crowd followed the quick hands of a short brother in a backwards cap as he shuffled three cards around the table in a lightning-fast round of Three Card Monte. He was talking fast, encouraging the onlookers, "Find the black queen and win 10 to 1!"

This is my chance! I was sure I could turn my $40 into $400 in just a few moments. Pushing my way through to the table, I watched two rounds, feeling smug because both times I correctly guessed which of the three cards was the black queen. The next round started. The brother switched the cards back and forth on the table really fast and shouted: "Place your bets, my people! We payin' 10 to 1!"

With the most confidence I had ever felt in my entire mothafuckin' life, I put my two twenties on the middle card. Within five seconds, I was as broke as I had been a half hour earlier. Y'all, I never gambled again!

I took my last couple of dollars to get some fruit at a bodega on the corner of 55th and Broadway, when who do I bump into but Gregory Hines. "Hey, did you audition for my new show? It's called *Comin' Uptown*." He gave me the address. "Tell the choreographer I sent you." I ran the short block to my apartment and put on a wig I had stolen from the "Oriental Blues" number in *Eubie!* (Ten years later I would be on the cover of the *Los Angeles Times* arts section wearing that same wig—and it was crooked!)

It took me just ten minutes to put on mascara and some red lips and power-walk to the rehearsal space off Broadway. As the lyric from *A Chorus Line* goes: I went "up a steep and very narrow stairway" in my flowing polyester red top and black tights to audition for *Comin' Uptown*. It was an outfit my *black-ish* character Ruby Johnson would have loved (but I was forty pounds lighter then!).

Once again, I belted out my stock audition number— "Everything's Coming Up Roses." The choreographer then asked me, "Can you dance?" As I've said, I have never been a great dancer. But like Streisand in the audition scene in *Funny Girl* where she is asked "Can you skate?," I said, "Absolutely!" If it might get me the job, then hell, yeah I will go for it.

In that moment, everything fell into place: the cheerleading at Kinloch High, the study of dynamics and Feldenkrais in college, and the vaudeville moves I had learned while touring with *Baggy Pants*. I drew back, and pow, my highest kick into a fantastic battement into a grand layout. I don't think I impressed the director, Philip Rose, but Michael Peters, the choreographer, went nuts! Yes, *that* Michael Peters—the chore-

ographer who would go on to win a Tony for *Dreamgirls,* but who is perhaps most famous for his genius work on the music videos for Michael Jackson's "Thriller" and "Beat It."

I got the job, my second Broadway show in just six months of arriving in New York City. *Comin' Uptown* was a musical update of Charles Dickens's *A Christmas Carol.* Gregory Hines played Scrooge, reimagined as a Harlem slumlord. I played one of the Salvation Army Trio, which also included Debbie Burrell and Deborah Bridges. Loretta Devine was making her second Broadway appearance, too. This was also the show where I became close with Shirley Black-Brown, a former Ailey dancer, who played Bob Cratchit's daughter. The show opened at the Winter Garden Theatre in December 1979, but ran for fewer than fifty performances.

FOUR

DICK DIVA

ike most successful Broadway shows, *Eubie!* spawned a national touring company. I got cast in the upcoming six-month tour just two days after *Comin' Uptown* closed.

The day before I departed for the tour, Ken, a journalist friend, came over for a little "afternoon delight." Right after he left, Perry called and said he was leaving town and wanted to see me. Dear, delicious Perry! We had been lovers since my sophomore year at Webster (during my breakups from Miguel, of course). Perry had moved to New York City to pursue a show business career.

I recall the first time I saw Perry as I stepped out of my dorm room on the all-girls floor where I lived. I knew immediately that he had to be a dancer because of his long, shapely

physique. Perry had trained with the great Katherine Dunham at her studio in East St. Louis. When I saw him, a freshman, wandering around looking lost, I had only one thought: *Come into my parlor, said the spider to the fly.* Fans of Tennessee Williams's *A Streetcar Named Desire* might have called my dorm room the "Tarantula Arms"!

That afternoon, Perry and I began a pattern of loving up on each other between relationships that would continue for several decades. We made love the entire night before I arose at dawn to fly to Los Angeles for the start of the *Eubie!* national tour.

I landed in LA with a terrible cold. Linda Saputo, a Webster friend whose outstanding talents had taken her to Hollywood, picked me up at the airport and drove me straight to the theater. My cold was really bad, so on the recommendation of Kelly, the company manager, that afternoon I went to an acupuncturist named Mrs. Chen. It seemed she porcupined my ass, but damn if those ten thousand needles didn't eliminate most of my cold symptoms. After she removed the last needle, she looked into my eyes, squinted, and spoke harshly in her thick Chinese accent.

MRS. CHEN
"How many boyfriend you got?"

JENIFER
"Excuse me?"

MRS. CHEN
"How many boyfriend you got last night?"

JENIFER

"Ummm . . . one?"

[*MRS. CHEN'S squint grows tighter.*]

JENIFER

[*sheepish*]

"Uh, uh, okay, two."

MRS. CHEN

[*growling*]

"You listen to me very carefully. Two man. With one wo-man. Make one wo-man poison!"

How the hell did Mrs. Chen know I had sex with two men on the same day? I ran out of there as fast as I could. Years later, after reading Louise L. Hay's *You Can Heal Your Life*, I learned that some people have the skill to just look at you and know where you are sick. It's in your body language, your face, and, most certainly, the eyes.

I was thrilled to be part of the *Eubie!* national tour and grateful to be working with a wonderful cast of talented, fabulous gypsies. Touring companies are like unconventional families. We were young and energetic, dancing and singing through eight shows a week. Our stamina equaled that of any Olympian.

The show was getting rave reviews, and I felt blown away by the effusive praise my performance received from the newspaper critics:

"Half laser beam; half lava flow . . . vibrant stage presence."

"Meteoric voice."

"Could hold the note from here to September."

When the show moved to the Studebaker Theater in Chicago, my father's family bought out a couple of rows. My parents had separated when I was two weeks old. Daddy lived in St. Louis, but there was a huge contingent of Lewises in Chicago. These were South Side family people—you know, Patty, Pinky, Popo, Minkie, Keesha, Junior, and dem. I felt proud. These were the aunts and cousins who had heard me proclaiming my stardom since childhood. For them to see me on the stage of the Studebaker was exhilarating. They were so supportive and happy for me. "G'on Jenny!" they shouted from the audience, clapping and whooping as I belted "Roll, Jordan, Roll" and shook my money-maker.

The party continued well into the night when at least a dozen Chicago relatives came back to my hotel room after the show. They brought buckets of fried chicken and Tupperware filled with spaghetti, potato salad, collards, and chitlins. There were coolers of cold beer, soda (pop, as they say in Chi-Town), and Kool-Aid, plus nine or ten fifths of hard liquor and a bottle of Ripple to boot. I invited the entire *Eubie!* company. When you were on the road, home-cooked food was always a treat.

Gypsies are nocturnal creatures. We would do the show and then go to bars or clubs, where we'd sing, drink, and likely pick up a "piece," the term gypsies used for the "civilians"

they'd meet in a club and spend the night with. For me, nothing could extend the thrill of a standing ovation like great sex with a gorgeous guy. After all, I deserved my reward for a job well done! Not only was it fun, but I had discovered that sex could lessen the "crash" I sometimes experienced when I came offstage.

It's pretty common to have a heightened sense of self when you are performing: a rush of bliss, and an almost uncontrollable sense of accomplishment, like what runners feel when the endorphins kick in.

The applause coming over the footlights is like a slow-motion tsunami of adoration, like jumping on a spaceship and riding it bareback to Pluto. The crash after the show, I assure you, is just as intense. Let's just say that I had sort of an unconscious habit of using post-show sex to come back to earth.

Well, "unconscious" habit isn't really accurate. I wore my sexuality like a medal. I was Cleopatra, Pam Grier, Marilyn Monroe, and Jezebel rolled into one. A jaguar with skin supple as a baby's ass, capturing my prey with lust and laughter. Then, ever the alpha, it was I who chose the locations, the positions, and the durations.

Let me be frank—I did a lot of fuckin' during those years of crisscrossing the nation in concerts and shows. But hey—*everybody* was having a lot of sex. The sexual revolution was still in full swing. Despite my Baptist upbringing, I'd been sexually active since my teens and, as a young woman, I was pleased with my ability to attract men and had never been shy

about talking about my sexual escapades. In fact, I cracked everybody up with my exaggerated stories—"Girl, it was so big that when he stood up in the bathtub, he knocked out my front tooth." Ultimately my girlfriends nicknamed me "Dick Diva."

My men were handsome, talented, and accomplished. I mean no scrubs. For instance, there was the club bouncer in Chicago who looked like a black Clark Gable. One night, after earning two ovations, I knew I was not going to bed alone! I escaped drinks with the rest of the *Eubie!* cast and went off on my own to a disco. As the bouncer unhooked the velvet rope for me, he flashed a perfect set of teeth with a big Ultrabrite smile. He was so beautiful there was no thought in my brain other than "Nigga, you goin' down!"

We spent a few hours at the club chatting about his travels and studies before I took him back to my hotel and drew a bubble bath. That was my ritual with new conquests, my way of assessing the goods. It was a tactic that I learned in Kinloch as a young teen.

Me and my girlfriend, Ethel Rue, decided to skip junior high school one day. We were walking down Cranberry Road when a big white Cadillac pulled up. It was Fat Jackie, the town prostitute. She hollered out of the car, "Y'all skippin' school? Git y'all's asses in this car. Go on. Git in the back seat."

Me and Ethel were scared that we would get in big trouble for playing hooky. Fat Jackie was just driving along, and when she got to a stop sign, she put her right elbow over the seat

and looked back at us. She had rings on damn near every finger, blond coif grazing the car roof, two gold front teeth, and a fried chicken leg in her right hand. She pointed that chicken leg at us and said, "Y'all fuckin' yet?"

Personally, I had only made out once with Jessie under the bleachers at school. But I knew Ethel was already on the fast track to getting pregnant with Raymond's baby. Naturally, we both said, "No, ma'am."

Fat Jackie said, "Yeah, well, when you do start fuckin', make sure you always check the meat."

We didn't know if she was talking about baloney, ham, or Spam, especially since she was waving the chicken leg. She went on to explain.

"I carry a flashlight wherever I go. Some men always want to keep the lights off, but I always check the meat. You girls hear me?" She jabbed the drumstick in the air to punctuate her words: "Always. Check. The meat!"

By this time, Ethel and I were pressed against each other in the backseat, scared to death. Fat Jackie pulled up in front of the school and said, "Now, git the hell out of this car and go git y'all's education! Next time, Imo tell y'all's mamas."

Running from the car as fast as we could, we heard Fat Jackie yell once more, "Be sure you check the meat every time!"

In the bubble bath, I checked out the bouncer, Mr. Clark Gable, whose name was actually Maurice. He turned out to

be a master of Shotokan karate with an eight-pack torso and a dick the size of a small garden gnome. I sank lower in the bubbles, thinking "Mer-ry Christmas!"

For the next couple of weeks while *Eubie!* played Chicago, Maurice joined my rotation of sex partners, which also included a musician I'd met named Steve, along with Ken and Perry via phone. Usually, I would see a guy for a few months, often juggling him along with a few others. Yes, y'all, I was skilled.

Things were going pretty well until I found out that Steve was planning to get married. Like I said, I've always been dramatic. Steve's news gave me overwhelming pain, and I missed a performance because of it. Not that I wanted to marry him—I had a rule never to mess with other women's men. But not to worry; Steve was soon replaced with Pierre and Jerome.

The tour moved on to the Music Hall Center for the Performing Arts in Detroit. They put us up at a dump called the Leland Hotel, which fortunately had a piano in the bar. Never show a gypsy a bar with a piano—the show is *on*! We gathered in that bar every night.

Basically, I had a "man in every port." Although I started out in Detroit dick-less, I soon met Leon, a professional masseuse who gave me a massage in my hotel room and came back two days later for sex.

Needing attention from more than one man, I felt the need to check in with all my boyfriends. I called Ken, the journalist in New York, and Maurice in Chicago. I hung up when

a woman answered Maurice's phone. I've kept a journal since junior high and wrote:

JOURNAL ENTRY: que sera, sera, motherfucker.

Despite this merry-go-round of men, Miguel, who was still in the Dominican Republic, always remained in the lead position.

One of the most popular recording artists around at this time was the sultry Phyllis Hyman. When I heard she was playing in Detroit, of course I had to go see her. Phyllis was a sexy, quiet Amazon who demanded your attention. You would bow down as soon as she hit the stage. Her stunning beauty, six-foot frame, and that big-ass hat she always wore made her an imposing and impressive live performer.

I admired Phyllis not only for her talent. In television interviews, she had spoken out about racism in the music industry and the price she had paid for being a black woman and telling it like it is.

Phyllis was not a belter like me; she was softer and quieter but still very powerful. Most important, she had achieved the success that I dreamed of. Watching her sing was a rush because it was proof that my dream was possible; through my eyes that was *me* on the stage. Her performance and mastery thrilled and excited me to the point that I couldn't get to sleep until eight the next morning, which caused me to sleep right

through our matinee show. But I was willing to take the hit of losing a day's pay to experience the great Phyllis Hyman.

During the weeks on the road, it seemed like I always had a cold. No surprise, considering my diet consisted of chips, pickles, and Manischewitz wine. I ate lots of cheese, which I now know puts mucus on the vocal cords. I also had no clue that a steady diet of Kentucky Fried Chicken and doughnuts wasn't a good idea. It wasn't surprising, then, that midway through the Detroit run, I had to have my costume let out a full inch. Maxie, the head of wardrobe, looked me dead in the eye and gave me some of the best advice of my life. She had spent years in the theater and witnessed numerous svelte entertainers bloom beyond the point of no return. "Don't do it, Jenifer," she said sternly. "You will never be able to get it off." Her advice has stayed with me and is one of the reasons that thirty years later, I am still in pretty good shape and still cute, thank you very much!

After Detroit, there was a short break in the tour, so I flew back to Manhattan for a couple of weeks. Landing at Kennedy, I took a bus to Columbus Circle. It was the midst of the great transit strike of 1980, so I had to roll my suitcase the few blocks down 8th Avenue to my apartment. It felt good to be home, to feel invigorated by New York City's unique pulse.

I walked to Colony Records and bought the new Dionne Warwick album that included "I'll Never Love This Way Again." I couldn't wait to wrap my vocal cords around those high notes come the next audition. Despite my resolve to watch my weight, I treated myself to a sundae at Howard

Johnson's. I started to crash from having been on tour so long. I found it very difficult to adjust after the excitement and elevation of performing every night. My solution was to blast Ethel Merman until the wee hours. My poor neighbors!

Come the next morning, I was back into my routine of dance classes and voice lessons every day. I was hanging tough with Terry Burrell and Shirley Black-Brown, who would always bring the weed (*I never* bought it). Then we'd go shopping—you do *not* want me shopping while I'm high! After dropping serious dollars at Bergdorf and Saks, we spent a good hour in Ray Beauty Supply on 8th Avenue getting every product needed to maintain our diva-ness! Hanging with the girls was great, but you can best believe I always had calls out to a couple of my men.

Within a day or so of arriving back in the city, I was having phone sex with Ken around one in the morning when someone buzzed from downstairs. To my surprise, it was Gregory Hines, who had just returned from the Continent. He was a bit tipsy and had brought over some African wine from his trip. I suspected that he didn't realize I was back in town and that it was Debbie Burrell whom he was really looking for. I had sublet my apartment to her while I was on the road.

When Gregory and I performed together the previous year, our flirtations were pretty minor, and I was among the few women on the Broadway scene with whom Gregory hadn't had sex. *Allllthoughhhhh*—there was that one time after the first act in *Eubie!* We came off stage exhausted from the last number, an uptempo piece called "Jazz" that

ended with about fifteen roundhouse kicks. The dressing rooms were several flights up and I just couldn't make it. I sat on the stairs and as Gregory climbed toward me, I made a request:

JENIFER

[*heaving to catch her breath*]

Gregory, I am sooooo thirsty, but I am just too tired to go all the way back down for some water. Could you go get me some?

GREGORY

[*sweetly*]

Jenifer, I'm tired too.

JENIFER

[*in joking whisper*]

Gregory, if you go get me some water, I'll let you suck my ti-

Schwinggg! Gregory took off like the Road Runner! In a matter of moments he was back with a cup of water. When I finished drinking Gregory stepped toward me. I said, "Gregory you know damn well I was playing!" He smiled and said, "A promise is a promise, Jenifer." And with that Gregory gently lay me backward on the floor, opened my robe, revealed my right titty, and proceeded to suck it vigorously for at least a couple of minutes. I squirmed in protest (hey, I had to act like I didn't like it), but I probably came twice in that brief session.

A few of my castmates saw what was going on and shook their heads, but I didn't care—they were probably as turned on as I was.

So, when Gregory showed up at my apartment with the wine, there was no hesitation on either of our parts and we quickly took our relationship to a new level on the kitchen counter. We were pretty wild and somehow wound up naked, with me riding piggyback and shushing Gregory from making so much noise as he trotted out of my apartment and down the hallway, singing loudly. Like bare-ass fools, we hopped into the elevator to the lobby and Gregory galloped around the concierge desk a couple of times before we made it back to my apartment without being seen by anyone. Oh, to be young, silly, and free! Years later, I started to regale some friends with my Gregory story. My good friend Lorraine Fields stopped me cold. "Oh, Jenifer, Gregory told everybody that story the day after it happened!"

During my break from the *Eubie!* tour, I enjoyed dates with several guys from the corral of men I had assembled in New York. Besides Ken, there was Ron and Patrick. But then I was forced to go to Roosevelt Hospital with a raging yeast infection. The burning was terrible. Fortunately, it cleared up by the time Miguel called. He was back from the Dominican Republic and invited me to Brooklyn. When he opened his apartment door, we fell upon each other and I sucked his entire body. I loved him so much. No other man got this kind of attention from me. Here he still wanted to marry me, yet he knew I'd been with other men while we were apart. I didn't

mean to treat him badly—it's just how things had been between us for years.

The first night back on the *Eubie!* tour in Kansas City, I met a conventioneer named Nick at the hotel bar. A day later, we had sex. I felt terrible; how could I have sex with a stranger right after sharing such a beautiful time with Miguel? He deserved better from me. Nick showed me a picture of his girlfriend back home. Her name was Becky, and she was a home economics teacher. He called me from the airport.

JOURNAL ENTRY: Poor baby. He's in love.

My family drove from St. Louis to see me in the show. On one hand, I loved having them. But on the other hand, I felt a higher level of stress because I wanted them to be proud of me, especially Mama. She seemed to always find something to criticize.

We all ate at Gates Bar-B-Q, and I was so happy that my sister Jackie stayed with me in my hotel room. Her son, Michael Quinton, was a toddler at the time, and shared my bed. It was so cozy and sweet until I awoke with a full diaper in my face!

The combination of my guilt about Miguel and the stress of having my family in town made me irritable, which caused some bad blood with a couple of members of the *Eubie!* company. I felt remorse about being on the outs with my cast-

mates, but I just didn't know how to fix it. I lacked certain social graces. I had no boundaries, I teased and joked and often went too far. I also always flat-out spoke my mind, resulting in people either loving me or hating me.

A week later during the opening-night reception in Boston, I drank too much and basically acted a fool, even jumping onto the piano and rudely hushing the crowd so that I could sing to them. When I finally took a breather, a beautiful blond woman who had been in the audience approached me. "Your performance was extraordinary. We just had to meet you." This is how I met my friend Temi Hyde. She took my hand and in a refined Boston accent, introduced her boyfriend Billy. Temi was gorgeous in a beaded silk dress and dripped of culture and wealth. I guessed she was in her mid-forties. We chatted awhile, and I became enchanted with this elegant, worldly woman who thought I was brilliantly talented.

As the evening wore on, I went with my castmates to a disco, where I continued to drink, trash talk, and act out. By the time I went back to my room, I was a drunken mess. Crying, I called Debbie and Miguel, but their words of comfort did not help much. I thought about calling Mama, but instead called Miss Mitchell, one of my mother figures, who I knew would comfort, not criticize me. Afterward, I still felt sad as I looked at myself in the mirror and thought, "God, what is wrong with me? The show went great, so what's wrong, baby?"

JOURNAL ENTRY: 2:30 a.m. I've failed. I need a cause in my life.

I tried to keep my mind on what Temi had said. Was I really "extraordinary"? I felt guilty about Miguel, at odds with my castmates, and completely fucked up.

A couple of days later, I met Temi and Billy for drinks. They brought along an older man named Jack. He was an alcoholic, which I saw as dangerous and exciting. I thought, *So what, I'm all those things too.* I brought him back to my room and had sex with him. I might have gotten gonorrhea from him. Or maybe it was Nick from Kansas City. It scared me and I was much more careful from then on.

On matinee days, I left the theater and aimlessly wandered the streets of Chinatown. Traveling and working with people in close quarters every day was becoming increasingly difficult. The thing is, while I was clearly an asset to the company, I didn't know how to be part of a team offstage. Ever since childhood I had been the lone wolf. There were seven kids in my family, and they paired up into three couples, leaving me the odd one out. With the neighborhood kids, I put myself above the crowd in order to lead. I became the alpha wolf. I was running the show. I would get loud and bullying and shut the shit down!

In high school, my nickname was "Killer" on account of my sharp tongue and pushy nature. In college, I was dubbed "Majestic" for my commanding theatrical abilities and queenly behavior. Throughout my adolescence and young adulthood, people had catered to me because I was talented, cute, and charismatic. Often, I received special treatment or I would get people to laugh and be forgiven for my

transgressions. As a result, I did not develop certain social skills—collaboration and conciliation—that were necessary in a touring theater company, and in life in general.

When I became a professional and show business added glamour to a persona that was already bullying, killer, and majestic, I emerged a diva. Now there's a two-edged term! It can be the ultimate compliment, indicating a woman's mastery of her art and, often, her "fabulous" demeanor. But the term can also be an insult, describing despicable grandiosity and disregard for others. Yes, a diva is admirable and a "Qween." But she is also a self-centered, demanding bitch. During the *Eubie!* tour, my diva-tude flourished, unfortunately in both senses of the word.

My shortcomings, combined with a working culture that breeds drama and competitiveness, caused me to continue to have friction and disappointment with the other gypsies. I was sort of the baby, straight out of college. They had been pounding the pavement and surviving for years, and here I come—fresh from four years of classical training and living in a dorm. In an unconscious move to protect myself, I became obnoxiously overconfident: "I am the best whether you know it or not."

JOURNAL ENTRY: I wish I knew who I really am. Why the fuck am I here?

Speaking of divas, when I went with several company members to see the incomparable singer Carmen McRae,

the great George Benson was in the audience. Following the show, I went to Miss McRae's dressing room to tell her how much I appreciated all that she'd contributed to the art of singing. To my surprise, she squeezed my hand and openly flirted with me. It made me uncomfortable. Remember, it was 1980, and lesbianism was still pretty taboo. I have never had a problem with people's sexuality, but be you man, woman, goat, rooster, or rhinoceros, don't be squeezing my hand with your sweaty palm!

I left the nightclub in a foul mood, feeling frustrated that Carmen McRae was a big star and I wasn't. During dinner with Terry and a couple of others, I boasted endlessly about my own talent and grandeur. It quickly became too much for my companions to take. I wound up in a showdown with the *Eubie!* hairstylist Breelum Daniels.

"Something's going on with you, Jenifer. It's like you're hiding the real Jenifer." What? It pissed me off. Instead of responding like an adult, I said, "Yeah, it's that 'other' Jenifer who gets the great reviews that keep you your job, ain't it?" I stood up and stalked out of the restaurant and walked for hours, trying to absorb Breelum's comment.

The next morning, The *Boston Herald* featured me in a spread with a half-page photo taken in front of the theater. I was ecstatic and mailed copies of the review to Mama, as I always did. But my joy was fleeting. I was feeling unnerved, isolated, and alone. Now that I was living my dream, why was I sad and confused all the time? I especially could not brush away the dark moods at night. Even as a child, I had

experienced extreme sadness, often sobbing silently into my pillow before sleeping. I'd sometimes awaken in the middle of the night and write in my journal or doodle, doodle, doodle. Otherwise, I often felt as though I could not control my anxiety, my scattered brain, or my impulsive, rushing speech. I spent a lot of time alone engaged in activities that would bring me peace, such as cleaning the apartment or braiding, unbraiding, and rebraiding my hair.

Things reached a low point after the showdown with Breelum in the restaurant. I got even more depressed when Miguel called to say he could not come to Boston for a visit. I missed him so much. Then my crazy ass called Jack, of all fucking people. He answered, mumbled, and the line went dead. Alcoholic!

JOURNAL ENTRY: I feel so scared, empty, lonely. Not really alive. No real cause. Nothing. But on stage, nothing can hurt me!

Toward the end of the Boston run, I flew to NYC a couple of times to spend time with Miguel. I was disappointed to find he was not in the mood for making love. He had more pressing issues on his mind; nobody was hiring Dominicans, even one with a PhD and two master's degrees. I felt for him deeply.

JOURNAL ENTRY: As God is my witness I love this man.

The next morning, I flew back to Boston on the shuttle, did the show, got drunk, and called Maurice (Mr. Garden Gnome) in Chicago. Within two days, I met a new man at a disco, an Ethiopian named Joe. I wrapped my legs around him as we danced, reaching for his third leg. I took him straight home. But, God bless him, his dick was so small that I told him, "Honey, the only place you can put that is in my ear!" I faked a sudden headache and escorted him out with a smile. Poor bastard.

Boston was done, and we moved on to Toronto, Canada. I was excited the entire trip to Toronto because it was the first time someone in my immediate family had left the United States. We stayed at the Waldorf Astoria Hotel, with a pool and sauna. It was a lot nicer than the usual dumps they put us in.

I had yet to meet a man in Toronto, so I hung out a lot with the other gypsies—the museum with Donna Ingram, a street fair with Billy McDaniels. My friend Roderick Sibert and I went to see *Alien*. He was from Toronto, so his mother cooked dinner for us at her home. I gobbled up her delicious stuffed cabbage, sweet yams, and cornbread. Later, Roderick and I went and did the show. The reviews were great, singling out my performance. I was getting ovations, but it was becoming the "same ol' same ol'." A routine. In addition, the pressure of the backstage drama was getting tough. I was seriously thinking about leaving the tour.

I was unhappy and welcomed some one-on-one time with Terry, a true friend. She invited me to her room, and we talked about me becoming more aware of other people's space and being more disciplined. I asked her if the other cast members liked me. She said, "Jenifer, everybody loves you. You're talented, you're fun, you're fabulous. You just come off as intimidating. You need to calm down, girl."

Thank goodness we got off the subject and started sharing our excitement about going to see Tina Turner the next day. I splurged and bought a beautiful blouse for the occasion for $29.99. We pulled up at the York Hotel. We knew we'd have good seats, as we received special attention in every city because we were performing at the big theaters.

When Tina came onstage and opened with "Disco Inferno," my own body was so filled with electricity, my head damn near exploded. There she was, all legs, hips, arms, and hair. So much fucking hair. It was all I could do not to just run the fuck up there and fall to my knees and weep. All hail the queen.

We were allowed backstage. Tina's assistant opened the door and led us into her dressing room. And there she stood—THE Miss "Rollin' on the River." Miss "Shake a Tail Feather." Miss "Nutbush City Limits." Miss "Rock Me, Baby, Rock Me All Night Long."

Tina's legs were as long as the Mississippi River. Though she was just standing there, it was as if her hips were still gyrating. As she opened her arms to embrace me, her wingspan was that of a golden eagle, and in that raspy voice, she said, "How's everybody?"

I was speechless. Here was my opportunity to bow, and I bowed lower than I ever had. We all hung out in her dressing room for a little while, and when we left, our feet never touched the ground.

By the way, there's a rumor on the Internet that I auditioned to play Tina in the 1993 movie version of her life, *What's Love Got to Do with It.* I did not. The reason I wasn't asked to audition for the role of Tina was because my titties were too big. Too bad, because I could've sung that motherfucker and acted the hell out of it! Bitch better have my money. Anyway, nobody could have played the role as well as Angela Bassett.

Lo and behold, the director of *What's Love* called me during the casting process to tell me they wanted me to play Tina Turner's mother. I was just about to say "fuck you" when he told me how much I would be paid. Before I hung up, I told him, "Well, for that kind of money, I'll play the daddy."

That, ladies and gentlemen, is how I began my career as the mother of black Hollywood. I played the hell out of Zelma Bullock. The real Zelma Bullock loved me in the role—even if she didn't like how the film portrayed her overall.

A year or so after the movie came out, I was in a vitamin store. I heard a woman say: "Alline, come over here in this aisle and show me which one of these vitamins I should get." *Wait a minute, do I recognize that voice?* And the name Alline, could it be? Oh my God, my God, my God. I stage-whispered to my friend, "I think that's Tina Turner's mama . . . It's Zelma Bullock!" I went into the next aisle and saw an older woman in tight pants. She had Tina's form and was quite fit for a woman of her age. I approached her timidly. I said, "Ms. Bullock?" She

turned around—the spitting image of beautiful Tina—grabbed me, and hugged me so tight. She pulled back with water in her eyes and said, "I wanted to be so dressed up when I met you." I knew what she meant and felt humbled. When she passed in 1999, it was an honor to sing at her funeral.

Apparently, in all that heightened excitement, while we were in Tina's dressing room I cracked a joke that was insulting to one of the cast members, Cheryl. When I got to the theater the next day, she ambushed me. I was shocked by her fury over what I saw as innocent joking and teasing. She looked so hurt and I felt so sorry. I apologized profusely. It was rare that anyone would confront me at all, especially like this. As Terry had said, I had a way of distancing people when they'd get too close. It was a moment of insight for me. I wanted to make amends immediately. Fortunately, she listened when I explained that I meant no malice toward her. She softened, and after the show we went to the hotel and watched TV together.

The TV news headlines were all about the eruption of Mount St. Helens in Washington State. Volcanic eruption seemed an appropriate metaphor for my demeanor in those days. Show after show; man after man; the blindness of persecuting my colleagues and thinking they would be okay with it. I felt sorry for myself. I knew I wasn't a bad person, but it did not stop me from carrying on and being argumentative. I felt out of control of my behavior or blamed others for my treatment of them. I felt my brain was moving too

rapidly and I was constantly chasing after myself. Except for Terry, nobody seemed to be on my side. I hung around Roderick a lot, even though he got on my nerves. One time he tried to undermine me by telling everyone I was a lesbian. Foolish boy! Given my track record, how far do you think that rumor went?

Hanging out with the girls and the gay boys was fun, but I was on the hunt for a straight man. I had started to recognize that I "needed" regular sex. Without it, I felt scattered and moody, like I was coming apart at the seams.

As they say, the show went on. I was invited to sing "My Handyman" on Canada's national morning TV show. I was so happy afterward that I called Miguel, but we fell into the same old fight as he pleaded the usual: "Come back to me. Let's get married. We should have cheeldren, Yenifer . . ."

FIVE

LOVE VERSUS
DREAMGIRLS

A couple of weeks into the Toronto run of the *Eubie!* national tour, the earth turned over. I met Thomas Linzie, the tour's new stage manager. Our eyes locked, and everything changed for both of us. Thomas was smart, generous, sweet, short, and freckled. I couldn't wait to kiss his lips. I couldn't wait to feel his skin. And maybe Terry suggesting that I calm down helped me not to jump his bones immediately.

Thomas was a really great stage manager who everyone liked. We talked until 2:30 a.m. the first time we met. We had dinner the next day. It was so nice to be with him. On our day off we went to the Yorkville neighborhood, had ice cream,

and saw *The Empire Strikes Back*. We walked home. It was a beautiful, romantic night.

Around this time, a woman I knew, Kimako Baraka, called about a musical revue, *Foreplay*, that she wanted to produce with me and Loretta Devine in the cast. I was intrigued by the title alone. Kimako, also known as Sondra Lee Jones, was the sister of the famous writer and activist LeRoi Jones, now known as Amiri Baraka.

I saw *Foreplay* as my way out of *Eubie!* and arranged with Kimako to fly to NYC later in the month to audition. I told Terry that I planned to give my notice to quit the show.

I didn't tell Terry about Thomas. She would have said, "Don't shit where you eat." I knew I was falling in love with him. He was a good man, born and raised in the Midwest. A gentleman, even, he always opened the door for me, wouldn't let me carry anything. And, yes, he gave me the last bite of food. I always found that so sexy. I had become a pool shark in college, but when we played, I let him win, because when the real moment of truth came, I wanted to be sure I had never threatened his manhood. I wanted that first time to be real good.

Thomas had so much going for him that I wanted this relationship to grow and last. I didn't really know a lot about the internal workings of men. My father had been mostly absent and my older brothers pretty much had nothing to do with my little crazy ass running around making trouble.

One memorable evening, Thomas and I went to a club called the Chicken Deli to see Earl "Fatha" Hines, the great jazz pianist. We still had not made love, which was an indi-

cation that he was special to me. I was a bit tipsy when we returned to the hotel, but we parted and went to our separate rooms.

When Thomas and I finally made love, it was wonderful. We had both known it was inevitable. In the morning we had breakfast on his balcony. I wanted Thomas to know who I was, what he was getting himself into. Rather than have an adult conversation with him, I tried to shock him by sitting on the balcony topless. Topless, while workers in the building across the way watched us eat. My inability to tap into my emotions and talk about them warped my thinking and caused me to "test" Thomas by pushing him away. "This is who I am. Run while you have the chance!" But he stayed. He accepted me.

The company had rented a bus to take us all to Niagara Falls that morning. So when my castmate, the ever-so-fierce Leslie Dockery, went to my room to get me, of course I wasn't there. She, along with the rest of the company, figured I'd spent the night with Thomas. They all sat on the bus and gave me the side-eye because I had had sex with the stage manager.

At Niagara Falls, the sound, the roar. It was my first waterfall ever; one of the most overwhelming experiences in my life. The falls were so unbelievably loud, I swear I thought I had died. When I got off the bus I said, "What the fuck is that sound?"

"Jenifer, it's the falls."

"Where is it?" I ran like a crazy person in the direction of the sound and found myself looking straight at the famous Horseshoe, Niagara's largest waterfall. At that moment, I

knew there was a God. It was a sight to see, ya'll. A sight to see.

I took a brief break from my new love affair with Thomas to fly home to sing "You Light Up My Life" at my aunt Janice's wedding in St. Louis. Later that night, Mama and I watched TV and I talked to her about Daddy, life, and love. I was hungry for anything that made sense. In passing, I asked about her pastor at First Baptist. I was sidestepping. Pastor Heard had molested me as a teenager. When it happened, I told Mama, but the issue was never resolved and we never discussed it. The experience shattered our already tenuous relationship and for many years, I wondered whether Mama was in my corner.

The next morning, Mama made me breakfast and told me she had arranged for Pastor Heard to take me to the airport.

In his car, I disconnected from my history with this person in order to survive the present situation. I repressed my rage and chitchatted with him. This is what trauma does to you—it shuts you down and shuts you up, just like the hundreds, thousands, and millions of women who are molested and say nothing.

On the way back to Toronto, I stopped in Manhattan and turned out the *Foreplay* audition. *Foreplay* was planned to tour several capital cities of Europe. I was excited at the prospect of becoming an international star like Josephine Baker. When I returned to Canada I immediately called Kimako and learned I got the part. I hardly had time to celebrate before I

was on the stage belting "Roll, Jordan, Roll." I started to call Mama to tell her the good news but instead called one of my mother figures, Graziella Able, the producer and choreographer I'd worked with a few years earlier in *Baggy Pants*. I knew that she would express authentic happiness and pride in my accomplishments. Then I quickly showered and ran to Thomas's room, where I had him, and had him, and had him again.

It was like Thomas and I were on our honeymoon. We spent all of our time together enjoying Toronto's great restaurants and cultural venues. Once we declared our love for each other, my interest in other men disappeared. I was a demanding partner, but Thomas didn't mind, and we made love morning, noon, and night.

As soon as we were back in the city, Thomas took me to the Bronx to meet his family. It became obvious that Thomas was less interested in introducing me than in proving to his older brother, who was a nightmare combination of cigarettes, liquor, and barbecue, that Thomas could get a hot girlfriend.

I was *soooo* glad to be back in New York City. My days were once again a blur of activity: rushing to and from dance classes and voice lessons, spending time with Mark Brown and Bobby, or hanging out at popular watering holes like Possible 20 and Barrymore's. My favorite restaurant was a Chinese-Cuban place called Numero Uno, just a block away from my apartment. I swear I ate their shrimp egg foo yung almost daily. I also took great pleasure in sneaking into Broadway shows after the intermission to see the second and third acts for free.

Despite being home, my bouts of sadness seemed to be

getting worse. There were nights when I would allow sorrow to consume me, making a mini-production of it by watching in the mirror as the tears streamed down my cheeks. The crying became habitual, familiar. It was a place of comfort in itself as I spoke aloud to my reflection, "Tomorrow will be a good day, Jenny." The tunnel was dark and long.

Meanwhile, *Foreplay* rehearsals were starting soon at the Minskoff Theatre. The composer-director was Chapman Roberts, a highly respected Broadway music director and arranger. The cast included Loretta Devine, Edmond Wesley, Nat Morris, Jackie Low, and Steve Semien.

But then a day passed and I realized I hadn't heard from Thomas. When we finally connected on the phone, he told me he wanted time off. I listened as he talked about needing time for quiet reflection, alone. I rushed directly to his apartment and we made sweet, beautiful love.

I was hoping our relationship would work out, but the impact of Thomas's flagging interest was that I reopened my life to other men. If I couldn't get my drug from Thomas, then I had to find another pusherman.

In late summer, Michael Peters phoned and asked me to audition for a new show he was co-choreographing with the director Michael Bennett called *Project #9*. Four years earlier, in 1976, Bennett had garnered worldwide acclaim as the director and co-choreographer of *A Chorus Line,* which won nine Tonys and the Pulitzer Prize for Drama.

Project #9 was the brainchild of playwright Tom Eyen and

the composer Henry Krieger. The two had been inspired by the actress Nell Carter to develop a story about black back-up singers titled *One Night Only*. The show was renamed *Project #9*. But then Carter left in 1978 to appear in the soap opera *Ryan's Hope*, and the idea was abandoned.

The next year, the show was renamed *Big Dreams*—and brought back to life because Michael Bennett became interested. The workshop resumed with Jennifer Holliday, a gospel singer, as Carter's replacement. In the cast also were Ben Harney, Obba Babatundé, and Cleavant Derricks. Holliday became upset that her character, Effie White, died at the end of the first act, and she quit. Eyen, Bennett, and Krieger continued to develop the musical while they looked for a new Effie.

Between dance classes, I taxied to a rehearsal space on 19th Street to audition for Effie. I was thrilled that my friends were involved—Sheryl Lee Ralph, Loretta Devine, and Shirley Black-Brown, who had become Michael Peter's assistant. Nevertheless, in my mind, this production was not a huge opportunity. After all, I had already been in two Broadway shows, so the idea of being part of a "workshop" seemed a bit of a step backward.

When I met Tom Eyen at the audition, I immediately disliked him. He came across as a stereotypical cruel queen who found joy in belittling his actors. The next day, Michael Peters and Shirley Black-Brown called to tell me that I had turned out the audition and they suspected I would get the role.

I didn't have time to worry about *Big Dreams*. I was rehearsing *Foreplay* and taking classes, but mostly I was being

forced to come to terms with the fact that Thomas wanted to end our relationship. I was hurt and numb when he told me, "I never said this was a steady thing." But when I went to his place, we made love. We just could not let each other go. And for the next eight fucking years, we became locked in that old song by the Stylistics, "Break Up to Make Up."

In September, a whole month after the audition, I got the call and started working on the *Big Dreams* workshop. The music was outrageously fabulous! I remember listening to Krieger create the chords around the bassline for "Steppin' to the Bad Side." Ahh, the colors and the levels! How he decided to stop the music and allow Loretta to riff in "Ain't No Party" was phenomenal. This wasn't Hollywood. These were thespians. Giants-to-be of the theater.

I loved Michael Bennett. He said to me, "Your mind is like a computer—not to mention your talent!" It was clear also that Michael Peters believed in me, while the other bosses were lukewarm. By the time I joined, the rest of the cast had been rehearsing for weeks and were quite polished. I was intimidated and did a lot of overacting and overcompensating. Where *Eubie!* had been a musical revue, *Big Dreams* was my first "book" musical as a professional. This meant the show had more lines and required more acting. Plus, Effie was the lead character—the pressure!

And that song—"And I Am Telling You I'm Not Going"— the expectations! I just couldn't sing it like Jennifer Holliday. Nobody in the world could. I always felt they hired me, the trained actress, to develop the character, knowing all along they were going to hire Jennifer Holliday back for that voice.

I played Effie in two mildly successful workshops of *Big Dreams* for the Nederlanders and the Shuberts, major producing companies in the theater world. Shortly thereafter, when Tom Eyen called and said, "We're going with Jennifer Holliday," it was clear he wanted me to break down on the phone. He was that kind of person. But it felt good to say to him, "I've got a job. I'm fine," as I was working on *Foreplay*.

Thank you. And fuck you very much, Mr. Eyen.

What I'd missed out on didn't hit me until the billboards went up all over the city for the show, which had been renamed *Dreamgirls*. A spasm of pain went through me as I saw those images, thinking it could have been me. It was my first major professional disappointment. However, my pain was lessened by the knowledge that I would be paid throughout the entire run of *Dreamgirls* on Broadway for my contribution to creating the role of Effie in the workshop production. God bless Michael Bennett and God bless Actor's Equity.

F*oreplay* had unraveled, but unfortunately not before a couple of my paychecks from Kimako had bounced. I was disappointed but resumed my routine of dance class and auditions. During this period, I had begun to realize how soothing I found nature and I began spending a lot of time during the day in Central Park. Almost every night you would find me holding court till the wee hours at piano bars and clubs like the Horn of Plenty and the Grand Finale. My crowd included Mark and Bobby plus a revolving assortment of fabulous gypsies—Jackée Harry, Shirley

Black-Brown, Pi Douglas, Yolanda Graves, Ebony Jo-Ann, Julia Lema, Mel Johnson Jr., Janet Powell, Jeffrey V. Thompson, and Pauletta Pearson (who, of course, later married Denzel Washington).

I got the call to go back on the *Eubie!* national tour. I was seeing a few guys, but I was still trying to make things work with Thomas. But then he told me he planned to be "all business" (meaning no sex) when we went back on the tour. It didn't help things when he ran into Miguel in the lobby of my building. It was inevitable, I guess.

Despite Thomas's pledges of celibacy, when we got to San Francisco we were having daily sex; sometimes even in the dressing room, which, I must admit, was made hotter by the possibility of someone catching us. But more, it was a loving, romantic time for us in that beautiful city—Ghirardelli Square, Sausalito, the enchantment of foggy nights. San Francisco is still one of my favorite cities!

The show was doing well, and yours truly was enjoying herself! I was a fucking beast on stage, laser-focused on my performance from the moment I set out for the Curran Theatre each evening. I was staying at the apartment of Jo Kalmus, a friend from Webster. Jo was my scene partner when I competed for the Irene Ryan Acting Scholarship (y'all know "Granny" from *The Beverly Hillbillies,* right?) while I was in college. Before we went on stage at the semifinals in Nebraska, I took Jo aside, gripped her arms, and said, "Fuck this up and I will kill you." Pretty nasty thing to say to someone who's helping you out, huh? Well, Jo didn't fuck it up, but karma is a

bitch because I fucked up and lost at the finals later that year at the Kennedy Center in Washington, DC.

After Thomas and I had a fight one day, I went with Roderick to a small gathering at the hotel suite of the legend herself, the incomparable Lena Horne. After the show, Miss Horne invited us for a visit at the Fairmont Hotel, where she was staying at the time. She welcomed us into her suite and then, wrapped in at least two robes with several lush, textured scarves around her neck, she reclined majestically on her long chair. She was coming down from her show and had three humidifiers running.

I sat at Miss Horne's feet and drank every syllable of every word she spoke that night about show business, music, and politics. I was in the presence of someone I wanted to emulate. She was not just a performer—she was an activist who had stood up for black soldiers in the Second World War, and she had marched with Dr. King. This wasn't just a legend in front of me—this was a goddess. It was Lena Horne who turned her back on Hollywood, vowing to never play either a maid or a hooker.

She was one of the most beautiful women I had ever seen. Ageless. I asked her, "Miss Horne, how do you stay so young?" She pointed to the humidifiers. "I live in moisture and I surround myself with young people, baby."

'Nuf said.

When the tour got to San Diego, there were more great reviews: "Then there's the stunning Jenifer Lewis [whose] delightfully naughty number . . . leaves no doubt about what

she means"; "It is impossible to tell whether the women in this show were chosen primarily for beauty or talent . . . Lewis' 'Handyman' number is . . . merely a prelude to her sensational rendition of 'Roll, Jordan, Roll.'"

I flew home over Christmas and then back to beautiful San Diego. Thomas and I were still going back and forth. I had had words with Terry and was feeling pretty lonely. As we welcomed 1981 amid glittery hats and horns at a New Year's Eve party, Terry drank a few too many and told me I was a superficial bitch. My feelings were hurt. I got drunk on Black Russians, wobbled back to my room, and handled things, if you know what I mean. The orgasm took me to the cold, linoleum floor. Happy New Year, motherfuckers!

The *Eubie!* tour had a break, and I went back to New York. Around this time Phil Valentine, who I'd been seeing since the previous year, became a big influence. I had not known anyone like him up to that point. A gorgeous man, Phil was a black cultural nationalist (if you don't know what that is, Google it!) and vegan who owned a holistic health center in Brooklyn. I was searching for stability, a sense of clarity, and inner peace. Phil provided some answers.

Phil wanted me to get over the "Jesus stuff." He believed Christianity had been forced upon enslaved black people as a way to control African Americans forever. He said what was most important was to take care of my health, especially my diet. He told me to try not to eat meat and to stick with more

vegetables and fruit. He encouraged me to move my body every day with some kind of physical activity.

"And whatever you do, throw these cigarettes in the trash."

He said firmly, "Look inside, Jenifer. Pay attention to your instincts. There's a song in everyone."

I was really searching at this time. Along with Thomas and many friends in the theater community, I started attending services offered by the Unity Center of Practical Christianity, an organization that combines elements of Christianity with Eastern philosophies and metaphysics. Unity publishes the well-known and respected *Daily Word*.

The church I grew up in had let me down, as it failed to be the safe and loving place it was meant to be when Pastor Heard molested me. I sought God and thought Unity might hold some answers.

The services were held at Avery Fisher Hall at Lincoln Center on Sunday mornings, led by Reverend Olga Butterworth and her husband, Reverend Eric Butterworth. I felt like I was going to church. I don't know that I fully understood what Unity was talking about, but I was captivated by the idea that the "answers" I desired about my purpose might, in fact, be inside me. I had not quite abandoned Jesus. I still hoped He would appear and let me know what the fuck I was supposed to do with this gift God had given me. But Unity fed me what I needed at the time. One Unity phrase that stayed with me for many years was "say yes." The concept jumped off the page and into my soul—to be all right with being all right.

It comforted me. It meant to breathe. It meant be kind and forgiving. Pay attention to the world around you. It meant everything I wanted for my spirit.

Although many friends attended Unity, we did not discuss what we were learning. We had been raised Christian, but our religion was Theater. We read the *Daily Word*, but really our bibles were *Variety* and *Backstage*.

Jesus wasn't the only one I was waiting for. I expected to be rescued by my career savior—the person who would "discover" me. The one who would recognize my superior talents and take me to unseen heights of stardom. You know, like in the movies and all the books I'd read. Like Lana Turner at the counter in Schwab's pharmacy. I imagined that I would be having drinks at the Russian Tea Room or doing high kicks in some nightclub and my Aaron Russo or Mike Nichols would show up. Russo was the manager credited with boosting Bette Midler from performing in gay bathhouses to superstar status. Mike Nichols, the brilliant producer, director, and writer, took Whoopi Goldberg from street-corner artist to a one-woman Broadway show. Incidentally, I first met my dear friend Whoopi when she was doing stand-up in a tiny off-off Broadway theater. Like my gypsy friends and I repeatedly said to one another, I was just "waiting to be discovered." Waiting for that one big break.

During these days of the early '80s, I had no career guidance. No strategy. In fact, my whole life was all over the place. I couldn't sit still. I moved fast and talked fast, acting on

every impulse. My thoughts raced from one thing to the next. I knew that my high energy helped me get a lot of stuff done, but the energy often came hand in hand with high anxiety. So, even as I rushed here and there, it always felt incomplete, hollow, like it was not enough.

SIX

"MA'AM, ARE YOU A DELEGATE?"

n early January 1981, the *Eubie!* tour went to Washington, DC. It was the week of the inauguration of Ronald Reagan. Even though I was not a fan of the new president, I appreciated the city's celebratory atmosphere. I visited the Rayburn Building, where members of Congress have their offices. I was excited to meet Bill Clay, a black congressman from St. Louis; Charles Rangel, who represented districts in New York; and Shirley Chisholm, the first black woman elected to Congress, in 1968. Chisholm became a *huge* role model for me when I was in high school and she later became the first woman to run for the Democratic Party's nomination for president. The title of her memoir says it all: *Unbought and Unbossed.*

African American political "firsts" mean a lot to me. It's no surprise, then, that years later, I used every trick up my sleeve to be front and center at the Democratic National Convention in Denver, to see my baby (yes Lord!) Barack Hussein Obama become the Democratic Party's first black nominee for President of the United States.

It was a last-minute decision, and every hotel was booked, of course. I stayed with my dear friend Brian Norber, whom I had performed with at Six Flags over Mid-America when we were both seventeen years old. He even did my hair for this historic event—teased it up as only a gay boy in show business could. There was a bus for celebrities, but it was leaving for the Pepsi Center far too late for my taste.

See, ladies and gentlemen, having been in the theater for a hundred years, I knew that when an event is this big, get your ass there early! I got on a bus with forty celebratory civilians. It was six hours before Barack Obama would accept the Democratic nomination. Everyone on the short bus ride was laughing and carrying on, spouting our hopes and wishes for a new era.

As the bus neared the stadium, I saw that CNN had been right when they predicted forty thousand people would attend, because I swear to you, all forty thousand were standing in a line, in the sun—and in my way. Yours truly would not be number 40,001. Yes, I admit I have entitlement issues, so don't even go there. We got off the bus. It was hotter than a whore from hell that day. The sun was blazing and Brian had teased my hair so high, I was unable to wear one of my famous large straw hats to keep the sun off my (yes Lord!) pretty skin. I

heard a high-pitched voice to my left. "Lana Hawkins?" That was my character on *Strong Medicine*.

In all of that heat, I had one thought: *A fan! Merry Christmas, bitches.*

I rolled up on the woman who I'm sure had attended every Democratic National Convention since Franklin Delano Roosevelt won. She had ten thousand buttons on her orange security vest and a hat sporting ten thousand more. She was classic. She was sweet . . . and she was my ticket to get to the front of the line.

I said, "Hey girl, yeah it's me, Lana. Ooh, girl, ooh, girl, ooh, girl . . . ooh . . ." I whispered, "I can't stand in this line. I got plantar fasciitis—"

Her Southern drawl was real: "Plantar what now, baby?"

"Plantar fasciitis, and I'm allergic to the sun. Help me, girl. Help me, girl. Ooh."

She twanged, "Well, honey, the only way I can get you through this mess is to roll you across the parking lot in a wheelchair."

Other people were looking on at this scene, so when the wheelchair came, I knew I had to at least limp. In my own desperation, I proceeded to drag my right leg behind me like Dracula's servant, Igor. I'm sure it was the worst performance of my life. But fuck y'all, like I said, I wasn't standing in that goddamn line. My therapist Rachel herself would have killed me had she witnessed this great lie and manipulation.

When I rolled up to the checkpoint, a sizable woman security guard spotted me and said, "Hey Tina Turner's mama! Get over here and come through *my* line." She swiped that

security wand one second across my body and said, "Go-on in, baby. Go-on in there."

I cautiously walked through, thinking that at any moment I would be shot in both knees and taken out for my subterfuge. But no. In fact, a young African American girl spotted me all by my lonesome and said, "Miss Lewis, may I help you?"

Again, merry fucking Christmas in these streets.

I said, "Yes, yes, yes, baby. Ooh, yes, baby. Please, help me find my seat. The Democratic National Committee sent me this ticket at the last minute. How do I get there?"

Well, lo and be-fucking-hold, if the seat wasn't all the hell the way at the top of the stadium, behind the podium where my new president would be speaking. I conjured the tears and they came swiftly.

I said, "Ooh, girl . . . please, girl, I can't sit all the way up here. I'm terrified of heights and sure to be mobbed. Ooh, you know how famous I am and important to my people. Help me, girl. Help me, if you can."

Well, bless her heart. She did. Sistergirl had an all-access pass and I had my teased hair. As far as I was concerned, the sky was the limit!

The young woman said, "Now, Miss Lewis, I can try to get you down on the floor, but I don't know if this is gonna work."

I said, "Lead the way, baby." Something I don't think I've ever told anyone to do, but in desperate times you leave your alpha self behind.

At the entrance to the VIP area all the way down on the

floor, we came upon a large white woman with a sheriff's badge on. Scariest woman I'd ever seen in my life. My knees buckled. I was reduced to Little Jenny Lewis. I stood humbly behind the girl as she told the sheriff my tale of woe. When the sheriff's eyes shifted over to me, I blurted out, "I'm with the Jesse Jackson people."

She knew I was lying, but she also knew me from television. Thank God. With a vigorous wave of her wand, which I was grateful didn't hit me or fuck with my teased hair, she said, "All right, y'all go on."

And there my lying ass was free to run amok and find myself a good seat before being discovered. I saw that the seats were sectioned off with names of states—Illinois was front and center. Now, being a sneaky little manipulator most of my life, I knew not to sit down front. I wasn't that stupid. So I walked back about a dozen rows in the Illinois section. It wasn't five minutes before another volunteer with ten thousand buttons on his ass stood in front of me.

"Ma'am, are you a delegate?"

I said, "Oh, yes. Yes, I am. I'm Michelle Obama's oldest college friend."

He looked at me as if to say, "Lady, I ain't seen you at none of the parties. You ain't no delegate," but he said, "All righty then." But I knew he knew I was lying.

I sat there, imagining a SWAT team carrying my unticketed ass out of the stadium. Instead, God showed mercy when I spotted Jesse Jackson Jr. in the front row, shaking hands with everyone and being the politician that he is. Having never met him, I went down and tapped him lightly on

the shoulder. He turned around and immediately said, "My favorite actress."

We embraced, and as we did, I whispered in his ear, "I sneaked down here, and I know they're getting ready to throw me out."

He pulled back, held me by both shoulders, and said, "No, they're not. Sit down."

There you have it, ladies and gentlemen. I witnessed Barack Hussein Obama accept the nomination, front and center, twenty feet from the podium sitting between Jesse Jackson Jr. and Spike Lee.

I was close enough that Michelle Obama actually made eye contact with me. I waved and blew a kiss to my "old college friend." Merry fucking Christmas, Easter, Thanksgiving, Rosh Hashanah, Kwanzaa, and Fourth of July, bitches.

The evening was life changing, and I assure you, after all that conniving, I sat there with great humility and reverence for that historical moment. When the ceremony was over, once again, I knew not to try to get in the departing crowd. I stayed seated and wept. I sat there weeping with gratitude for Harriet, Sojourner, Frederick, Nat Turner, Emmett Till, Dr. King, Malcolm, Bethune, and the men, women, and children who took the hoses and the dogs on the front lines of the '60s.

When I raised up my head, a young black man in an orange vest with a bald head was standing in front of me. I was about to say, "You're too late to arrest me, fool." Thank God I didn't, because he leaned down and without words, put his head on my shoulder, and sobbed like a baby.

What a night. What a night . . . what a night.

With newfound inspiration from one of the greatest speeches I had ever witnessed, I made my way out of the stadium and boarded one of the two buses left. When I stepped onto the bus, I was immediately recognized and applauded by a bus full of black people. All right, there were three white folks, too. God bless them. After the applause died down, in perfect comic timing, as only Jenifer Lewis could, I shouted, "Well, I guess we don't have to sit in the back of the fucking bus tonight!" I walked down the center aisle giving high-fives and black power signs and hugging and kissing. Then I realized that the only seat left was in the very back of the goddamn bus. Everybody laughed at my crazy ass.

That night, I lay in Brian's guest room and thought, "My God, my God . . . it's a new day."

E *ubie!* wasn't the only "black" show in DC that winter of 1981. *Sophisticated Ladies*, a musical based on the works of the masterful Duke Ellington, was at the Kennedy Center before heading for Broadway. This meant that every night the casts of both shows would gather at a club called One Step Down. It was wonderful to hang out with Gregory Hines again and the beautiful Amazons Judith Jamison and Phyllis Hyman, who were all starring in the show.

In DC, the reviewers again singled me out. But, when would I get my big break?

Back in New York City, I resumed classes at the LeTang Studio. Lonnie McNeil, a brilliant dancer and choreographer,

told me, "If you want to be famous, Jenifer, you need to pull back and not be so damn good."

This was a theme I'd heard before. About a year earlier, when I'd been turned down for a major Broadway role, the director said, "Jenifer, I just can't see anyone else when you're on stage." What was I supposed to do? Be less? Idiots!

My mood plummeted. I was on unemployment, hanging out every night at Possible 20, drinking Black Russians, smoking a little pot, and regretting each Virginia Slims while trying to figure out my relationship with Thomas.

JOURNAL ENTRY: I can't take this sick ass way of living. Struggling so hard to get out of this funk.

But I couldn't pull myself up. In March, I missed the opportunity to sing for the great Cy Coleman because I'd awakened from a drunken stupor too late to make the audition. I knew I was truly fucking up because I had never missed an audition before. My professionalism and discipline were my greatest assets. I did not understand what was going on. I wanted to blame anyone, everyone else. I could not see that it was full-out self-sabotage.

I got myself together enough to be cast in *Sister Aimee*, a gospel-infused musical, which debuted off-Broadway at the Gene Frankel Theater. The show told the story of Aimee Semple McPherson's rise to cult status as the first successful radio

evangelist. It was directed by David Holdgrive, with book, music, and lyrics by Worth Gardner. I played Louise Messnick, a young woman stricken with crippling arthritis whom Sister Aimee cures miraculously through the laying-on of hands. The show was warmly received, and I got my first review in the *New York Times*:

> Miss Jennifer Lewis . . . is what is sometimes called a shouter, but the shouting has intelligence and style. Her "Glory Train" is a joy.

People, there is one "n" in my name. Remember that. Anyway, even though John Corry, the *Times* critic, misspelled *Jenifer*, I was thrilled. A favorable review in the *Times* was a huge accomplishment.

Sister Aimee played only on the weekends. While it was running, I started rehearsals for another off-Broadway musical named *El Bravo* at the Entermedia Theater on 2nd Avenue. *El Bravo* transplanted the Robin Hood legend to the barrio of East Harlem. It was directed by Patricia Birch, the much-admired choreographer who had been nominated for numerous Tony Awards, including for *Grease*.

I played two roles: a police officer and a ventriloquist with a dummy named Madge (again I point you to Streisand in *Funny Girl*: "Can you skate?").

Although *El Bravo* was trashed by the critics and ran only forty-eight performances, the show is memorable to me for many reasons. My castmates included Vanessa Bell.

She was so pretty and talented and has remained a friend through the years. She later appeared as Eddie Murphy's arranged bride in *Coming to America*. I also became close with the lovely and graceful Starr Danais and Olga Merediz, who sang my favorite song in the show, "Funeral, Funeral, Animal." The music director's name was Louis St. Louis and I, being Jenifer Lewis from St. Louis, hit it off with him right away.

It was during rehearsals for *El Bravo* that I met Quitman Fludd. He always used his full name. In noting it I want to honor his grandeur, splendor, and beauty: Quitman Daniel Fludd III. Something happened in rehearsal, and we both laughed. When two people laugh at the same ignorant shit, they are instantly bonded. They want to play together, laugh together, sing together. And boy did we sing! He was a soprano and I was a baritone. He was feminine, I was not (sexy and fabulous, yes, but never a "lady," as it were).

Quitman was a new kind of person for me. He was an only child and he had been well loved. He had grown up a talented Southern gay black boy in the '50s. He couldn't wait to get out of Nashville and become a dance major at Juilliard. He used to recite a poem, "Incident," by Countee Cullen, to illustrate what it had been like in the Jim Crow South.

> Once riding in old Baltimore,
> Heart-filled, head-filled with glee,
> I saw a Baltimorean
> Keep looking straight at me.

Now, I was eight and very small,
 And he was no whit bigger,
And so I smiled, but he poked out
 His tongue, and called me, "Nigger."

I saw the whole of Baltimore
 From May until December;
Of all the things that happened there
 That's all that I remember.

At only sixteen, Quitman danced in the original Broadway production of *Hello, Dolly!* and later in the Broadway production of *On the 20th Century*. In the mid-'70s, he understudied Ben Vereen in the original version of *Pippin*.

Quitman was beautiful—tall, fit, perfect teeth, mustache. You could tell he was a dancer: he walked on air, chest out like an ostrich. I had never known anyone who gave himself so many facials, always while wearing a pink shower cap to hold his hair back. Quitman was refined, bourgeois, and elegant. He was always groomed to the T. He was perhaps ten years older than me and was fascinated by my youth, drive, and naiveté. He thought I was the cat's meow.

We spoke every morning. When I'd pick up the phone and there was no answer to my hello, I knew it was Quitman on the other end of the line. Neither of us would speak. For minutes at a time. Then one of us would crack up. We did this every morning for years. We were innocent! We had a pure relationship and truly knew who the other was.

Let me tell y'all what me and this fool used to do. Sometimes I would show up at his apartment devastated that I didn't get a part. I would bust in, totally fucked up over one thing or another—usually it was a man or a lost audition. I would sit by his window on the forty-fourth floor of the Manhattan Plaza with the string tied tight on my white hoodie in full makeup and, yes, black mascara running down my face. Gesturing, flailing my hands about, posturing, sobbing, jumping up, pointing out the window, blaming anybody but myself for what had happened.

Quitman would let me go on and on and on. Then he would sweetly say, "Let me get you a tissue," but instead he would come back with a white towel wrapped around his head, reflecting my white hoodie and my madness to myself. He would then proceed to reenact the entire scene ver-fucking-batim. As I watched him imitating me, this man with a photographic memory and a sense of humor to boot would make me damn near pee myself. After he'd gotten a cold towel for me to wipe that shit off my eyes and blow my nose, he would gently push me out of the door and whisper, "I'll see you in a month."

This son-of-a-bitch I loved. Had Quitman not been gay, he is the only man I would have ever actually married.

Within a couple of months of our becoming friends, Quitman started writing my first one-woman show. He wrote lyrics that were so true and spoke to our lives. *"Now that you're a star in the big time, do you ever think of you and me . . ."*

During this time, Thomas was on the road as stage manager for *Your Arms Too Short to Box with God*, and our relationship was off-again, on-again. While he was away for a few

months, I basically put a turnstile at my door as I rotated through Phil, Rudy, Pascale, Perry, Ken, and Tyrell.

I briefly allowed Perry to move in with me, which was a fiasco that lasted only a couple of weeks. I kicked him out in a fit of rage. As Perry left through the apartment door, I grabbed his T-shirt, tearing off the back and leaving the front of the shirt molded to his perfectly formed chest muscles. It was hot, like Marlon Brando's T-shirt in *Streetcar*. We did it against the wall in the hallway just outside my door. Then I put him on the elevator, saying kindly, "Please go now." When Thomas came back to town for a break, things got messy and I confused my lovers' names during sex. "Thom and Perry"— sounds like a cartoon.

When I wasn't juggling men, I was rehearsing for a two-city gig with *Baggy Pants*. A few years earlier, I had taken a sabbatical from college to tour with this truck-and-van production that was among the last vaudeville-burlesque musical revues. *Baggy Pants* had been making the rounds of dinner theaters since the early '70s. It was conceived and directed by Will B. Able, an actual vaudevillian, with assistance from his wife, Graziella Able, who, as I mentioned, became one of my mother figures.

I would often find myself sitting at the feet of and listening to women older and ever so much wiser than me. I took to Graziella immediately. I believe she was in her early fifties and was still kicking her foot over her head and slamming it down to the floor in a split. She was co-producer of the show, and she made sure we were as sharp as the Rockettes when we pranced around Will in our beaded bras and feathered hats. God bless

Graziella—she taught me how to kick above my head. Graziella had danced with the Swiss Opera Ballet and as a can-can dancer at the Moulin Rouge in Paris. I learned from the best!

Both Grazi and Will became parental figures for me and were utterly compassionate and gentle when I'd go off about one thing or another. The fact is many parents don't, or can't, give you everything you need.

Mine couldn't. So I went in search of substitutes. I often advise young people in this situation to understand there are probably people around every corner who will take them under their wing and help them on their way. But you have to ask.

Baggy Pants remains one of the most important experiences of my career. It was my first professional gig, and more important, it earned me an Actors' Equity Association union card, which gave me benefits. Working with Will and Graziella meant that I was involved with the heritage of American musical comedy as a whole. They had worked with the greats of vaudeville, Broadway, and Hollywood. I sopped up every bit of style and wisdom from them that I could.

I was nineteen years old, and so much about the experience was new, including castmate jealousy. When we opened in Louisville, Kentucky, the local paper singled out my performance as noteworthy. Some of the other dancers were jealous, and I heard one say loudly enough for me to hear: "Well, I don't think she was *that* good."

The words sent me into a rage. I snatched the poor girl who uttered those words out of her seat by her collar. Her feet were off the floor as I held her against the wall. I growled at

her through clenched teeth: "If I could give you my voice, I would. But I can't. So, please stop messing with me!" Then I threw her across the room.

Will was so disappointed in me. This man whom I respected so much, who had chosen me to do a solo after the great newspaper review, came to me and said, "Jenifer, I want you to listen very carefully to me. I've been in this business a long time. You're going to have to get rid of that chip on your shoulder. Your talent won't mean a thing if people don't want to work with you." I felt horrible, but I had absolutely no idea how to get rid of my uncontrollable anger. Of course, I apologized profusely, as there was just no fucking excuse.

Now that I was more experienced and mature, I was excited to work with Will and Graziella again and show them I had grown and really knew my stuff. We ran a few weeks at a dinner theater in Westchester, New York, which was a convenient train ride from Grand Central Station. At my first rehearsal, I found out that Will was very sick. In fact, he had shortened the show by cutting two of his numbers.

After Westchester, *Baggy Pants* went to St. Louis for a two-week run. I couldn't wait to see all my family and friends. There was a big barbecue, and all of Kinloch turned out for the show at the Barn Dinner Theatre.

After the second performance, Will was rushed to Barnes-Jewish Hospital. We all were unclear about what was wrong with him. Before I entered Will's room, Mama, who worked as a nurses' aide at the county hospital in Clayton, made me put on a mask, gloves, and robe. This alone frightened me, but then, when she said, "You cover up good before you go in

there because they don't know what this disease is," my fear became dread. A few days later Will died of an extreme type of pneumonia. He was only fifty-seven years old. I mourned this great entertainer and mentor.

When I got back to New York, Quitman and I got serious about writing my show, which I decided to name *Who Is Jenifer Lewis? HOT!* I know, what the hell does that mean? At the time, I had no clue as to who I was or what I stood for. "Hot mess!" would have been more appropriate.

By mid-November, Thomas and I were back together, and he invited me to Jamaica with him. I really could not afford the trip, but after Gregory Hines loaned me $500, I was able to track down several gypsies who owed me money. Altogether, I came up with about $1,000, which I spent at Bloomingdale's on sunglasses, a swimsuit, and some short-shorts. Quitman asked, "Why are you putting yourself in debt for a man who doesn't love you for who you are?" I had no answer.

Thomas and I had a wonderful time relaxing on Trelawny Beach on Jamaica's north coast. We went horseback riding and visited the beautiful Dunn's River Falls near Ocho Rios. I won the hotel talent show singing "Over The Rainbow." I got a little trophy and a Rasta brother slipped me some superb ganja. By the time we got back to New York, it was clear that I wasn't going to change for Thomas, and that he wasn't going to stop wanting me to be someone else. So we broke up, but deep down inside we knew it wasn't over.

I had auditioned for a show called *Mahalia* before I'd left for Jamaica. When I got home my girlfriend Yolanda Graves

was on my answering machine screaming, "We got the part! We got the part! We got the part!" Three days later, I heard that Thomas had been hired as the stage manager for the show. Oh, Lord, now here we go again!

It had been ten years since Mahalia Jackson had transitioned, and I knew if anybody was running around heaven, it was her. In my book, and those of many others she is the greatest gospel singer that ever lived. This amazing songstress created the blueprint for twentieth-century gospel, building worldwide appreciation for the genre through her tours and many albums. I also admired her for her political activism. She was there with the Civil Rights Movement from the start and sang at the 1963 March on Washington just before Dr. King gave his famous "I Have a Dream" speech.

Mahalia was everything. Among all my mother's albums, Mahalia Jackson was the one I would play over and over and over. This woman was so embedded inside me, I felt her joy was mine and that her sadness played into my own. I listened intensely and began to mimic her voice. But Esther Marrow, not I, was given the lead, and I was tapped to understudy the role. I was thrilled and honored to be a part of the production, which included Danny Beard, a singer I became friendly with, the fierce Keith David, and my close friends Tucker Smallwood, Ebony Jo-Ann, and Yolanda Graves.

To my surprise, during rehearsal one day, Danny became unnecessarily rude to me, commenting snidely while I was at the piano, mocking me in the funeral march scene. I'd heard

he'd been doing a lot of coke. I stepped to him and warned him about karma. My spiritual studies with Phil had inspired me, and I was working to get the rage out of my soul.

A couple of hours passed, and Danny was all up in my face again. I broke and said, "That was some fag shit." Y'all, that boy slapped the pure shit out of me! I didn't return the slap, because deep down, I probably knew I deserved it. Plus, fighting with my hands is not my thing. Instead, I turned the other cheek, smiled, and went to put cold water on my face. Ow, that shit hurt!

When I told Mark Brown about the incident, he said I asked for it for using that awful slur. Mark's response cut deep because I wanted his respect. I didn't intend to be homophobic; a "faggot" in my mind was a nasty person, not a homosexual. Poor excuse, I know. It sickens me that I once said that terrible word in anger to someone I loved.

The next day, with my eye swollen, I was pissed. I planned to head down to Centre Street to get a summons against Danny's ass. Just in time to avoid that drama, Danny called with apologies. I was silent.

I went to the rehearsal studio and warmed up as normal while the vibe among the company was as tense as I was calm. Some women in the cast laughed at me as they gathered around Danny. That made me vengeful.

Miguel was furious when he heard about the confrontation. He immediately assembled several bad-ass Dominican friends he'd made in the underground movement to kick Gulf and Western out of the Dominican Republic. They were prepared to fuck Danny up. But then Phil Valentine said, "You

don't want that kind of karma, baby." I swallowed my anger and pledged to just forget the whole thing.

The show premiered at the Hartman Theatre in Stamford, Connecticut. I had decided that in order to get through the run of the show, I just wouldn't speak to Danny or Thomas. But on the show's third night, an hour before the curtain went up Thomas burst into my dressing room, looked me dead in the eye, and said, "Esther's been in a car accident. She's all right, but do you think you can go on?"

Even though my stomach turned inside out with anxiety, I looked at him with the confidence of the great Helen of Troy and proclaimed, "You know damn well I can do it."

He knew better than anyone that understudy rehearsals always begin the day *after* opening night, meaning I had a total of forty-five minutes' rehearsal for the lead role. The challenge would be huge. When Thomas gave me a brilliant, heartfelt pep talk just before I took the stage, I knew he still loved me.

A critic for the *Greenwich Times* was in the audience and wrote, "Although [Miss Lewis] carried the script throughout, she handled it with such grace that after a while it went unnoticed. What became noticeable was the reaction of the audience and the outburst of applause, coupled with a standing ovation . . ."

When the show moved to Boston the next week, I was just about ready to try to make formal amends with Danny, but as we stood backstage in the wings, where it was very dark, Danny started taunting me again. I ignored him until he deliberately stepped on my foot. Rage welled within my soul as I reached for a broken steel pipe leaning against a nearby wall. Raising

up to swing the pipe against Danny's head, I somehow violently banged my own head against an overhang and immediately blacked out. When I woke up a few hours later in Boston Medical Center I knew Phil had been right—karma *is* a bitch.

The cabaret scene in New York City was heating up with many new piano bars and small nightclubs that offered fertile ground for Broadway gypsies to take the spotlight. Yours truly was the first headliner when the New Ballroom, a trendy restaurant located at 253 West 28th Street, recast itself as simply 28th and 8th.

Who Is Jenifer Lewis? HOT! was a campy hour of original songs, jokes, and connective patter. Otis Sallid produced the show. I knew my show would be good, but would people come? If there's one thing I can't abide, it's empty seats. Therefore, I worked as hard to promote my shows as I did rehearsing. I printed at least a thousand flyers and addressed and stuffed the envelopes. I licked the stamps and then carried it all to the post office. And y'all, I did not have anywhere near one thousand names on my mailing list, so I sent flyers to random strangers I found in the telephone book, too! (Yes, I was a twentieth-century spammer!) I made a huge effort, although most cabarets hold only about one hundred people.

I took to the streets and avenues of Manhattan in my gym shoes and sweat suit (remember those '80s nylon sweat suits?). If you were human and had a heartbeat, I put a flyer in your hand. I went through Bloomie's, Macy's, and I hit all the street fairs and tourist attractions from the Statue of Lib-

erty to the Empire State Building and Rockefeller Center. The most fertile spot was the TKTS booth in the middle of Times Square, where I belted songs Merman-style and did high kicks for the folks waiting in line for discount Broadway tickets.

I'd spot a couple and say, "Where y'all from? Oh, honey, you guys are so far back in line, there's not gonna be any tickets left for a GOOD Broadway show. You might as well come see me."

I'd sing eight bars of "Don't Cry Out Loud," do a shuffle-step ball change, three high kicks in succession, a lay out, and snap my fingers in the Z formation.

"Y'all come on now. And my show is cheaper, too."

And damn, if I didn't spot fifty percent of those tourists in my audience.

Even though I had performed in two Broadway shows and to adoring audiences across the nation, I was not prepared for the opening night response to *HOT!* Every seat was filled. When I ended my final note, my vision went into slow motion as the audience began to clap and rise from their seats. I left my body for a split-second, and when I refocused, the roar of the crowd's applause and shouts grew incredibly loud, even louder than in that watershed moment back in First Baptist when I was five years old. It was more deliberate. It was my first electrifying ovation. Not unlike the one I received at Carnegie Hall in 2014. (What, you haven't seen my Carnegie Hall performance? *Be-yotch*, have you heard of You-Tube?) My show was proof of the wonderful magic Quitman and I created together. Without a doubt, the creative genius of Quitman made *HOT!* a hit. He devised fun moves such as

accentuating my high kicks by clanging a spoon against a skillet. Word spread, and almost every performance of *HOT!* sold out immediately. I felt happy, rewarded, recognized.

During the summer, Quitman and I both got parts in Pennsylvania Stage's production of *Ain't Misbehavin'*, the Tony-winning musical tribute to African American composer Fats Waller. I won the role that had made Nell Carter a star. Rounding out the cast were Tonya "sings her ass off" Pinkins, Lynnie Godfrey, and George Bell.

It was a great summer gig at the J. I. Rodale Theatre in Allentown, and it was close enough to easily bus home for our off days. The summer was a hot one, and Allentown reeked of sweaty, obese people eating massive amounts of food. I was sitting in a restaurant with Quitman, and I couldn't help but stare at a man who was emptying half of the salt shaker on what seemed like eight eggs and dumping an entire bottle of syrup on his pancakes.

Quitman saw my face and suggested I build a tunnel from the hotel to the theater and stop judging people. "We're all God's babies and doing the best we can."

Quitman and I fought and laughed, as best friends do, the entire run, though I took time out to have a short affair with a skinny, sweet white local named, wait for it, Dick.

About halfway through the run, we got news from New York that Danny Beard had died in a fire at his home in Harlem. I mourned. Although we had our fights, the truth is I had really loved Danny—that boy could sing his ass off!

In the fall, I was excited to be cast in my third Broadway show. *Rock 'N Roll! The First 5,000 Years* was directed by Joe

Layton, a two-time Tony winner who was best known for a series of critically acclaimed television specials starring Barbra Streisand. Layton loved me when he saw my Graziella-inspired kick into layout, but little did he know that was my best dance move. What made Layton so good, however, is that he zeroed in on every performer's forte. He made the most of my athleticism and flexibility, including having me straddle two pianos during a David Bowie song while Hula-Hooping two hoops around my neck! I was thrilled to have a solo in "You Keep Me Hangin' On," a song made famous by her highness Diana Ross. It was extremely rewarding to perform alongside talented artists including Ka-ron Brown, Lillias White, Marion Ramsey, Carl E. Weaver, and Lon Hoyt. Unfortunately, following terrible reviews, the show closed after only nine performances. We called it "Rock 'N Roll! The First 5,000 *Minutes*"!

SEVEN

A DOLL NAMED "KILLER"

Lester Young was a hugely influential tenor saxophonist who came to prominence with the Count Basie Orchestra in the 1930s. "Prez," as he was known, was a close friend of the legendary Billie Holiday and accompanied her on several recordings in the late 1930s and early 1940s. Soon after reuniting with Billie for a CBS special in 1957, Young's alcoholism caught up with him, just as Holiday addictions would soon catch up with her. During the final two years of his life, his companion, a woman named Elaine Swain, took care of him. Elaine wasn't a musician, but she was well known in jazz circles and dated several high-profile musicians during the heydays of jazz. She also was a good friend of Holiday.

When I met Elaine in early 1983 at the Red Apple grocery store on 54th and 8th, she was probably in her late seventies. We were standing in the checkout line, and she was telling jokes to the cashier, cracking me up in the process. Seeing that I was amused, Elaine took the opportunity to ask me to go back and check the dairy section because she believed she had left her half-full wine cooler there. I was so entertained that I carried her groceries home for her. She lived in one room above Possible Twenty, the bar on 55th between 7th and 8th Avenues. I remember having to stop at the bar for a key, walk through the nightclub, and up the stairs and down an unlit hallway to knock on her wooden door.

I was enraptured by Elaine's tales about Billie and all the other famous jazz musicians she had known. For instance, she told me that during Billie's later years, she had become fed up with white people and refused to sing "Strange Fruit" to predominantly white audiences.

Here was someone from the golden era living in one room, and I wanted to take care of her in the name of all the musicians who paved the way for people like me. Elaine had her own struggles with alcohol, and once, when she opened her front door butt naked, I saw that her body was covered in liver spots as a result of years of drinking.

Before visiting Elaine, I'd usually stop at the Red Apple and pick up a few staples for her. I spoke with her about my life, hopes, and career. When I asked her advice about my messy love life, she leaned over in her armchair, looked at me sideways, and, twisting open her fourth wine cooler, slurred, "Don't trust no niggas!"

I continued to build a name for myself through a series of one-woman performances. Toward the end of 1982, I was asked to do my show at Don't Tell Mama, the newest cabaret in the city.

Don't Tell Mama, located on Restaurant Row, the eatery-laden block on 46th Street between 8th and 9th Avenues, was owned by Erv Raible. Erv was perhaps the most successful cabaret owner in New York City history, with three other high-profile piano bars—the Duplex, Brandy's Piano Bar, and Eighty Eight's.

I first met Erv at the Duplex on Christopher Street in Greenwich Village when I was playing in *Sister Aimee* and would hang out there with director David Holdgrive. A few months later, I performed in a small revue produced by award-winning lyricist David Zippel and his sister Joanne Zippel called *It's Better with a Band* that opened at Don't Tell Mama before moving to Sardi's. My performance caught Erv's eye, and he invited me to bring my solo act to Don't Tell Mama, which was quickly becoming *the* hottest cabaret in Manhattan.

Of course, Quitman helped put together my show, which had no title. I asked Mark Brown to write monologues and some lyrics and enlisted Lon Hoyt as music director. The show was a huge hit, and after the first performance, which was standing room only, I went to Erv to get my portion of the door proceeds. Erv, a seasoned and compassionate night-club veteran, gently shook his head at my shocked face when he handed me about $33. The slight reprimand delivered in his nasal whine was a lesson: "You comped your whole dance

class, Mary." As was the fashion among gay men of a certain age, and showbiz types at the time, Erv called everybody "Mary." I loved that!

One of the songs Mark and I wrote for my first show at Don't Tell Mama was "Come Along with Me," a musical rant filled with my observations on the changing world—yuppies, vegetarianism, Madonna. With Lon Hoyt on piano, my performance of the song exemplified the Jenifer Lewis of 1983: fabulous and manic as hell.

The Saturday after my Don't Tell Mama debut, Mark and Bobby came to my place at the La Premiere to watch *What Ever Happened to Baby Jane?* for the hundredth time. I was in heaven sitting with my friends, all of us talking to the screen and offering commentary. (". . . But cha *are* Blanche. Ya *are* in that chair!")

The phone rang and I thought, *How dare someone assume I would be home on a Saturday night?* Nevertheless, I picked up. It was Bonnie Bruckheimer, calling for Bette Midler to say they wanted me to be a Harlette, one of Bette's back-up singers, and could I be in LA on Monday to start rehearsing for a three-month tour? Through my shock, I managed to tell her that I had a sold-out show at Don't Tell Mama on Monday night. Bonnie said she would call back shortly.

I had worshipped Bette Midler since I was in college. I had been walking down the hall of my dormitory freshman year when I heard somebody blasting this fabulous gospel rendi-

tion of "Delta Dawn." I didn't recognize the voice, thinking, "I know every black singer. With an album, anyway."

So I knocked on Henry's door and asked, "Who is that singing?"

He said, "Oh, honey, that's the Divine Miss M."

Henry turned the album cover around, and I was shocked to see the singer was white. I went out and bought every recording of Bette's I could find. She was fabulous. She had personality and sass and was funny as hell. She was now a member of my personal Pantheon of Idols, which around this time included Aretha (of course), Judy Garland, Josephine Baker, Pearl Bailey, Ethel Merman, Lena Horne, and, believe it or not, Mae West, Fanny Brice, and Sophie Tucker.

Wide-eyed and shaken, I squeezed in between Mark and Bobby on my little loveseat and the three of us looked at the phone for ten minutes until it rang again.

"Hello?"

"Hello, this is Bette Midler. Nice to meet you. We really need you out here on Monday. Can't you get your understudy to go on for you?"

Her clipped tones sent a shiver through me. I had only heard Bette's voice on albums and on Johnny Carson's *Tonight Show*. As I gathered my response, I could feel the tension and excitement emanating from Mark and Bobby.

"*Ummmm* . . . it's a one-woman show, Bette. There is no understudy."

Her answer was one letter: "O."

Not "Congratulations for having your own show at the

leading New York cabaret," or "I'm so happy for you. I heard you are great." Just a curt "O," followed by an unsaid, but clearly implied, "So you all that, huh?"

And it started from there, the dynamic of mutual admiration combined with sheer competition between me and Bette.

I agreed that I would arrive in LA on Tuesday. My farewell show that Monday night at Don't Tell Mama was perfect. John S. Wilson, the esteemed critic who had covered jazz for the *New York Times* for four decades, attended. When I announced I was leaving to become one of Bette's Harlettes, every fabulous queen in the club lost their damn mind!

CABARET: JENIFER LEWIS
By John S. Wilson
New York Times, May 26, 1983

A MONTHLONG series of performances by Jenifer Lewis that had been scheduled at Don't Tell Mama, the West 46th Street cabaret, was interrupted last week when Bette Midler asked Miss Lewis to become one of her Harlettes during a current tour. Miss Lewis immediately took off for the hinterlands but it is doubtful that she will be a Harlette for long.

She already has the aura and the confidence and the projection of a star. She is the very essence of show business—a singer with a dazzling voice, a high-kicking dancer, a lusty comedienne, a coiled spring of energy. And, after all her

razzle-dazzle, she has the ability to sit down at the piano where, in tribute to Mahalia Jackson, she sings a gospel song in a big, imperious commanding tone that echoes Miss Jackson, building to a climax of explosive passion.

Miss Lewis in action is a fascinating study, not only for what she does but for the shadows of other performers that flicker through her personality—suggestions of Pearl Bailey's monologue style, even the tone of Duke Ellington's mock elegance. They are just passing accents and seem a completely natural part of Miss Lewis, but they indicate the range of show-business background that she has absorbed and reshaped.

There are moments when she is overcome by her own exuberance and enthusiasm, and the discipline of her performance is broken. But she is such a skillful craftsman that she will undoubtedly learn to control this or, more likely, to turn it to her own advantage by the time she returns to New York on her own—as she inevitably will.

The first time I met the Divine Miss M in person was at the S.I.R. Studios in Hollywood. It was supposed to be a rehearsal without Bette, just us three Harlettes. We were in the middle of singing "Pretty Legs and Great Big Knockers" when the music suddenly stopped. Bette entered the room. She was dressed casually, but every inch a star. All I could

think at that moment was *What presence*. There to survey the new recruits, she chatted with us a bit in a fun and fabulous way, but also with an air that conveyed that she was all about business. Soon she was saying, "Come on, girls. Get in those mermaid fins and pull up a wheelchair. Let's get this shit in tip-top shape."

When I joined *De Tour '83*, Bette was at the height of what continues to be an amazing career. By that time, she already had won two Grammy awards, two Golden Globes, and an Emmy, and had been nominated for a Best Actress Oscar and awarded a special Tony Award. I studied her from the wings and talked to her every chance I got. Her vocal talent and comedic timing were peerless. She was funny, fun, artsy, and smart as hell. She always had a book in her hand.

Bette immediately clocked that I was plenty crazy, but she respected me and honored my talent. I wanted to be the best Harlette she ever had, and she knew that. She featured me, but in a mask. She wasn't about to let my charisma and star quality upstage her. Yet she loved to have me entertain her during breaks or at parties. She'd often ask me to do a monologue or song from my show. Bonnie Bruckheimer, who went from Bette's assistant to her producing partner, told me I was one of the few who could make Bette laugh out loud in those days.

Bette was sort of an introvert and could come across as removed—even shy. You knew when she did or did not want to engage; you didn't have to guess her mood.

We'd all been drinking one night after the show and Bette said to me, "Jeni-Fah" (she still says my name like that!), "you

don't want this, Jeni-Fah. This is hard shit!" But my idol was wrong. I did want it. I wanted those ten thousand voices in the arena to be cheering for me.

De Tour '83 was sort of a mixture of rock and roll meets Broadway. We did forty-six cities in about three months. It was incredibly fabulous, but exhausting, even for my twenty-six-year-old body. The show included several big high-camp numbers, including "Pink Cadillac." We also performed one of Bette's torch songs, "Here Comes the Flood," as well as the anthem "We Are Family." There were elaborate costumes and sets with ramps, levels, and one scene where we wore mermaid fins and rolled ourselves around in wheelchairs. I did my specialty (Hula-Hooping) and had to learn to play the accordion. We Harlettes rehearsed endlessly, mastering the tight vocal harmonies required to back up Bette.

I fought with the other Harlettes, Siobhan O'Carroll and Helena Springs. We three were replacing the Harlettes who had done the wintertime portion of *De Tour.* There was plenty of drama. Stupid shit. Once I threw my Hula-Hoop during rehearsal and had to apologize the next day.

We usually shared a limo as we traveled from the airport to our hotel. I guess I was too loud or teased too much because eventually Bonnie and the rest requested my silence. On one occasion, I needled Helena to the brink, and she jumped out of the moving car (we were going very slowly and she wasn't hurt).

JOURNAL ENTRY: I am a monster.

Frannie the dresser said to me, "You have to get over this shit because it will kill Bette."

Fortunately, our make-up artist, Geneva Nash, had a loving but stern way of settling my ass down.

Bette was a class act, but this *was* a rock-and-roll tour, so there was plenty of sex and drugs. In general, we were a pretty wild bunch. Bette's collaborator Jerry Blatt, whom I loved very much, had pink hair. I sported a crazy Mohawk. We had a rollicking time, but Bette never allowed our antics to compromise the show's professionalism. Believe me, we snapped to attention when the Divine Miss M arrived!

The tour started out in Philly and East Coast locations. When we got to Saratoga Springs in upstate New York, I had sex against a sugar maple tree with Ed Love, the choreographer. A few days later, he showed up backstage with another girl, so that was that—until we got to Montreal a couple of weeks later and I had a ménage à trois with Ed and Billy, with whom I'd toured in *Eubie!* I also had sex with one of the band members. But his enormous penis stayed soft. Too much cocaine.

The day we opened in Boston, I went ballistic because someone forgot to put VIP tickets aside for Temi, Billy, and their friend June. I pulled a full-out diva tantrum, banging on Bette's trailer door, crying and whining. She barged out of the trailer half made up, hair flying, robe flapping, and shouted at the assistant: "Get her four fucking tickets in the front row! The last time she cried, she fell off the fucking ramp!" It's true, I did have a few major gaffes on stage, like in Costa Mesa, where I fucked up the whole mermaids-in-wheelchairs routine.

If Bette got irritated with me, she rarely showed it. When

the tour got to Newport, Rhode Island, and I asked Bette to sign my *De Tour '83* poster, she wrote: "To the greatest black entertainer who ever lived . . . I am the white one!"

Bette knew I was loyal and that I only wanted the best for the show. I think by this time she suspected I had deep emotional problems. But I also think she saw a bit of herself in me. I felt she kind of took care of me in her own way. I wish only that I had been able to pull my shit together this first time we worked together.

When all is said and done, Bette Midler probably had a greater impact on me than anyone else I have worked with. She polished my game and upped it several notches. She validated me and confirmed what I knew about my talent, especially the fact that JeniferMothaFuckinLewis does not belong in the chorus, be it as a Harlette, Ikette, or Ronette!! Honestly, though, the experience of observing Bette's artistry and getting to know her as a loving friend made it all worth it.

Toward the end of the tour, Bette gave me a wonderful gift of original sheet music from an old Ethel Waters song. In turn, I gifted Bette a black Raggedy Ann doll. She named it "Killer."

Prince came to see *De Tour* at the Greek Theatre in Los Angeles. During the after-party at Spago on Sunset, I found him in the back in the dark. I approached him. He extended his hand, which was swathed in a black lace glove. At first, I thought he expected me to kiss it. Instead I gripped his hand firmly, but got grossed out when I felt the sweaty moistness of his palm through the lace. Unfortunately, because I was so focused on my own glory, I did not take the opportunity

to engage with this master. Damn. Prince and I met again twenty-six years later, backstage at the (first) final *Jay Leno Show* in 2009. I said, "Hey, Prince, I'm Jenifer." He smiled and said, "I know who you are." Then he turned to his beautiful companion and said, "Yeah, she's funny all the time." I get tingles just thinking about it.

In September, we did our final show in Minneapolis. The entire company sprayed their hair pink for closing night. I fucked an Italian guy named Frank in my dressing room. The party was over.

Nearly fifteen years after we toured together, I was still foolishly competing with Bette. I flew to Las Vegas to see Bette in her show called *Diva Las Vegas*. I went to her dressing room after the show and started clowning, telling jokes and singing loudly. Bette asked me, "Jenifah, why are you performing?" I said, "Well, didn't you just perform?" She said, "Yeah, but I got paid." I shut the fuck up.

Touring as a Harlette with Bette had put me in greater demand. I was happy to finally start getting the attention for my work that I felt I deserved. I was asked to do one-woman shows at popular venues in New York City such as Sweetwater's, Freddy's, and the Red Parrot. I was everywhere.

The performance at Sweetwater's earned one of the few bad reviews I've ever gotten. The writer for *Variety* said, among other things, that I used too many props to get my point across.

JOURNAL ENTRY: Kiss my black ass.

I found the review meaningful. I learned something about simplicity from the critic. Small things such as knowing when and how to use your body alone to convey a message makes the difference between an amateur and a professional.

I did a New Year's Eve show at Don't Tell Mama. I knew I had to be good that night. It cost $50 to get in, and that was a big deal.

I woke up on New Year's Day 1984 with my head banging and my face feeling like it was made of cement. Peter, a bassist I'd been flirting with, called at 6 a.m. to wish me happy New Year! I went back to sleep till 2 p.m., when Tyrone came by. We watched the Orange Bowl, and let's just say Tyrone made it to the end zone more than once. He was going down on me during halftime when Peter and Ken called. And yes, to answer your question, I picked up both times. I loved to push the limits—fucking one guy while talking with two others was a complete power trip for me. Thomas called twice and hung up before finally leaving a message. The neighbor next door banged on the wall and shouted for us to keep it down. Being in my twenties, how could I possibly keep it down?

June, a friend of my friend Temi in Boston, introduced me to an agent in Washington, DC named Jim Keppler, who owned a successful speakers' bureau. Keppler encouraged me to develop a solo show that he could book at colleges during Black History Month. I started to work on an idea for

a one-woman show I called *From Billie to Lena with Jenifer* that would pay tribute to great African American women singers whose lives and art had inspired me.

I spent weeks doing research at the Schomburg Center for Research in Black Culture in Harlem. Every contemporary African American singer—Toni Braxton, Beyoncé, Rihanna, and, of course, my li'l Brandy—stands on the shoulders of genius women whose artistry and struggle, I feared, were becoming lost in the tide of history. I chose seven women: Billie Holiday, Ethel Waters, Mahalia Jackson, Dinah Washington, Aretha Franklin, Tina Turner, and Lena Horne. God knows I wanted to include them all—Gladys, Nina, Patti, Natalie—but the show was only one hour long!

I listened to dozens of songs written or recorded by each singer, ultimately choosing not their most popular songs, but songs that seemed to offer special meaning for the singer or that gave insight into her character. For instance, rather than Tina's "Proud Mary," I sang "Show Some Respect," and whereas Billie's "Strange Fruit" had become iconic, instead I sang "T'Ain't Nobody's Business." Mahalia laid the foundation for gospel music with "Take My Hand, Precious Lord," but I instead chose to sing "Trouble of the World." (Years later, on the set of *Touched by an Angel*, Della Reese, who was close with Mahalia, told me that this was in fact the perfect song.)

It was not my goal to imitate the singing styles of my subjects in *From Billie to Lena*. Instead, I sang the songs my way while framing them with monologues that dramatized the women's lives and struggles. The show was pretty serious, even somber, especially when I spoke of the hardships and

racism the women had faced. But there were plenty of fun parts too, like during Dinah's "Evil Gal Blues," when I splayed myself onto the piano, threw one leg in the air, and sang, *I'm a evil gal, don't you mess around with me; I'm gonna empty your pockets and fill you with misery!*" Dinah had sewn mink coats and always carried a gun.

In February 1984, I took to the road with *From Billie to Lena with Jenifer.* My first booking was at North Greenville University, a small Christian university in North Carolina. It literally was the first time I had performed before an audience made up entirely of strangers. No gypsies. No relatives. No fans. Was I really as good as I thought? Who would start the applause? I hardly even knew Billy McDaniels, my genius pianist. It was quite possibly the first time I was actually nervous before going on stage!

The show was well received. Mark Brown cowrote the show's monologues, and I am eternally grateful to him for creating a meaningful show that entertained and educated college audiences for a full decade of Black History Months. After every performance, I held a question-and-answer session with the students. This was my favorite part, because I got to relax and just be myself. There might be a question or two about the show, but mostly the students wanted to hear about how I had "made it." I must have seemed like an exotic bird to these college kids, with my big '80s hair teased to the ceiling, my sequined gold lamé Don Klein jumpsuit, caked blue eye shadow, and extreme liquid black eyeliner. Many of the students came from small, rural towns and had never visited New York or met a professional entertainer.

I enjoyed sharing with them what I had learned and seen of the world. I wanted them to know the importance of finding their passion, working hard to fulfill their dreams, being good citizens, and, above all, giving back to those less fortunate.

I crisscrossed the United States doing *From Billie to Lena with Jenifer* mostly at rural schools. Billy and I flew in raggedy propeller planes that served small cities. I always did my best to go through St. Louis to gorge on some of Mama's fried jack salmon with spaghetti before I had to catch my flight on Allegheny or Ozark Air Lines.

Attending services at Unity and listening to Phil Valentine had expanded my thinking, and I began to explore spirituality on my own. I really wanted to be more connected and to understand life outside of show business. To that end, I experimented with everything that was a part of the New Age Movement. Being among artists meant that I was exposed to all sorts of new ideas. Artists are discontent by nature; we are thrill seekers who are hip and in the know and are often the first to open up to new ways of thinking.

Unity's philosophy of "say yes," which had resonated so deeply for me, evolved into a general appreciation for positive thinking after reading *The Greatest Salesman* by Og Mandino. The book moved me to think about the possibility that I, not an unseen force, was in control of my life. I began to practice the breath of fire technique in Kundalini yoga class and

learned to sit still long enough to meditate (no easy task for me, I assure you).

Perhaps the most important book for me at the time was *Out on a Limb* by Shirley MacLaine, in which she chronicled her exploration of New Age spirituality. The book brought ridicule to MacLaine for her talk of aliens and trance channeling. In her speech after winning the Golden Globe Award for Best Actress for her role in *Terms of Endearment*, MacLaine said, "If you can dream it, you can make it happen." I was hooked. Shirley was famous, and I wanted her recipe for success.

Fast forward to 2000. I walked onstage for one of my one-woman shows and immediately spotted a head full of red hair sitting sixth row center. It was Shirley MacLaine. Need I say, I performed my ass off that night. I wasted no time at the end of the show pointing out that she was indeed in the house and had been an influence on me and my spiritual journey.

When she came backstage after the show, she embraced me, pulled back, and held me by the shoulders. "That was the best show I've seen ever," she said.

I wrinkled my face a little, thinking, "Sinatra? Sammy? Judy? *Me*?"

And then she repeated herself: "Ever."

She said something else I'll never forget: "Your landscapes are vast."

Well, let's just say that after that, I never gave a flying fuck what anybody had to say about anything. After Shirley's

amazing compliment, she invited me to walk with her on the beach early the next morning. Trust me, I wouldn't get up that early for nobody but Shirley MacLaine and her dog. She said to me, "I have one question for you—why aren't you the biggest star in the world?"

I looked at her and said, "I am the biggest star in the world."

I knew she understood.

I was beyond excited to be cast as a featured performer in *Harlem Story*, which was conceived by Peter Herbolzheimer, a German arranger and conductor known for bringing American jazz artists to perform with his orchestra in Cologne. *Harlem Story* was a musical revue of works written or recorded by African American jazz and gospel artists. A producer friend assembled an impressive company of gypsies and Broadway actors, including Clare Bathé, Vondie Curtis-Hall, Connie Brazelton, Ty Stevens, Yolanda Graves, and Roxanne Reese. I soloed in a scene featuring songs made famous by Bessie Smith and a medley of songs by Eubie Blake.

It was wonderful to be away from New York City. I strolled along the Rhine River and visited the city's gothic Cologne Cathedral. On the down side, I found the German food inedible and mostly ate McDonald's.

I seriously thought about remaining in Europe to do the whole Josephine Baker thing. She was the first black person to become a world-famous entertainer and to star in a movie. In the 1920s, Baker fled American racism and became the toast

of Paris. But never being good with languages, I took my ass back to New York.

I wrote a series of shows with Mark Brown and David Holdgrive, including *Jenifer Lewis in the Cosmos*, which was a celebration and a send-up of my spiritual search. We three also wrote *Jenifer Lewis Broke and Freaking Out*, which is self-explanatory. Unlike my earlier solo endeavors, these shows had a through line, and thanks to Mark, a lot of commentary about current events and politics. I also unveiled characters such as Little Jenny Lewis and a Baptist pastor. The shows at Don't Tell Mama were mostly sold out Tuesday through Saturday nights. The eight o'clock show usually was full of tourists. The eleven o'clock show would be filled with savvy New Yorkers and Broadway gypsies who'd just come off stage at whatever show they were performing. The *Dreamgirls* gypsies came damn near every night.

Occasionally I'd get out-of-town bookings at places such as the Tralfamadore in Buffalo, New York, and the Pilgrim House in Provincetown, Massachusetts. I did private parties in the Poconos and even went back to Kinloch for a "home girl makes good" concert. I was asked to do a benefit performance for an AIDS Charity at Studio 54. The legendary disco was just a block from where I lived, but it was my first time there, and it would be my last. I was there to work. I didn't go to clubs to socialize, not disco clubs anyway. I wore a silver lamé jumpsuit designed by Don Klein and a big, fabulous vampiress mask. The famous husband-and-wife comedy duo

Stiller and Meara introduced me on stage to perform "Black-uella." It went a little something like this:

My name is Black-uella
And you are my prey.
Don't tell me you gave at the office
Cuz I don't drink during the day.
I hope you're without a date tonight.
You want me to tell you why?
Cuz I'm gonna pick you up and dust you off
Then drain you 'til you're dry.
Why? I'm a vampiress.

Jon Voight, who had won the Best Actor Oscar a few years earlier, was in the audience that night, and I could see him eyeing me. Later, he asked me to dance, and we did, scandalously, to Annie Lennox's "Sweet Dreams."

At the end of the night, Jon and I walked to Central Park and took a romantic carriage ride. We admired the moon and the reflection of the illuminated skyline off the lake. We talked about being from families of hard workers. We stared into each other's eyes and kissed. We went to his room on the thirty-fifth floor of the Essex House. I was spellbound by his sensitivity and kindness. He ordered cognac and caviar. Let's just say he was a real Midnight Cowboy. He walked me the six blocks to my apartment the next morning. I wanted so badly for one of the gypsies to see me with Jon Voight, but gypsies don't get up that early.

I began to develop a more mature, professional performance. I had learned so much from Bette, like the technique of getting the audience laughing hard and then changing the mood on a dime and dropping some knowledge.

And I found myself comfortable enough to improvise based on what was going on with the audience. I'd give latecomers sass from the stage: "What time does your ticket say? You missed my first three numbers—which I did naked!" If you have ever seen one of my stage shows, you know I love to fuck with *errrrrybody*!

JENIFER

[*To audience member returning to her seat from
the ladies' room*]
You there in the red dress. Everything taken care of?

AUDIENCE MEMBER

[*Completely baffled and embarrassed*]
Huh?

JENIFER

Could you still hear me in the ladies' room? You
know they've got a speaker in there.

AUDIENCE MEMBER

[*Now playing along*]
No, I'm sorry. I couldn't hear you.

JENIFER

Well, we heard you!

But don't get it wrong, I am no Don Rickles. For the most part, I am the butt of my own jokes.

It was nothing for me to walk the halls of my apartment building looking to bum a cigarette. With my head wrapped and wearing a fuzzy robe, I'd knock on a neighbor's door, regardless of whether I knew them. One time when I knocked on a strange door, it was opened by the Hollywood musical star Jane Powell. I immediately recognized her and after chatting a bit, I invited myself into her penthouse. She was gracious and lovely and told me I was a "sweet girl." Thank goodness she didn't live next door to my loud ass!

One day I knocked on 4D. A cute guy answered the door and soon produced a cigarette. "You got a light?" I asked, and he presented a lighter. Then I said, "I'm Jenifer Lewis. I'm a diva. We'll have to meet again when it's not so morning and not so ugly."

A couple of weeks later, the guy and I were riding in the same elevator. This time, I was in full beat and dressed to kill. When he made eye contact with me, I said, "See?"

That was how I met Lee Summers, a wonderful friend, actor, and singer. He was in the original cast of *Dreamgirls*. One of our favorite things to do together was people watching. Like the time we were sitting at an outdoor café and saw a man running away from a taxi driver he'd stiffed for a fare. Poor bastard slipped and fell on his face, and in unison we sang, "Karma, Karma Jackson, that bitch'll get you every time."

Then we fell out with laughter.

It didn't take long for me to know that I loved Lee and his singing voice. When the opportunity arose to headline for a

week at a swank club in Monte Carlo, Monaco, I wasted no time asking him to join me singing backup with my friend Todd Hunter, an amazing dancer.

Monaco was memorable for a number of reasons. I even met Grace Kelly's son, Prince Albert, who currently is the small country's reigning monarch. But Monaco will always stand out for me because I was there when the AIDS crisis really broke open in the US media. One day I decided to go ahead and sleep with the club's gorgeous maître d' after that night's show. Then someone phoned and told me that Luther Vandross had AIDS. He had lost a lot of weight, and as a result, this rumor was born. During this period people were paranoid. Anyone who had lost weight or suddenly fell ill was rumored to have the virus. Nonetheless, when I heard that, oh, did I put the brakes on the maître d'! I had heard someone on the news say something to the effect of "Whomever you've slept with, you have essentially slept with everyone they have slept with for the last seven years." I said to a friend, "Honey, I want you to book me a flight around the world. Put it on the credit card because I'm a dead bitch."

Of course, I had been aware of HIV/AIDS for some time. The plague hit the entertainment community, especially the world of gay black gypsies, like a freight train. In these years, you knew what was coming when yet another call began with "Sit down Jenifer, I have some bad news." It started slowly at first. Curtis Worthy Jr., a cast mate from *Mahalia* passed away. A couple months later, Jerry Grimes, a dancer I knew through Shirley Black-Brown, died. Then we bore helpless witness as our friends started to die, two or three in one week. For God's sake,

they dropped like flies! Another dancer, another hairstylist, another costume designer. By now I understood that the rare form of pneumonia that killed Will B. Able was no longer rare and that he was among the nation's earliest victims of AIDS.

By the time I returned from doing my shows in Monaco the entire United States was in an uproar. President Reagan had finally mentioned AIDS publicly for the first time, but those SOBs in the government did almost nothing to address or remedy the situation, probably because it was mostly gay men, drug users, and poor people who were dying. But then, Americans began to freak out when it became clear that heterosexuals, women, and children were also at risk.

I recall watching Ted Koppel's Town Hall on the AIDS crisis. We were glued to the television. *Come on, you SOBs, do something.* It was a horrible time. The following month the legendary creator of *Dreamgirls*, Michael Bennett, died. The Broadway community was devastated, and groups like Equity Fights AIDS and Broadway Cares were organized to raise money and to push the government to do more for AIDS research and treatment.

To try to alleviate our feelings of helplessness, my friends and I came up with an idea called "Divas for Dollars." For several Saturday nights, when the gay spots were jumping, a few of us gypsies, including Sharon McKnight, Karen Mason, Lena Katrakas, Nancy LaMott, and Amy Rider, popped in to perform a couple of songs before we passed the hat for AIDS relief and research. It wasn't much, but I like to think that we made a difference.

I cursed at God as the AIDS toll mounted. And not just in

New York City. During Black History Month, when I toured the college circuit with *From Billie to Lena with Jenifer*, I was often asked back by the same schools year after year. Usually, when I'd arrive in a small town to perform at the local campus, I'd immediately go to the black hair salon, hoping to find a gay man who would appreciate my diva-ness and get my hair teased and snatched for the show. But far too often, I'd return to a salon I'd used the previous year only to learn their sole gay male stylist had passed away. The plague had reached small-town America. It was relentless and horrible.

The reality of just how many friends and colleagues of mine were very sick or had passed away was overwhelming. The relentless epidemic claimed nearly two hundred of my friends and coworkers in the span of about eleven years: Roderick Sibert and Breelum Daniels from the *Eubie!* tour; Tony Franklin and Larry Stewart from the *Dreamgirls* original cast; Philp Gilmore, from the *Dreamgirls* Broadway revival; Jerry Blatt and Ed Love from *DeTour '83*; Carl Weaver, from *Rock 'N Roll! The First 5,000 Years*; three of my favorite hairstylists: Stanley Crowe, Jerry Terrell, and Michael Robinson; Sharon Redd, who had been a Harlette in the '70s; Robert Melvin; Stanley Ingram; Chris Vaughn; Keith McDaniel; Mart McChesney; Craig Frawley. There are just too many to name. The trauma of their suffering, and their untimely and unnecessary deaths, haunts me to this day.

In late January, Quitman gave me terrible news: he was leaving New York City for San Francisco. I went all the way *off*!

A screaming, crying, snot-filled breakdown. He said he was going out west to find someone to produce the musical he'd been working on for years. I cussed him out for losing hope and leaving. I did not know what I would do without him nearby.

Quitman was always in my heart and on my mind. Had I paid more attention a few weeks earlier when Quitman told me the doctor had found nodules on his neck, I would have understood the real reason he felt he needed to be in San Francisco, which had become a mecca for HIV research and treatment. Throughout the next few years, he was in and out of the hospital, very ill, and he was deeply depressed. I remember calling him to tell him how well things were going with a series I was working on, *Crosstown*, but he was not in the mood. He didn't want to hear about how I was doing all the things he had dreamed of doing, which now, we both knew, he would never do. I tried to raise Quitman's mood. Changing subjects, I began to regale him with stories of all the guys I'd been dating in Hollywood. He cut me off: "Stop it, Jenifer. I don't want to hear about all the sex you're having." I was so sad for him and for myself. I didn't know what to say.

I was working hard and looked forward to the still-almost-daily "silent" phone call from Quitman. God, how I loved him. We laughed and cried together as always. Around Christmastime, I remember discussing the death of Sylvester, the gay disco music icon, at only age forty-one. A couple of days later, we repeated the call, but this time it was Max

Robinson, the first African American anchor of a national news program, cut down at age forty-nine.

One morning in early January, the bedside phone jarred me awake at 3 a.m. Quitman spoke slowly, the fear in his voice nearly palpable. "I'm in the hospital, Jen. I'm sick. This time I thing I'm real sick."

My friend Beverly Heath drove most of the nearly eight hours it took to reach the hospital in Oakland. The nurse told me not to touch or hug Quitman; confusion still remained about how the HIV virus was spread. I entered the dimly lit room where Quitman lay still in the bed. This Adonis, this god, whose body could leap as high as Mount Everest, lay there, covered in purple lesions.

I stepped forward and touched Quitman's face and took his hand. He whispered, "Oh, Jen, you're the first person to touch me without wearing gloves in two years." I held myself together long enough to laugh and joke with Quitman a little.

The nurses would not allow me to stay in the room for more than a few minutes. By the time I got to the parking lot, I was falling apart. I saw red. Then I saw black, because all I could see was death. In the car, I screamed, clutching my chest and banging the dashboard. I asked Beverly to drive to a liquor store, where I walked around like I was shopping for shoes. My eyes fell on a bottle of Wild Turkey, which I had never heard of but bought anyway. Back in the car, I turned the bottle up and chugged the burning liquid, needing to erase the image of my friend rotting to death.

As we drove to the home of Beverly's friends, where we would spend the night, Beverly said, "You're grieving, Jenifer, and I understand, baby, but there's something more. Something's wrong."

I was too distraught to make much conversation with the lovely couple who were opening their home to us. As Beverly stirred the gumbo dinner, I dialed the kitchen wall phone to call Mark and Bobby to tell them about Quitman. But before I could even say a word, Mark blurted, "Jenny, I'm glad it's you. Clyde Vinson died." Clyde had been my acting coach a few years earlier in New York.

It was all too much. I collapsed to the floor and crawled under the kitchen table, holding myself in a ball and sobbing into my knees. Beverly calmly looked down at me as she continued to stir with the long wooden spoon.

BEVERLY
[*gently*]
What are you doing under the table, Jenny?

ME
[*looking up and screaming*]
I don't know! Don't leave me! Just don't leave me!

BEVERLY
[*a bit less gently*]
Jenny, get your ass up off this floor!

ME
I can't! I can't move, Beverly!

BEVERLY

Jenny, you've got to listen to me baby.
Something is going on with you. Really,
this is more than sadness about Quitman.
You need to get professional help with
this. You need to talk to somebody.

ME

[*starting to gain composure*]
Really? You think it will help me?

BEVERLY

I know it will. There's no greater journey than the
journey within.

Quitman's illness, and the near-constant news of another friend stricken by AIDS, caused me to channel my grief into many AIDS causes. Over the years, I launched at least a dozen AIDS Walks and performed at numerous fundraisers. No doubt there has been progress on the AIDS front, but it saddens me that many people, gay and straight, continue to get the disease. The struggle isn't over.

EIGHT

HOLLYWOOD NOT SWINGING

My friend Louis St. Louis, who has been truly important to my career, came through for me in a big way. Louis was well-connected in showbiz circles and invited agents from William Morris to Don't Tell Mama to see my one-woman show, *How I Spent My Summer Vacation*. And, yes! The biggest talent agency in the business signed me immediately! Finally! My big break!

In short order, William Morris arranged auditions for a Broadway show, a couple of movies, and a screen test for Bonnie Timmermann, who at the time was the casting director for Universal. But I didn't get cast in anything. After I auditioned for *Grind*, a Broadway-bound musical starring

Ben Vereen, the director, Hal Prince, commented I was "too powerful to be real." (This feedback actually made me smile.)

My early days with William Morris underscored my persistent dilemma of not fitting into a marketable box. I was too unconventional, not "commercial" enough. One of my William Morris agents, Greg Mullins, told me I needed to be "more glamorous." What the fuck did he mean by that?

The agency sent me on several auditions for roles that I knew could take my career to the next level. I auditioned for the role of Shug in the movie *The Color Purple*. I was hugely disappointed that Reuben Cannon, the casting director, felt I was too young. It was sort of nice to hear that because in show business having large breasts usually means they cast you as characters that are ten years older than your age.

Then came the audition for *Saturday Night Live*. In its ten seasons on the air, *SNL* had featured only one African American woman, an actress named Yvonne Hudson. Excitement does not describe how I felt. This could be it: an opportunity to show my versatility, vocal ability, comedic timing, and charisma. Nora Dunn was auditioning that same day. I must have done well, because a day or so later, I got a call back and met the show's creator, Lorne Michaels. Then a few days later, my agent Lucy Aceto called to tell me, with great compassion, that I had not gotten *SNL*.

If one real test of a person's mental health is their ability to experience rejection and great disappointment, then, not surprisingly, I failed the test. I fell the fuck apart. I staggered to the Sheep Meadow in Central Park. As soon as I got there, I dropped to my knees, sobbing, and fell face-first into the

grass. Damn, that hurt. I lost control of my body, shaking, writhing, and crying out. I lay there and cried until nightfall.

By morning, my sorrow had turned to rage. I stormed the few blocks to the William Morris building on 55th Street, blew past the secretary, and burst into Lucy's office. Pounding on her desk, screaming and shouting blindly, I blamed the agency for misguiding me. I know I scared the shit out of everyone in the nearby offices. I was lucky William Morris didn't drop me on the spot.

The *SNL* role went to Danitra Vance, a talented actress who lasted through only one season. Frustrated by the stereotypical parts given her on the show, Danitra left *SNL* in 1986.

Although auditioning was getting me nowhere, my cabaret shows were still in great demand and provided me with a creative outlet that kept me from completely losing my mind. In the audience one July evening at Don't Tell Mama was Bob Wachs, the founder of the Comic Strip in New York City. Wachs (pronounced "Wax") had discovered Eddie Murphy, and Bob's other clients—Arsenio Hall and Chris Rock—were bursting onto the entertainment scene. Bob loved my show, believed in my talent, and felt that as my manager, he could take my career to new heights. Finally, my knight in shining armor had arrived!

I was now where I had hoped to be. In addition to Bob Wachs, heavy hitters including the Zippels were fighting for me. But as months of auditions rolled by without success, it still was not clear where my niche was. I did not fit on Wachs's roster like the others. He knew what to do for them, but my offering was too broad and uniquely individual.

Mark Brown heard me say I was "going crazy" waiting for my big break. He had started seeing a therapist and knew I could benefit from therapy, too. But rather than doing that, we devised a new show, *Jenifer Lewis on the Couch*, in which I spoke to an unseen shrink and "analyzed" why I wasn't a star yet. David Zippel and Joanne Zippel were the producers. Backed by a full band and two muscle-bound singers named Keith McDaniel and Craig Frawley, I opened *Jenifer Lewis on the Couch* at the Roundabout Theatre in April. This was big; the Roundabout was a "real" theater, not a cabaret. The show was a hit with critics and audiences, and even won me a spot on *The Today Show*, where I was interviewed by Jane Pauley, who was very pregnant at the time. I wore a beautiful white suit and added some dangly gold earrings my mother had given me the Christmas before.

JANE PAULEY

[*smugly*]

So Jenifer, are you ever going to be a star? When do
you think it will happen?

JENIFER

Um, I don't know. I guess when I'm calmer.

JANE PAULEY

Well, maybe it will happen when the
earrings are real.

Excuse me? I know this woman did not just insult me on national television! I was stunned by her rudeness. Later, I

thought she must have had morning sickness or something. But, fuck that! Now that I have the opportunity, let me say this: "Ms. Pauley, that was rude, and by the way, I did become a star. And trust me, the earrings are fucking real!"

At the urging of Bob Wachs, my new manager, I decided to move to LA. I'd been in three Broadway shows and made a name for myself as a solo performer; now it was time for Hollywood—for movies, TV, Oscars, and Grammys. Bob bought me a used Mazda 323 and I had saved $6,000 from my *Billie to Lena* tour to cover me during what I thought would be a brief period before I achieved stardom. I moved in with Roxanne Reese, who had remained a friend after our concert in Cologne, at her small bungalow apartment on Troost Avenue, deep in the San Fernando Valley. Rox was working steadily in TV and as Richard Pryor's opening act.

Bob put me in the hands of his assistant, Tess Haley. Right off the bat, Tess commissioned a highly respected writer named Deborah Dean Davis to create a movie script for me which Bob could shop to the studios. Although the script got no mileage, Deborah and I became bosom buddies.

Bob was a powerful player whose client roster easily opened Hollywood's gates. He got me meetings with every major studio in town. Opportunity seemed to be banging on my door when Bob arranged a showcase for me at the Comedy Store and filled the audience with Hollywood bigwigs. One of these was George Schlatter, the legendary producer who had transformed American television comedy in the late 1960s with *Rowan & Martin's Laugh-In*. Schlatter loved me, but

once again, he found me unmarketable. He told me, "If this was twenty years ago, you would become a star overnight." To this day, I believe this is true. Unlike the bygone '50s and '60s when multitalented performers like Flip Wilson, Carol Burnett, and Jackie Gleason reigned, show business in the '80s was designed to market artists who fit in a simple box—comic or singer or actor or sexy starlet—and I was all of those.

Yet, I persisted. I cast my net wider, auditioning for the movie *Beetlejuice*, to be a vee-jay on VH1, for a Fritos commercial, and for a CBS series called *Sirens*. I was rejected over and over.

Bob set up meetings with Paramount, Columbia Pictures, and Lorimar, the highly successful company that produced *Dallas, Knots Landing*, and *Falcon Crest*. After the meeting at Paramount, I was driving off the studio lot when I saw Chris Rock walking in the blazing California sun. I pulled up, and like back home in the Midwest, leaned out the car window and asked, "Want a ride, Negro?" We acted a fool in my little white Mazda until I dropped him off at his hotel.

I auditioned for the lead in *Clara's Heart*, but Whoopi got the role. I auditioned for a role in the movie *Scrooged*, and all I got for that was felt up by crazy-ass Bill Murray. All in good fun, but I got the hell out of there! I also met several times with Ralph Bakshi, whose film *Fritz the Cat* had been the first animation to receive an X rating. Bakshi gave me a super-funny script, but nothing ever materialized. I think he might have wanted to get in my pants (which did not happen).

Paramount had made zillions from the Eddie Mur-

phy movies. When *Beverly Hills Cop II* opened with a record-breaking $26.4 million box office, Bob Wachs threw a huge celebration for Eddie at his house in Beverly Hills. It was my first big Hollywood party, an all-day barbecue featuring all-day drinking. I felt a bit out of place and did not socialize much. However, I managed to down two margaritas when I arrived, drank a couple of glasses of red wine with dinner, and when they brought out the giant cake, enjoyed a few goblets of champagne.

When it was time to go, Tess put me in my Mazda and asked if I was okay, which I felt I was, until, driving back home to the Valley, I tackled the curving roller-coaster that is Coldwater Canyon. I had to pull over twice to pee and vomit in the dark bushes. It was the first time I knew what blind drunk meant. I could see only the yellow lines, and I followed them slowly all the way to my right turn on Victory and left on Troost. When I stumbled into the small apartment, Roxanne said "Damn, Jenny, you smell like a distillery." Never ever did that again.

After a few months I began to get anxious about work. I wasn't getting cast in anything. A big mouth and a deep backbend weren't cutting it in Hollywood. I had signed with ICM for movie and TV work on the West Coast, but a string of unsuccessful auditions led Iris Grossman, my agent, to tell me to get out of the business. This is not exactly what you want to hear from your agent. Tess was also getting frustrated with my failure to secure any jobs. Clutching at straws she bitchily told me I needed to lose weight—"You're in Hollywood now!" I wasn't

obese by any stretch, not even chubby. In fact, my strength and flexibility were two great assets that had served me well. But the pressure to meet the size 2 Hollywood standard was real.

I questioned more and more if I could cope because I was not centered or prepared. I had not yet trained to audition for screen roles; I was used to playing to live audiences, and now I had to pull everything back for the camera. And I hadn't "acted" in a long time—to develop a character for a role required more focus than my scattered mind was able to muster. I found it difficult to concentrate. My mind was always racing off on tangents.

I became homesick for New York City. I especially wanted to be in Central Park's Sheep Meadow in mid-August to participate in the global meditation marking the Harmonic Convergence, a big event in the New Age movement. The importance of the date had to do with the Mayan calendar and a prediction of something big and transformative happening, signaled by an alignment of the sun and planets on August 16, 1987. Some believed the spectacle would usher in a new era for humanity. Well, that turned out to be bullshit.

The first thing I did when I returned to New York was see Thomas. But being with him was a drag. He was really worried that we would never get married because now I was living in Los Angeles. But he was still telling me not to curse and to "act like a lady."

Thomas had good reason to be worried. I was jetting back and forth between the East and West Coasts for auditions and meetings, taking acting classes, performing in nightclubs, and sleeping with a few other guys in New York and Los

Angeles. The Harmonic Convergence did not seem to extend to my crazed ass.

To relieve my anxiety and try to get a grip on my life, I continued to search for answers by immersing myself in popular spirituality—Rolfing, crystals, chakra cleansing, totems, channeling, past-life regression, and on and on. I reread Mandino's *The Greatest Salesman* and became motivated by Shakti Gawain's *Creative Visualization*, which spelled out how to manifest your dreams. A few of these approaches helped me immensely, although they didn't solve the underlying problems. I also was consuming titles such as *Overcoming the Fear of Success* by Martha Friedman and *Love Yourself Into Life* by J. Z. Knight.

I had begun to build my West Coast corral of lovers. First with a man named Tim who pulled out his HUGE dick and said, "Not bad for a white guy, huh?" After Tim, my stable of men grew as I began to date Gary, a musician, as well as Aaron, Jeff, and Peter.

Dick. The men weren't human; they were my tool, my drug. My need for the euphoria of the orgasm was acute. I was starting to think there was something off about my behavior, but I felt compelled to have sex. It was the best way I knew to calm my anxiety.

I could no longer deny the fact that I was fucked up in deep fundamental ways that were too overwhelming to contemplate. It was becoming more difficult to overlook my extreme, abiding depression or to deny that my clowning and promiscuity were, in fact, inappropriate behavior.

I wanted to be different, to take control of my life. And I did find hope. Many of the books I read gave me new per-

spectives and new self-help tools for becoming the person I wanted to be. The Seth books by Jane Roberts were hugely important to me. The themes they addressed made me increasingly convinced that maintaining positivity and staying focused on what I wanted, instead of what I did not want, would enable me to manifest the life I sought.

My metaphysical studies taught me that energy is highest where the water meets the land, so I booked myself for a weekend at Gurney's Inn, a historic spa resort in Montauk, on the tip of Long Island, New York. The sunset was magical as I stood on the rocky shoreline. It seemed the perfect setting for manifesting, and each time the waves crashed against the rocks, I shouted, "I want a job in Hollywood!"

The next day, I lay in a darkened spa room, mummy-like in a seaweed mineral wrap. I heard the attendant enter, sensed her bend in close to me, and softly whisper, "Someone is calling from Los Angeles, Miss Lewis. I believe it's Hollywood."

The moment felt just like one of those scenes in an old movie where the actress gets the call that changes her life: "Hollywood calling." The attendant had a phone on a long cord and held the receiver to my ear as I said "hello" through the mud that restricted my face.

Bob Wachs was on the line shouting from excitement that I had to catch the earliest flight to Los Angeles because a producer named Haim Saban wanted me to audition for a pilot called *Love Court*. There was a limo already waiting for me, which drove me back to my apartment and idled at the curb while I hurriedly packed. On the way to JFK airport, I had

the limo stop briefly at Thomas's apartment to pick up a few things I had left there.

Thomas said, "How long will you be gone this time?"

I said, "Baby, this might be it."

I saw his face and thought to myself, let the fucking limo wait. I held his face in my hands and kissed him. He drew back just a little—I could see he was trying to cover the heartbreak he was feeling. I felt bad, but I didn't feel horrible, because I had never lied to him. He knew this day would come. We had a sweet and powerful quickie, and like the gentleman he always was, he carried my luggage to the limo and waved me off.

You're wondering if I cried in that limo. The answer is yes. And for the five hours on the fucking plane.

I had just ended a seven-year relationship, and by the time I got back to Roxanne's apartment, my whole body was itching. The next morning, I broke out in red welts and my entire body was sore. This had never happened to me before. I was sure it was AIDS. I couldn't get to the doctor fast enough.

Roxanne and I were holding hands when the doctor came into the room. He asked me if I had been under heavy stress. I looked at him like he was a damn fool and told him I had just gotten a divorce. He said, "Well, this is very common. You have shingles."

I had remembered playing hopscotch with torn shingles from our rooftop in Kinloch made of sand and tar. Good Lord, what a come-around and what a hideous name for a hideous ailment.

I proceeded to skip my happy, itchy ass to the car and took my scratchy, itchy ass home.

From the *Los Angeles Times*, November 27, 1987:

> Jenifer Lewis has been appointed to the bench
> in *Love Court*, a new syndicated half-hour series
> to premiere in September 1988. Lewis, an ac-
> tress, will dispense opinions to couples wran-
> gling over romantic problems. The series is
> described as a comedy takeoff on TV's *Divorce
> Court, People's Court, Superior Court* and *Love Con-
> nection.*

And there it was: my first television gig.

After we shot the pilot for *Love Court*, things got really
busy for me during the next few months—but not in Holly-
wood. Once again, Erv Raible came to me with a great oppor-
tunity—this time a concert in Paris featuring me and several
wonderful singers: Sharon McNight, Lena Katrakas, Naomi
Moody, and Nancy LaMott.

On the way to Paris, I stopped in New York for a few days
and Thomas asked me to marry him. I said yes! When I told
Mama, she said, "There's no way you're marrying anybody."

While in Paris, I became friendly with our pianist, Michael
Skloff, and his wife, Marta Kauffman. When we got back to
the States, Marta and her creative partner David Crane cast
me in a musical called *Let Freedom Sing*, which played in Philly
and then at the Kennedy Center in Washington, DC. Com-
pletely forgetting I was engaged, I simply couldn't resist the
adorable young doorman at the Kennedy Center. I was his
first, and I pity the poor girl who was his second—nobody

could follow the acrobatics I performed after he escorted me into an elevator and I pulled the Stop button!

I returned to LA and had good auditions for shows on CBS and ABC, and at MTM, which was Mary Tyler Moore's production company. It was disappointing when the *Love Court* pilot didn't get picked up, but nonetheless, things were moving in the right direction and stardom seemed within reach. More opportunities came along, including a pilot with Eddie Murphy called *What's Alan Watching?*, which unfortunately did not make it to the airwaves. Around this time, I went on a date with Eddie's brother, Charlie Murphy. (I swear I didn't touch him, y'all!) We laughed so much, I think we just forgot to screw!

In March 1990, I was cast in my first regular television role, on *Crosstown*. The series star was Tony Alda of the famous Alda acting family. I was nervous as hell. It was the first time I had acted on camera on a consistent basis. During the second day of filming, the director stopped me mid-scene. He shouted, "What are you doing? This is a soundstage, not a theater stage!"

I had been trained to hit the back row of a large theater. But when the director showed me the footage of my performance, the problem was clear. I came across loud, over-the-top, exaggerated, like a kabuki actor among regular people. The camera is intimate, it sees more keenly than the eyes of an audience ten feet away. On stage, you have to tell the truth; on camera, you have to tell the truth, the whole truth, and nothing but the truth. Anything less comes across as fake acting—we call it "ackin'."

I realized that in order to deliver that much truth, I had to know the truth of who I was. It meant I had to take that "journey within." I wanted to please the director; I wanted to be as great in Hollywood as I'd been in college and on Broadway. I had to play to the intimacy of a camera and a few people in my face, not a cabaret full of nightclubbers at a distance.

I listened as the *Crosstown* directors helped me. And I did the work. I dove all the way in, and it was a hell of a transition. Stanislavski. The Method. Acting classes with the brilliant Janet Alhanti served as a sort of therapy for me, because I was forced to examine my emotions in order to create authentic emotions for the characters I played. The greatest method actors achieve unity with their characters—Marlon Brando, Denzel Washington, Viola Davis. They say Robert De Niro comes to set with a stack of index cards of notes he has rooted out about his character. I focused on my *Crosstown* character. How could I create her truth? I was so proud the day that same director yelled "cut," then smiled at me. "Very good, Jenifer."

Working on a TV series is no joke. Like running a marathon every day. Great actors can make it look easy. Trust me, it is not. Sometimes we'd start at five or six in the morning and shoot two episodes in a single day. A couple of times Tony Alda and I stayed at the studio overnight. I was exhausted during *Crosstown*. But I was very happy.

Despite our failed engagement, Thomas and I were still on the "make up to break up" treadmill. We flew to

Hawaii together for a vacation, hoping the beautiful setting would help heal our differences. Conveniently, we both forgot that our trip to Jamaica had failed at achieving that goal. We boarded a helicopter to sightsee over Kauai. The helicopter lowered itself down into the canyon surrounded by all sizes and types of waterfalls, absolutely gorgeous. Then, as the helicopter ascended, the song "[Love lift us] Up Where We Belong" blasted through the headphones they had given us. It was utterly breathtaking and romantic. I reached my right hand to take his left. Thomas was left-handed, and when I didn't feel his sweet fingers reach back for mine, I turned to discover he was writing a note.

I remember mouthing to him over the music, "What are you writing?"

He said, "I just want to remember to tell my mother what I saw today."

God, help me, his mama always came first. *Would I ever really be able to be number two for any man?* I'm gonna let y'all answer that and keep it moving.

I came to find the scenic hills and dramatic ocean views on the West Coast calming to my soul. They say nobody walks in Los Angeles, but one of the joys of living here is hiking. From my first days as a resident, when I felt confused, I would hike the mountains that frame the San Fernando Valley, sometimes singing a song that was a favorite when I was a little girl, *Climb every mountain, ford every stream, follow every rainbow, 'til you find your dream.* I'd choose the steepest slopes,

singing a gospel phrase I loved that went *God give me mountains with hills at their knees; mountains too high for the flutter of trees. God, give me mountains and the strength to climb them.* This was a soul-searching time for me. I sought to be more connected to nature, to pay more attention to sunsets and the rising of the moon.

I ran into Bette one day while hiking the Hollywood Reservoir with my friend Thom Fennessey. She had just started work on a new movie, which turned out to be *Beaches*. She got me a featured role in a number written by Marc Shaiman called "Otto Titsling" (a fictional account of the invention of the bra), wherein my already-oversized bosom was costumed in outrageously huge falsies. During a break, Marc, Bette, and I walked out onto Wilshire Boulevard. Still in full costume, I stepped to the curb, where I pretended to hitchhike while bouncing up and down to jiggle the enormous breasts. We three fell out at the faces of the passing drivers!

When I wasn't working, I grasped for anything that might help me feel whole—crystals, face reading, moon baths, the Ouija board. What a mess I was! Longing for Thomas. Longing for Miguel. Confused as to why I was not elated at the progress of my career. God help me. Nothing was ever enough. And, of course, it didn't help that I was having sex with far too many men: Adam, Tim, Tucker, and Eddie (Green, not Murphy!).

Tucker introduced me to porn, but I never really liked it. It gave me a headache. The videos showed too much banging and not enough foreplay. The action always looked painful to me. Okay, maybe I like to see a little hair pulling, but not all

that oversize extra. You know you're bored with porn when you find yourself criticizing the acting skills of the participants.

Tucker also introduced me to the waterbed thing. He liked waterbeds because he had back problems courtesy of the Vietnam War. All that splashing around spoiled the rhythm. I pretended to fall on the floor so we could finish up on solid ground.

I discovered how annoying it was to have sex wearing Lee Press-On Nails. I had to wear them for a television show, but they made sex difficult. A few men complained. Poor bastards.

I flew to New York for an audition and while I was there, made my appearance at a few of my old haunts, including Possible 20.

> JOURNAL ENTRY: Rude waitress tells me Elaine Swain
> is dead. Horrible moment.

I returned to the West Coast and was in a downward spiral for weeks. The inevitable breaking point came after a huge long-distance fight with Thomas the day before I had an important audition for a role on *Thirtysomething*, the drama series about yuppie angst that was the hottest show on television at the time.

I was already in emotional distress when I arrived for the audition at a nondescript office building. My scene was with

Peter Horton, the director and one of the show's stars. Right from the start, things went south. I was auditioning for the character of Rosie, but I was drowning in the character of Jenifer Lewis and wearing a mask. I felt like my entire career depended on this one audition, a crushing weight that made it impossible for me to focus on the character or remember the lines. I became overwrought, and for the first time in my life, I said, "I can't do it."

Peter Horton was lovely. "Yes, you can, Jenifer." I started over but simply could not get the words out. I thanked Peter and, barely holding myself together, walked blindly out of the room. As soon as I stepped into the elevator, I completely lost all control, sobbing and gulping as I slid down the wall and melted into a puddle on the floor. The suit-clad people in the little compartment just looked at me.

Back in my Mazda and still sobbing uncontrollably, I could barely see the road as I drove through Laurel Canyon. When the red light stopped me at Ventura Boulevard, I collapsed on the steering wheel. I looked up when I heard two beeps from the car adjacent to mine. The older white driver looked at me compassionately, and I could see him mouth, "I'm sorry." It was just the sweetest little toot-toot on his horn and a simple acknowledgment. I had been seen by this stranger, and it uplifted me, just enough to get home.

Everything was crashing in on me. I spent a lot of time alone watching rented movies on my VCR. One of these was *Frances*, starring Jessica Lange. It was about Frances Farmer, a mostly B-movie actress during the 1930s and 1940s. Sadly, she is famous largely for having been the victim of an invol-

untary lobotomy following a diagnosis of manic-depressive disorder.

From the first scenes, Lange's brilliant portrayal of Frances Farmer's descent into mental illness triggered recognition in me, especially her crippling depression, the dark cloud that lay over her very existence. Her impatience and impulsiveness. Her lonelinesss. Her inability to handle failure. Her blaming others for her own mistakes. It was all familiar.

I cried through the entire movie. Subconsciously I knew it was my story, but still, I did not—could not—acknowledge that I, too, could be "mentally ill." I turned the video off with one thought: *Damn, I don't want to be like that.*

I never mentioned my reaction to *Frances* to anyone. I convinced myself that I could make myself better on my own and continued to search for answers in metaphysical spirituality.

Around this time, I got a call from Shirley LeFlore, the dean of students while I was at Webster. Shirley, a wonderful poet and excellent dean, had been extremely supportive of me in college. As a freshman, I went to her office in tears because "every time I do something that gets applause, people steal it." Shirley didn't make fun of or patronize me. Instead, she said, "Jenifer, you should be flattered because by the time they've stolen your material, you've gone on to create something new anyway."

Shirley was my connection to Beverly Heath. They had been best friends in St. Louis. Shirley had flown out to Bev-

erly's house in Pasadena for a few days. Like me, Beverly was a native Kinlochian. As soon as I met Beverly and her family, I knew I had found home. Beverly is a social worker and artist and her husband, Albert "Tootie" Heath, is a world-renowned percussionist and was a member of the acclaimed Heath Brothers jazz group.

Beverly drew me into her circle of friends, which to this day I credit for saving my life. These were educated, professional women who came together on a regular basis to exhale, share their stories, eat, laugh, and support one another. They were the most sophisticated women I had ever socialized with. Several were therapists or social workers. Their talk of politics, their Afrocentric clothing, and their worldliness were new to me. I wanted to drink up every drop of their wisdom.

Tootie, observing how Beverly and her friends kept one another afloat, dubbed the group the "Boat." These women *were* mighty ships. Some were freighters; others, tall ships with sails. They became new mother figures for me. Beverly, along with Jeanne King, Dr. Medria Williams, Azhar, Myra Lebo, and Dr. Barbara Richardson, gave me levels of practical, professional, and spiritual guidance that I had never encountered before.

I was the youngest member and the entertainer of the group, but the women cut me no slack when it came to honestly assessing my life. When I regaled them with stories of my sexual escapades, they laughed but clearly grew tired of hearing me proclaim again and again, "I am a star and dick is my life." And when I described some of the esoteric methods—such as trance channeling and Tarot cards—that I believed

could help me find direction, Beverly told me, "Jenny, I don't believe none of that shit! You need to carry your ass to therapy!" I half-nodded, feigning interest.

My lack of political consciousness was appalling to my Boat sisters, who had spent their lives in the Civil Rights Movement. They pressed me: What's in there, Jenifer? What is your foundation and purpose? Echoes of Miguel's "Joo say no-thing" rang in my head.

One of the members of the Boat, a family therapist named Jeanne King, took me to address a group of teenage mothers she was counseling in East L.A. The young women seemed hungry for the stories about my career, my travels, and hardships. In turn, it was gratifying to hear them open up and speak honestly. The afternoon became a very sweet memory for me.

Fast forward to 2016, when I'm at a track meet with my great-nephews somewhere on the outskirts of Los Angeles. As I was leaving the stadium, someone called to me. "Miss Lewis!" I turned, expecting the greeting had come from a fan requesting a picture. But instead, the smiling fortyish woman immediately launched into her story: "Miss Lewis, I don't know if you remember, but about twenty-five years ago, you came and spoke to a group of us who had just had babies. I was the one that was really quiet and sad because I wasn't ready to be a mother and they had made me keep the baby."

My heart started to melt as she continued, "I never forgot that day and always hoped that I would meet you again to thank you. You went around the room and asked us what our favorite song was; when you got to me, you said, 'Why don't

you sing it for us.' I did, and I been singing ever since, Miss Lewis. My baby's all grown now. I got two more out on the track and my husband up there in the bleachers." She looked at me meaningfully and said, "And I am doing all right, Miss Lewis. Doing real good."

I've learned in life that what you give to others is what provides the most value to your life. There I was, a mess myself, yet I still had something to offer that would have an effect on another person's world.

Shortly after being embraced by the women of the Boat, I received some of the worst news possible. The love of my life, Miguelito Hermongez Henquez Gomez, had died of a massive heart attack after leaving Washington Square Park, where he had played his last game of chess.

It had been six years since I'd seen Miguel. He had aged, but he was still fine and still mine. I had sublet my New York apartment, so we went to a hotel near the Museum of Natural History. It was a dump, and they dared to charge $120 a night, but we knew we wanted to be together. We were kind of shy with each other at first. But, God help me, it was a one-thrust orgasm for us both. That's love.

The next morning, I walked him to the train station. Before he went down the dirty staircase to the N train, he turned back and said, "Joo have to have some babies, Yenifer. So joo'll have somezing to live for when joo get old."

The fact that I needed psychological help became even more evident after losing Miguel. During my nervous

breakdown following my visit to Quitman's hospital room, Beverly had told me "there is no greater journey than the journey within." Her words touched me deeply. I trusted and loved her enough to know that I should follow her advice. I agreed to let Beverly help me find a therapist. It's one thing to decide that therapy can help you. But, it's another thing to actually take the necessary steps to get it. I had a few good auditions and callbacks, making it easy to just put the "therapy thing" on the back burner.

One day, as I packed up the six loads of laundry I had done at Beverly's house, she really pushed me about it. Feeling guilty, I got home, picked up the Yellow Pages, and randomly chose the name of a woman psychotherapist nearby. A few days later, I entered the therapist's elegant office, and we shook hands. She was confident and composed, her blond hair carefully coiffed. As she asked me a question, I noticed the Harvard diploma on the wall. As my lengthy and increasingly intense response flowed forth, the therapist started inhaling deeply through her nose as if to manage her rising emotions. Her widening eyes seemed incapable of looking away from mine. I recall no details of the content of our conversation, but I swear when I left forty-five minutes later, her hair was sticking straight out like she had stuck her finger in a socket. She said, "We'll be in touch." She wasn't.

Another Boat member gave me the name of a middle-aged woman shrink whom her friend had been seeing for some time. But within five minutes, I knew that therapist was more depressed than I was! I felt frustrated about the whole damn thing.

A nasty argument with Bob Wachs and Tess over some bullshit sent me plummeting. Jesus, was I immature. I told Bob I had to be true to myself. He shouted back, "What the hell is that?" His scorn hurt me deeply.

At this point, the dark night of the soul came to a head. There was nothing left but this masked entity, this "life of the party" who sobbed into her pillow every night. The depression was all-encompassing, even as I raced through every day at full speed.

Probably, I should not have attended the opening-night party for the wonderful show Loretta Devine was starring in about Billie Holiday, called *Lady Day at Emerson's Bar & Grill*. With several of my Boat sisters, I drove down to San Diego where the show opened at the famous Old Globe Theatre. The party after the show was loud and boisterous. I got drunk and jumped up on the table, ordering everyone to shut the fuck up! The entire crew, especially my buddy Loretta, was soon falling out with laughter as I recounted my experience of searching for a therapist, adding all sorts of outrageous exaggerations. "Oh, honey, then they sent me to this fine black man who had been educated at Harvard. And he was poised to put me straight. I knew the only thing that was going to be straight was his back on that sofa with me straddling him!" It was clear that I was an entertaining motherfucker, and that something was wrong, especially when I wrapped up the mini-performance with a monologue about being so poor, I lost my virginity to a rat. When I finished, Jeanne King pulled me aside and said, "Honey, you're about as crazy as you can

be. I have a friend I sent a schizophrenic to, and she worked wonders with him. Let me give you her number."

I didn't even look at the paper Jeanne gave me before stuffing it in my cleavage. But at yoga class the next day I began to sob uncontrollably, and I went straight home and called that number.

A few days later, when I met Jeanne's friend Rachel, I was in an extremely agitated state. I could not look Rachel in the eyes and was unable to sit still. I dropped to the floor and began to do push-ups as she watched from her small armchair. She asked a couple of superficial questions. I batted them away as I rose from the floor to look out the window. Her incisive eyes followed me around the room, obviously assessing my every move. My modus operandi is to scare a bitch when I feel vulnerable, and I felt my hackles rise. She calmly told me to take a seat, which I did—on the back of the couch with my bare feet on the seat cushion. I responded to her next question dismissively. Then, Rachel dropped the bomb: "Tell me about your mother." Seeing red, I lunged off the couch into Rachel's face, yelling through clenched teeth and pounding my chest: "I came here to talk about my career! Don't. You. Ever. Mention. My *motherrrr*!!"

KINLOCH

My earliest memory of Mama is her roughly pulling a white ruffled shirt over my head when I had the measles. "Mama, it hurts," I said, referring to the shirt on my tender skin. She softened, but just a bit. She had no time for coddling.

Dorothy Mae Johnson Lewis, the eldest of sixteen children, was herself the mother of seven by the age of twenty-six. To say Mama was strong-willed and outspoken is an understatement. Once, ADC ("welfare") sent a white male investigator to our house. When Mama opened the front door, the social worker peered in and said, "Nigger, how can you afford a piano?" Mama calmly said, "Just a moment" and closed the door. Thirty seconds later she reopened the door and threw a bucket of piss dead in his face.

My mother was the sort who found my father in a bar with another woman and took his cash from him right on the spot. She told his date, "You're gonna buy your own drinks tonight because this money is going to feed his seven kids."

Edward James Lewis, my father, was a sharply dressed, good-looking man the color of the walnuts that grew plentifully around town. The story goes that my mother was walking home from high school one day when Ed rode up on his bicycle, put her on the seat, rode her to a romantic spot and proposed. She was nineteen years old when they married in 1949. I arrived in 1957, after Wilatrel, Vertrella, Larry, Edward (Ba'y Bro), Robin, and Jackie.

My parents separated when I was just two weeks old, and Daddy wasn't around a lot as I grew up. Like many men in Kinloch, Daddy drank. He was often out of work, again, like a lot of men in Kinloch, and when he did work, it was for low wages.

Kinloch was the first self-governing black town in Missouri. We were a racially segregated island of poverty surrounded by the white St. Louis suburbs—Berkeley and Ferguson. Yes, *that* Ferguson, where the murder of a young black man by a police officer in 2014 reinvigorated a nationwide movement against police violence.

The Kinloch of my childhood consisted of little wood houses, some not more than shacks, outhouses, and rocky roads. Most residents were so damn poor they couldn't afford to go to the doctor unless they were damn near dead. It seemed that people were always dying just walking down the

street or coming out of the Threaded Needle, the only legal bar in town (there were many underground juke joints that sold moonshine). Diabetes, high blood pressure, and heart attacks took out all kinds of folk, young and old. Drugs weren't pervasive during my formative years, but there were plenty of liquor stores and alcoholism was the norm, along with the violence and despair that often occur when people see no way out of their lives. No one could afford a gun, but there were plenty of knives, bricks, and baseball bats. People were always on edge in Kinloch, and a fight was always breaking out, sometimes right there at home.

Don't get me wrong; there were a lot of good things about Kinloch, too, especially the benefits of growing up in an all-black town. The people in authority came from our community and were part of our culture. We had our own mayor, a police force, school system, post office, stores, and churches, of course—everything but a bank. No need for a bank when no one had more cash than what was in their pocket. We had wonderful black teachers who cared that we were well educated and classes small enough for this to be possible. Kinloch produced many high achievers, including Congresswoman Maxine Waters, entertainer and activist Dick Gregory, R&B singer Ann Peebles, and my good friend Beverly Heath.

People knew each other in Kinloch. We were a tight community with half of the folk in town related in some way. We sat on front porches, calling out to each other from the road

or across the yard. We had some characters, too. There was Huckabuck, Kookoo, Chicken Neck, the Pigfeet Man, and Cat Johnny, who always drove a Cadillac. We had a number of small shops and restaurants—Shack Pappy's for barbecue, Hal's Drive-In for delicious garlic fried chicken, and Uncle Dick's, where we bought dill pickles, Lay's potato chips, and penny candy. My favorites were Mary Jane's, nut chews, and watermelon suckers. At Mr. Harris's store, we all tried to ignore the sweat that dripped off his head and into the ice cream buckets when he bent to scoop cones for us.

All the kids had their real mamas and one or two "play mamas." When Mama was really struggling and our refrigerator was empty, I could stop by the house of any of my play mamas: Miss Barnes, Miss Clark, or Miss Benson. When I got real lucky, someone had made a tub of greens or cornbread in a skillet or a pot of neck bones.

Mama hated being poor and being dependent on government assistance. She was a proud woman active in the church and community. Mama was a den mother for the Boy Scouts and even got involved in politics. She served as an election judge during the 1950s.

She was ambitious for herself and for us kids. Shortly after I was born, she got job training and soon secured employment as a certified nursing attendant. When I was one, she found a job at St. Louis County Hospital, where she worked until it closed in 1982.

Even though Mama supplemented her hospital job by occasionally cleaning homes in the white suburbs, eight

mouths is a lot and we were still very poor. When I was a toddler, we were forced to move into an old, abandoned Baptist church on Jefferson Street to avoid homelessness. About nine or ten of Grandma Small's sixteen children were already living there. My family was in the basement, only two windowless rooms for Mama and the seven of us kids. Mama strung a towel on a rod to separate our space from Aunt Louise's and her three kids. We shared a kitchen with them and, oh, you can imagine the drama, especially when there wasn't enough to eat for one family, let alone two.

The church basement was dark and cramped, but my mother was an immaculate housekeeper. We slept three and four to a bed and even though we had no windows, Mama hung curtains on the brick wall to make the place look as nice as she could. She kept our hair pressed, our clothes ironed, and made us use that milky-white shoe polish on our tennis shoes every week. The Lewis children were always well groomed.

We were happy to move from the church to a creaky house on Wesley Street that had no hot water. Now that I was older, I had to use the outhouse. My ass froze on that seat in those subzero Missouri winters. The alternative was to do your business in a bucket in the house—which somebody had to carry out later.

A coal stove in the middle room heated the entire small house. We'd huddle in front of the small black-and-white television to watch *Godzilla, Abbott and Costello Meet the Wolfman*, or *Frankenstein* (with one of my favorites, Boris Karloff) on

the one channel we could get. Good reception depended on adjusting a wad of aluminum foil around the antenna and giving the console a few shakes.

Being the baby of the family was a drag. Everything I got was a hand-me-down—even bath water. After we heated pots of water on the stove, Vertrella and Wilatrel would share the first tubful. Then the boys, Edward and Larry, would do the same. Then Jackie and Robin would have a fresh tub to share. I used the same water after them, lukewarm and dirty from two kids. I felt like an afterthought.

The struggle was real, economically, physically, and emotionally. Our house was oppressive—not a happy place. There was always a sense of pressure—from unseen outside forces that prevented us from having a nice house, new clothes, and plenty of toys to the very identifiable fear that we would incur our mother's wrath. She was volatile and seemed to be angry about something or other most of the time. There were few hugs or kisses; she did not act as though she cherished us. She criticized us and ordered us around. If you disobeyed or gave Mama sass, a beating was the consequence.

But don't get it twisted! Mama was a great woman. She instilled values in her children that served us well throughout our lives. She was a model of hard work, civic involvement, and of making the best with what you got. She learned from life's hard knocks and wanted us to succeed. She would call us together, sit us down, and tell us of the dangers of the world. Education was the only defense: "You *will* go to college and you *will* finish college. Land in jail, and you will stay in jail."

I was considered a "bad" child. Quite unruly. I lied, tat-tled, teased, and yelled, making myself a general nuisance. I'd hit my siblings on their backs and then run and climb onto Mama's lap, thumb firmly planted in my mouth. I lacked companionship. My six brothers and sisters paired up into three couples and avoided me. I felt left out. More than once, I heard one of them introduce our family and end with "and then there's Jenny."

There was little or no discussion about why I behaved poorly, no "time out." Our parents, our village, grabbed a switch and beat your ass when you were bad, and Mama did not spare the rod.

One memorable beating took place when I ruined my freshly pressed hair. On Saturdays, Mama straightened her five girls' hair and neatly rolled it around brown paper strips so we'd look our best the next morning in church. Mama fin-ished my hair and sent me to sit quietly on the front porch. But it was so hot, I couldn't resist running through a lawn sprinkler. When I heard Mama looking for me, I crawled into the doghouse and sobbed as my hair went back to the nap. I stayed there until dark. When I emerged and tried to sneak into the house, Mama was waiting with a switch. She wh-upped me in the street.

Now calm down, y'all, it wasn't terrible all the time or I wouldn't be here, for goodness' sake! I do have some wonder-ful memories of my childhood. I always loved our family re-unions, the excursions up and down the Mississippi River on the S.S. *Admiral* steamboat, and marching with my siblings in the May Day parade. I can still almost feel the sun on my

face through the grapevines behind the old church when my sisters and I hid amongst the vines, laughing and shrieking hysterically as Ba'y Bro and Larry chased after us riding their hobbyhorses. I remember Mama had a real fox shawl, with a head and paws that fascinated me. When I was very little and Mama wore the stole to church, I'd sit next to her in the pew, toying with the fox's hard little mouth. It was so nice when Mama would break out in her clear soprano, *"This is my story, this is my song."*

A very special memory is of Daddy coming around on payday; that is, when he had a job. He'd arrive and call out, "Where's my baby?" He was there every Friday with that money because he knew the mountain of anger he would face from my mother if he didn't show up. There was a story that she had put him out once and when he tried to sneak back in through a window, she bloodied his poor head with a cast-iron skillet.

One of my cherished recollections is of tending to my mother when she was sick. I made her a bowl of cornflakes with six tablespoons of C&H Pure Cane Sugar from Hawaii and powdered government milk. She said, "Mmmm. This is really good, Jenny, a little sweet but it's really good." I was so proud of my li'l ol' self!

Looking back, I see how hard my mother worked to provide for us. But throughout my childhood, she was either emotionally absent or swinging her feelings around like a hammer, figuratively and literally. Sometimes she struck people, especially those who were closest to her. And sometimes

she drew blood. Her rage had no end, but then neither did the obstacles she faced.

Dorothy Mae Lewis was never the one to mess with. One day, when I was about six, I held Mama's hand as we walked from Miss Woods's store where Mama had bought a bottle of Coca-Cola. If I had been a good girl, I knew she would give me the last swallow, careful not to let me have too much sugar. Well, out of nowhere, her boyfriend, whose name was Jelly Bean, pulled up in his station wagon and called out for my mother, "Hey, Dorothy! C'mere."

Now, my mother was pretty much the queen of Kinloch, and the one thing you didn't do was summon her to do anything (and y'all wanna know where I got it from). My mother ignored Jelly Bean.

He said, "Dorothy, you hear me talkin' to you?"

She stopped. I stopped. I squeezed her hand a little tighter, because I knew Jelly Bean was in trouble.

She said, "Go on somewhere else, Jelly. Cain't you see I'm with my baby?"

Jelly Bean then made the biggest mistake of his life. He pulled the car over to where my mother and I stood, reached out of the window, grabbed Mama's right arm, and said, "You gonna talk to me right now, Dorothy."

I was still holding her left hand tightly, aware of the time bomb that was about to explode.

It was all over in five seconds with five moves on my mother's part:

Move one: Push Jenny back to safety with the left hand.

Move two: Pull the right hand holding the Coke bottle away from Jelly Bean's grip.

Move three: Grab the Coke bottle out of the right hand with the left hand.

Move four: Swing the Coke bottle downward and break it against the curb.

Move five: Swing the broken Coke bottle upward and damn near slice Jelly Bean's arm off.

Jelly Bean sped away as I peeped around Mama. I saw a trail of blood leading to the corner from where the station wagon had been parked. And in a town as small as Kinloch, we never saw Jelly Bean again. Mama looked down at me and said, "C'mon." Eyes crossed, I grabbed Mama's hand, plugged my mouth with my thumb, and we continued to walk in silence down the rocky road. All I could think was, *Where the fuck is my last swallow of Coke?*

M ama changed my birth certificate so she could enroll me a year early; hence, I was always a year younger than my classmates. My teachers loved me and validated me. I was often called to stand and come forward in class. I was far from a great student, but I was Miss Personality, the class clown, and a natural leader. I was a shining light at school most of the time. Whenever I would bring a sad mood into the classroom, my teachers would notice and listen to me. That's all I really needed.

I joined the Brownies and every after-school activity available. It kept me out of the house where Mama was often on

Little Jenny Lewis, age 6.

Me and Mama.

With my family. *Front row (left to right):* Edward, Vertrella, Wilatrel, Mama.
Back row (left to right): Lawrence, Robin, Jackie, and me.

Five generations *(left to right):* Dorothy Mae Lewis, Wilatrel
Bernice Rice, David Rice Jr., Grandma Neil, and Grandma Small.

"Bring it!" *(clockwise from bottom left):* Bridgette, Tereasa, Karla,
Monique, Debbie, Fannie, and me, in the center.

The love of my life, Miguel Gomez.

Quitman Daniel Fludd III.

My doodle, my brain.

"THE **REIGNING QUEEN**"

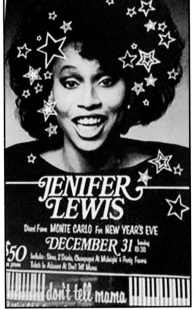

PHOTOGRAPH BY KENN DUNCAN

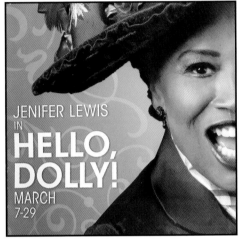

COURTESY OF THE 5TH AVENUE THEATRE

DESIGN BY PAULA SCHER/PENTAGRAM.
PHOTOGRAPH BY TERESA LIZOTTE

GRAPHIC DESIGN BY ERV RAIBLE;
PHOTOGRAPH BY KENN DUNCAN

OF HIGH-CAMP CABARET"

COURTESY OF DAVID ZIPPEL AND JOANNE ZIPPEL

Bipolar, Bath & Beyond at
Los Angeles LGBT Center.

COURTESY OF ALAN MERCER

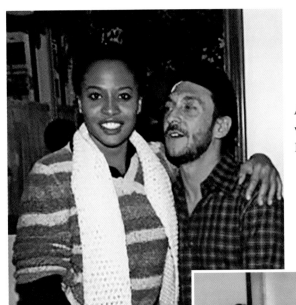

At the *Dreamgirls* workshop with Michael Bennett.

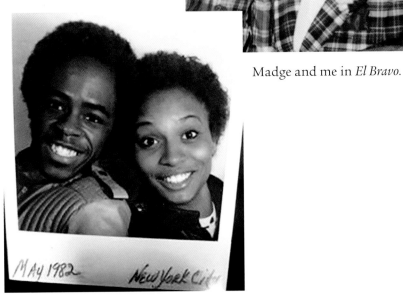

Madge and me in *El Bravo*.

My first "Pip," Cousin Ronnie.

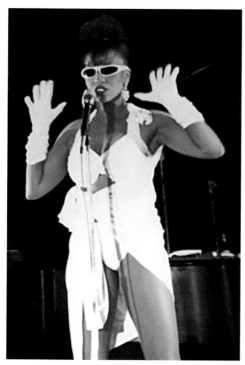

At Don't Tell Mama performing *How I Spent My Summer Vacation.*
PHOTOGRAPH BY MARIA PERATEAU

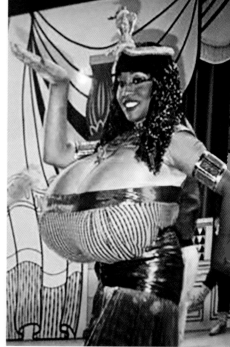

In my first movie, *Beaches.*

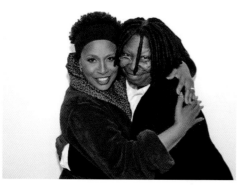

With my dear Whoopi Goldberg.

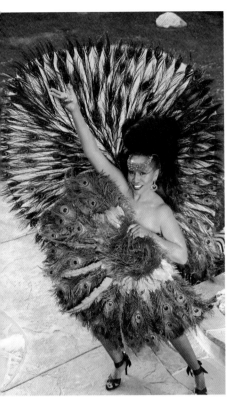

Peacocking in my backyard.
PHOTOGRAPH BY CAMRIN WILLIAMS

High-kicking in *From Billie to Lena with Jenifer* with pianist Keith Thompson.

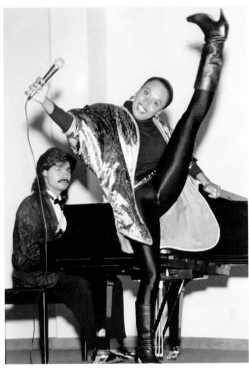

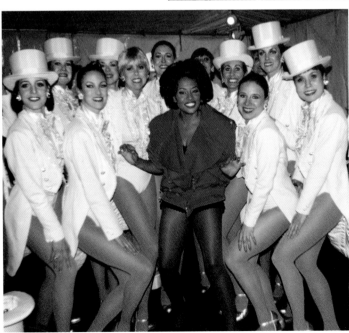

Backstage with the Rockettes at a benefit for AIDS Project Los Angeles.

Gorgeous, yes.
But this is what
depression looks like.

jenifer lewis
will not be
dismissed

On the road with music director Lon Hoyt. (I swear, I didn't touch him.)

Coco from *Jackie's Back!*

COURTESY OF AMY ROSENBERG

RuPaul backstage after my one-woman show.

COURTESY OF MARK MANN

DJ Pierce as "Shangela," and he's my baby boy!

"In These Streets" video with Roz Ryan and Brandy.

At Christmastime, with my beautiful daughter, Charmaine.

Me and Marc Shaiman getting into trouble.

With Mark Alton Brown and Bobby Cesario, best friends since college.

Standing among three of the most powerful people on earth.

With Bette Midler, at the *Hello Dolly!* opening-night party.

At dinner with the masterful Sidney Poitier.

At the premiere for *The Preacher's Wife*, with Penny Marshall, Whitney Houston, Loretta Devine, and Denzel Washington.

Partying with the Great One herself, Meryl Streep.

At the Oscars with Tyler Perry.

One of my many daughters, the amazing Taraji P. Henson.

Fun times with Jennifer Aniston.

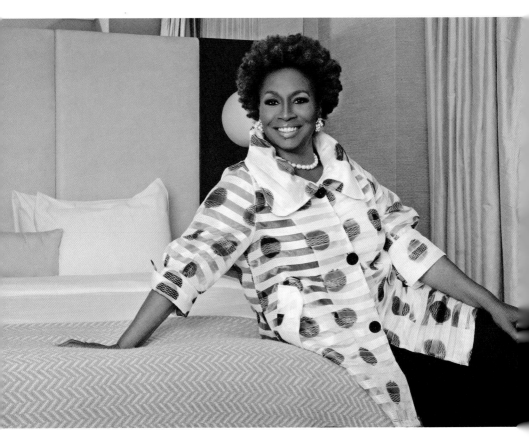

All grown up—Thank God!

A whale shark ... *WTF?!*

Standing with wrestlers
in Mongolia.

Among many beautiful young fans in Ngorongoro, Tanzania.

Anthony Anderson, Laurence Fishburne, Tracee Ellis Ross, and
black-ish creator Kenya Barris, with "Ruby."

Black Lives Matter.

the war path. She'd be bone-tired from cleaning two or three houses on the weekend, or working eight hours at the hospital, and then taking a long bus ride home, only to have to feed us, wash, iron, and sort out how to pay the bills. She was not in the mood for childish foolishness, and I was an overactive, needy kid.

My poor siblings bore the brunt of my hyperactive, mischievous ass. Like when they'd sit on the floor playing Monopoly. I was left out 'cause I didn't have the attention span for anything as boring as a board game. So, I'd make sure Mama wasn't around, and then, ever on a search-and-destroy mission, I'd run across the board, howling "I hate y'all!" as the pieces scattered.

Fortunately, my energy was channeled into sports and I was a pretty good athlete. Still, I often cheated, even going so far as to steal the blue ribbon from the judges' table at a track meet. I felt being number one would gain more attention from my mother. But even when I brought home a blue ribbon, her praise felt short-lived. Mama might smile at our achievements, but she always had other fish to fry.

When I was nine, Mama moved us to a house on Jackson Street. It was certainly a step up; we were overjoyed to have hot water and indoor plumbing. Life seemed to finally settle in for my family, especially because Mama's scrimping and saving meant she came home more often with bags full of groceries, giving us a welcome break from the powdered milk, lard, and blocks of government cheese.

The Jackson house is where I began impersonating movie stars and re-creating the dance moves I saw done by the Su-

premes and the Temptations on TV shows like *American Bandstand* and *The Ed Sullivan Show*. I learned to curse in the house on Jackson, too. But I was careful; I knew a bad word could get a severe beating from Mama. The house on Jackson is also where I first found myself overcome by sadness at night. I didn't think about where the sadness came from or tell anyone. I just would cry into my pillow or while I sat alone in the bathroom. To try to gain control, sometimes I would sing the mournful Mahalia Jackson songs that I loved so much.

The evening before my tenth birthday, we were hosting a meeting of the church's youth group. Mama sent me to the kitchen to wash dishes. As I turned on the faucet, a siren pierced the air, and seconds later every church bell in town began to ring. We Midwesterners knew what was coming. The lights flickered. I looked out the kitchen window, and the sky turned black. Then the biggest flash of lightning I'd ever seen illuminated the magnificent funnel itself. I felt suspended in a dead, quiet calm until the tornado, sounding like a roaring locomotive, snapped me into action. I ran through the short hallway toward the group in the living room as we were overtaken by an unforgettable whooshing noise. The house lifted off its foundation, dumping the youth group kids out of their chairs, and onto the floor. In the darkness Mama shouted, "get to the basement!" We started to run through the kitchen to the basement stairs, but stopped when a lightning flash showed us the glasses and dishes I had been washing swirling around in mid-air, then shattering against the walls. We huddled in the hallway, praying, crying and screaming as

hail as large as grapefruit pounded the roof and spears of wood pierced the walls as if God were using our house for target practice. Finally, silence—that horrifying calm after the storm.

The transistor radio told us we had survived a record-setting winter F4 tornado. Three people were killed in the St. Louis area.

The next morning, Kinloch was in shambles. Our house and our neighbor Miss Woods got the worst of it. It was the wood from her roof that had splintered, and pierced our house. It looked like a porcupine! But I wasn't about to let a tornado get in the way of my birthday. I trailed Mama through the mess, humming, whistling, and singing so she would remember this was my special day. It worked, and I took my five dollars straight to Miss Bubbles's Chinese restaurant. The owner, whose real name was Maddie Sue, had lived in far-away Chicago, and when she came back, she came back with the fried rice. You had to go down a cobblestone alley to the back of her house to order through the kitchen window. I used to love hopping from stone to stone to get a quart-size cardboard carton of egg foo young and fried rice, Chinese soul food–style.

Ultimately, our house was condemned. We moved to a house on School Way, into another basement. It was sort of a step backward, because once again we had to use an outhouse or the tin bucket. We kids rushed to get out of the house every day because the last one out had to dump the bucket in the outhouse. Mama left for work before us and she'd say, "I don't care who does it, but that bucket better be clean when

I get home." The task was especially humiliating because our outhouse was in full view of Kinloch High School across the street. To this day, my siblings tease me with, "Jenny, you never took out the bucket!" And to this day, I still respond with, "But I'm the baby!"

One good thing about the house on School Way was Wilatrel lived upstairs with her husband and children, and I began to experience the joys of being an aunt to little "Peppy" and "Wally Bear." But the best thing was there were no trees and bushes around. Mama couldn't easily go out and pull a switch. She took to beating us with a fly swatter. At least it didn't hurt as much.

By sixth grade, I had acquired a reputation as a charmer and a fighter, much in the tradition of my mother. With the kids on my block and at school, I was large and in charge. I had authority. When Sheila Williams damn near split open her head 'cause she tripped on the double Dutch rope, they brought her to me to see what should be done.

I had no sway in Mama's house, but in the street, I was determined to be the boss. People in Kinloch survived by being strong. Sometimes that strength creates a culture where the response to every challenge is "Let's take this shit outside." You step to people before they step to you: "Jump in my chest, and make a bird's nest" was what we said when we were about to fuck somebody up. It meant *Bring it, bitch, I'm ready*.

I was often quite the bully, but really I had little to back up my sharp tongue and controlling behavior. Sometimes I got in over my head. I teased Evette about a rash on the back of her neck. The next day I carried a kitchen knife, an-

ticipating an after-school fight. I didn't know how to use it, but I was going to try if I had to. A bunch of girls followed me home, with Evette leading the pack and determined to kick my ass. Just so happened that my daddy was riding by in his friend's car when he saw the crowd of kids. He looked a little closer and saw that it was his baby about to get a beat down, despite swinging a knife at her would-be attackers. He stepped right in and carried me out of there. To hear me tell the story the next day at school, I kicked butt and took names. I had the personality to convince everyone that I had won the fight.

Through my involvement with the YWCA and the Girl Scouts, I entered talent shows in Kinloch and the greater St. Louis area and usually won. I was gaining a reputation as a singer and when our choir visited other churches, I became the most requested soloist. These experiences were proof for me that I actually had the talent to become a star.

Around this time, I started to sneak out of the house to go to the movie theater in nearby Ferguson. My siblings and friends warned me not to go to Ferguson. It just wasn't safe for black folks. But Ferguson had a movie theater and Kinloch did not. I would save a couple of dollars, get on the bus, and spend hours alone in the dark watching movies like *Hello, Dolly!* and *Sweet Charity*, which left a lasting impression on me. I could see my future self, and she was on-screen and she was glamorous, just like Barbra Streisand and Paula Kelly.

During my adolescence, we moved into a new house, where I finally had my own room, sort of; it was also the bathroom

for the whole household. But I did have a curtain to separate me from the toilet.

Our household always had an undercurrent of tension, fear, and rage. There were mornings when Mama entered my room, pulled the bedclothes off me, and beat me for some infraction the night before. I was often miserable at home. When I wasn't crying alone at night, I prayed hard for Jesus to come and make everything right.

And then, of course, there was church—the First Missionary Baptist Church of Kinloch, Missouri. We had to attend every function—Sunday school, Bible study, choir rehearsals, junior usher board meetings, and on and on. Church turned out to be a refuge for me because I found many kind women there who took me under their wings, including Miss Parks, head of the usher board, and, of course, my great-aunts Ida and Membry. In addition to singing in the choir, I energetically joined in on all sorts of tasks and projects, basking in the smiles and praise of these substitute mothers.

First Baptist Church was full of drama, much of it revolving around competition for the pastor's attention. My mother, like so many women in the church, was in love with her pastor. The pastor was like the chief of the village infallible, like the pope. Women who lack support and love, who yearn for husbands and self-esteem, often fill the void with church. The problem is that many pastors know this all too well and take full advantage. It's a tired old story that's been played out forever.

My mother maintained good friendships and an active

social life in and outside of church. In 1962, she was a founding member of the Wild Rose Social Club, a dozen women who would get together regularly for the next fifty years. These were hardworking women who cherished a few hours a month to socialize and sip cocktails. And baby, the Wild Roses were fabulous! They would work to out-dress each other, usually in outfits they had whipped up on their Singer sewing machines. I dreamed of being as stylish, hip, and fun loving as these ladies. When the club met at our house, Mama sometimes would call me in to demonstrate the new dances, like the Jerk and the Funky Four Corners (not to be confused with the boring-ass regular Four Corners). The night I showed them the Boogaloo, I knew Mama was proud of me, but also knew she wanted to be the one in the spotlight. Nearly forty years later, Mama said as much when she came to see me in *Hairspray* on Broadway. When someone asked how she'd enjoyed my performance, her response was, "She may have the money, but I'm the one that's funny."

In junior high school, when I was elected class president, I began keeping a journal as an organizing tool. I'd note who would bring the soap and rags to car washes at the local gas station, whose mama would bake a cake for the bake sale, who would bring the record player and 45s for the dance in the basement of the YWCA, and who had lost their virginity.

As seventh grade class president, I was chosen, along with a boy in my class named Lenier, to go on a trip to Okalona, Mississippi with our teachers, Miss Downey and Mr. Griffin. During the trip, I decided Lenier would be the one to take my

virginity. We were staying at the home of a cow farmer. Lenier and I walked out into a cow patch, started fooling around, and soon were naked. Lenier sat in an old, worn chair that was leaning against a poplar tree and I straddled him like I knew what I was doing. He had a dick as hard as the stolen obelisk robbed from the Temple of Karnak that now stands shamelessly in the heart of Paris. I lowered my body onto his. An unexpected pain shot through me. I saw blood and thought I was going to die. Nobody had told me about this part. I had absolutely zero sex education. Once I got over the pain, I began to like it. I felt like I had conquered. Like I was in control.

Later that semester, I started organizing talent shows in the basement of the Catholic school. I'd both MC the shows and perform. I would do two songs, let someone else sing half a song, then I'd come back to do three more. If a song in my act had multiple parts, I'd do them all. At any given time, fifty or more people would pay thirty-five cents admission. Like I said, I admit I took *all* of the proceeds and usually went straight to Miss Bubbles for fake Chinese food.

Everyone at John F. Kennedy Junior High School knew I could sing and that Aretha was my favorite. One day, Mr. Santos, who was one of the few non–African American teachers, saw me with my head down on my desk, crying. "What's wrong, Jenifer?"

I raised my head and said, "I'll never hit those high notes like Aretha Franklin! I'll never be famous!" He smiled gently and continued the lesson.

Three days later, as we changed classes after the bell, Mr. Santos called after me in the hallway. He looked strange: both shaken and smiling. It was weird, and I drew back a little when he started to speak: "Last night when I was washing dishes, I broke a plate. It broke into several pieces. As I bent to pick up the pieces, I had a vision: you will be known, Jenifer. You will be famous in this world."

Mr. Santos's vision wasn't enough. "Do you think I can be a star?" was the question I asked every authority figure, including our pastor. I was in the front seat of his car, getting a ride back to Kinloch from the youth choir's visit to a church in the city. Riding with the pastor was a feather in my cap; anybody would jump at the chance to ride with Pastor Heard.

After I asked the question, my pastor pulled the car over to the side of the road and stopped. He leaned over to me and suddenly pressed his lips to mine. I clenched my teeth and leaned away from him. He persisted in trying to push his tongue between my teeth. He groped for my breast with the hand he wasn't sliding over my shoulder. I tightened up, pressing myself backward as far as the car door would allow. I pushed against his shoulders, and he finally stopped. He scooted back to his place behind the wheel and said nothing as he drove onto the freeway. As we got closer to home and he slowed the car onto an exit ramp, I opened the door on the passenger side to spit. I'd been holding it back for as long as I could, disgusted by the taste of his mouth. He must have thought I was going to jump out. He grabbed me by the left

arm. I snatched my arm from his hand and thought, *Don't touch me, motherfucker!* But I didn't say anything. I had been conditioned to respect and revere my elders, especially my pastor.

I told Mama as soon as I got home. She looked at me and said, "Go to your room." About ten minutes later, she came to my room, pulling the telephone extension cord as far as it could reach. When she got to my doorway, she aimed the receiver at me. She had called Pastor Heard.

"Now tell him," she said, "what you told me." I took the phone. But before I could say anything, she snatched the receiver out of my hand, walked into her bedroom, and closed the door. I was devastated, betrayed by my pastor and my mother.

By the time I entered Kinloch High School, my brothers and sisters were either working, in college or married. The house was quieter. I had fewer people to hide behind so I spent most of my time trying to avoid my mother.

My teachers at Kinloch High School knew about me before I even got there. As my friend Rose Wilson put it: "You were number one, Jenifer, our role model. We all wanted to *be* you." I soon ruled high school much as I had junior high. I was bossy (but not mean). I was captain of the cheerleaders, and no school could bring it like the Kinloch High squad! Of course, yours truly made up all the cheers. "Ashes to ashes, dust to dust. We hate to beat you, but we must, we must!" For the fourth year in a row, I was elected president of my class.

I was fine with my grades, but never got straight A's like my sisters.

We were living in times of great upheaval and promise. A spirit of rebellion could be felt everywhere. The Civil Rights Movement had won some big battles, and the Black Power and anti-Vietnam War movements were ever present, even in our small town and even smaller school.

Racism hit close to home when some men from Kinloch went fishing in Illinois. They never returned and we heard they'd been lynched by the Ku Klux Klan. We never felt far from the threat of those hooded murderers.

"Free Angela!" was our rallying cry when I staged a walk-out in tenth grade in support of Angela Davis, the brilliant young university professor and revolutionary whose huge Afro and miniskirts were unforgettable in the photos that captured her on the news. Davis's image hung in the homes of black people as a hero and in the post office on the FBI's list of the Ten Most Wanted Fugitives.

Now, in January 1972, Davis was being held without bail on charges of murder and conspiracy because she had purchased guns that were used in a courtroom shootout in Marin County, California, about a year and a half earlier. The shootout took place during the trial of George Jackson, a Black Panther and political prisoner who became famous as one of the Soledad Brothers. Angela wasn't a member of the Panthers; she was in the Communist Party, which was just as bad in the eyes of the FBI. She was also in love with the compellingly brilliant Jackson, who died, along with five others, in the courtroom tragedy.

Mind you, I had no knowledge of these details when I organized the walkout. I knew that Angela was a powerful black woman. I loved her Afro and had begun to wear one myself a few months earlier, as had my mama and some of my sisters. When I heard about the nationwide protest on the black radio station that morning, I was ready! With my big mouth and social power, it wasn't hard to get most of the students out of their seats.

When Davis was acquitted of all charges a few months later, I don't think I was aware of it. I was consumed by a million activities for church and school, staying out of the house as much as I could.

There was one teacher who didn't like my take-charge attitude and tried to take me down a peg when she could. She took my gym uniform and threw it on top of the lockers where I couldn't find it. Losing possession of your uniform could earn you an F. I had put my uniform on the bleachers next to my books while I went in the hallway and held court with some fellow students. When I went back to get my stuff, my books were there, but my uniform was gone. My name was sewn inside the collar, so I knew no one had stolen it.

After looking everywhere, I climbed on a chair so I could see the top of the lockers. My uniform lay in the dust and cobwebs. I was mad, but I shook the dust off and emerged with my uniform looking sharp and my nicely shaped Afro intact.

JOURNAL ENTRY: Got her ass! Bitch. I am Dorothy Mae Lewis's daughter. You can't come for me and win.

Just before my junior year, my mother's hard work and determination paid off in a big way. Jackie, Robin, and I discovered there was an empty split-level house on Smith Street. It belonged to a man who bought it for his family shortly before he lost his job. As a consequence, he had to sell the house.

In the days after Mama learned this, she prayed that she could qualify to buy it. She had been saving money while trying to get us into a housing project, but she heard someone had blackballed her. Her application for the project apartment was rejected, but she got a mortgage to buy the house. She cried some happy tears then.

The house was brand new, with four bedrooms and not one but two bathrooms. I shared with Robin—who was on her way to Lincoln University, in Jefferson City, Missouri. Vertrella and Larry were already attending Lincoln. Wilatrel had moved out of Kinloch with her husband, David, a Baptist minister. Ba'y Bro was at Florissant Valley Community College and Jackie got married shortly after we moved in.

I found my first job with the Neighborhood Youth Corps, cutting weeds, clearing out lots, and picking up litter. From time to time I would babysit Wilatrel's children. One of the kids broke my mother's stereo. My mother said to me, "You're going to pay for that." I responded with "No, I'm not." She slapped the shit out of me and said, "You forgot who you were talking to." I was so mad, I was ready to walk. I had saved $30 and planned to take a bus somewhere. Sister Robin was sitting on a lawn chair reading a magazine when I walked down the driveway with my stuff packed. She

didn't even look up when she said, "Jenny, don't do it." She knew that if I walked out of our yard, Mama would come for me and it would not be pretty.

The fall of senior year, I sought to complete my perfect record as class president for six years straight. My opponent, Dickie (one of my ninety cousins), was the smartest in our class, but I figured I was a shoo-in to win. I was the one who ran the car washes and bake sales that funded our junior prom. For years, I had organized our dances, and as a consequence, I had to work through them while the other students partied. I figured the classmates who liked me would surely vote for me and the ones who didn't would be too scared not to.

When the votes were counted, I had won, but by only one vote. Again, I felt betrayed. I cussed out several friends for their lack of loyalty.

That night I cried myself to sleep as I thought about what happened. But I didn't need a reason to cry into my pillow. It had become habitual, comforting almost. Here I was the shining star at school, but wracked by sadness at night. I was disappointed that my prayers to Jesus had been unanswered; it made me feel unworthy. I began to pray to my friends, in particular Mary. Unlike Jesus, she at least seemed to like me.

Midway through my final semester, I met a guy at the Northland Mall. He was a few years older, wore a sharp blue suit, had a gold front tooth, and was called—wait for it— "Goldie." I was enthralled. We went on a few dates, and he taught me how to drive. He asked me for money, telling me

he needed $50. I gave him $35. It made me feel even closer to him. Finally I went to his apartment and we had sex. I couldn't feel his small penis. I actually couldn't tell if it was in or not. Midway through, I felt him do something down there, but I couldn't tell what. Later, I figured out he had broken the condom.

My guidance counselor, Miss Butler, gave me the moral support I needed when I went to her crying about my plight. She helped me arm myself to tell Mama. The first thing I said to Mama was, "It's gonna cost two hundred dollars. But I have it. From the gifts." A few of my teachers had given me money for my upcoming graduation. They were women of modest means themselves, but they held great hope for me. They believed in my dream. Of course, Mama was disappointed, but she didn't dwell on it. I guess she sort of expected it.

I wasn't valedictorian. Dickie was. But I was chosen as one of the speakers at our graduation. It was a crowning achievement for a girl who'd been elected class president, voted class clown and most likely to succeed, and dubbed "the loudest" (what a surprise!). I delivered my speech with all the fervor and dramatics that I could. I stood before my classmates and their families, my fist raised. "Now is the time to move forward and go out into the world," I proclaimed. Two months later, I left Kinloch for Webster College and my life ahead.

The summer after my freshman year at college, Mama wanted me to come home, but I felt my place was out in the world, not back in Kinloch. I decided to stay on campus and get a job at a nearby McDonald's. After two days of cleaning

toilets and mopping floors, I begged the manager to change my duties because "I am going to be famous." He assigned me to bun detail. All I had to do was lower the toaster onto the buns, wait for the beep, remove the toasted buns, put the next batch in, and lower the toaster again. Easy enough. But then I began telling my co-worker at the beverage station about my future as a movie star. I described the songs I would sing, the shows I would do, and the awards I planned to win. The toaster beeped and I lowered it while continuing to talk. It beeped again and I lowered it again, never missing a beat in my monologue about my future success. Suddenly, flames shot out from the toaster and the buns turned to charcoal because I had lowered the toaster on the same batch about four times. I was fired on the spot. After that, ladies and gentlemen, I never had a job outside of show business again.

Kinloch receded into my past as the years rolled by. I grew closer to my siblings and was grateful when I could make it home for family reunions, kids' birthday parties and graduations. I returned for the sad times as well. Years later, when I was living in Los Angeles, the phone rang at 5 a.m. It was my niece calling from Dallas, Texas. She said, "Aunt Jenny, my daddy had a heart attack this morning," and then she screamed, "AND HE DIDN'T MAKE IT!" I, of course, flew immediately home to comfort Mama and siblings. Dear God, our Ba'y Bro, Edward James Lewis Jr., was gone. Ba'y Bro and I were never super close, but in my travels, I would always plan a layover in Dallas to visit him and his beautiful, sweet wife, Annette, and their amazing two children, Eddie and Ashley.

At Ba'y Bro's burial in Texas, I admitted to the crowd that I had stolen quarters out of the drawer where he kept his tips from working at the Ramada Inn during 1966. I apologized to him that day, confessing I had been driven to the crime by my addiction to Hostess Twinkies.

TEN

"IT AIN'T THAT KIND OF CALL, MOTHERFUCKER"

Fifteen years had passed since I had left my hometown when Rachel, my therapist, began to help me explore the details of my childhood and my relationship with my mother, despite my protests. At this point, Kinloch was a ghost town, sold off to the airport and its residents scattered around the country. Rachel had broken the shell; she cracked me open with her questions, and over the next few months I began to talk about Mama. Rachel did not see me as an alpha woman, head cheerleader, or Broadway star with ferocious talent. She saw me as a little girl—stuck in child-

hood pain. Her sympathetic response allowed me to begin to trust her and the process. I felt that Rachel liked me and that she could, and would, help me find those answers I'd been seeking for so long.

To say therapy was difficult is an understatement. The sadness and anger I felt while talking to Rachel permeated every moment of my life for months. During some sessions I could not speak; during others I lay sobbing on the couch, exhausted from digging down to the roots of my pain. Therapy became a burden. Just a couple of months into it and I was through! I just did not feel like having another big crying jag in that little fucking room. One Tuesday afternoon I lay with the bedcovers over my head, depressed and dreading therapy. As the hour approached, I decided I wasn't going and allowed myself to drift back into catatonia. Six minutes after the appointment time, Rachel called:

"Jenifer, are you on your way? Did you forget we had an appointment?"

"Wha? Huh?"

"You are supposed to be here in my office!"

I couldn't believe she spoke to me so directly. People rarely confronted me in that way.

"I, um, I don't feel so well."

"Jenifer, it is disrespectful for you not to show up or call."

"I am still in bed and I am very fucking sick!" (Lying ass.) "What do you want me to do?"

Of course Rachel knew I was full of it. She said she expected me in her office pronto. During the entire drive there,

I grumbled to myself about how unfairly I was being treated and how it was all bull anyway.

When I arrived, Rachel said, "You have twenty minutes left." I felt like a damn fool, but I respected her for not taking my shit.

Slowly, Rachel helped me to comprehend that the emotional scar tissue from my childhood had grown thick and heavy, blocking my ability to move forward in my life in a healthy way. She brought me to see that my mother's rage was not my fault and that my own rage was a replication of my experiences with Mama.

JOURNAL ENTRY: The reality of the darkness I've lived through is staggering. I have Mama's anger. I go off on people just like Mama used to go off on me. I just want to be better. God, please help me to stop being so scared all the time.

I learned that treatment is not a smooth, straight path. I would see bright moments but then become filled to the brim with anxiety and sadness, resolving it all in a drunken streak. My discussions with Rachel unearthed long-suppressed feelings that showed themselves in horrible dreams, my tears falling before I could wake. One time when I fucked up an audition, I threatened to quit and leave the country for good. Rachel said something to me at the time that turned a light bulb on in my mind: "When you're running, Jenifer, you take yourself with you."

There was more. It wasn't just about my mother's anger, our poverty, or feeling unloved. Rachel told me what I had refused to admit to myself as I'd watched the movie *Frances*. She explained that I had a mental illness, more specifically, bipolar disorder. I sat there, confused and skeptical, as she talked about the disease, which formerly was called "manic depression."

According the American Psychiatric Association (APA), "people with bipolar disorders have extreme and intense emotional states that occur at distinct times, called mood episodes . . . [that are] categorized as manic, hypomanic, or depressive. People with bipolar disorders generally have periods of normal mood as well. Bipolar disorders can be treated, and people with these illnesses can lead full and productive lives."

Say what now? Did she say "disorder"?

I had never heard of the term *bipolar*. *Okay, well, if white people need to give this bullshit a name, whatever.* I thought about poles, about opposites, about the Arctic and Antarctic.

I was dumbfounded when Rachel characterized my behavior as *extreme*. Had she said "you're crazy," I would have agreed. I had been crazy all my life. And when she said *mental illness*, I thought, bitch, *you* crazy. I associated mental illness with people who couldn't function, with raving lunatics in straitjackets. What was I doing in therapy, anyway? Black people don't go to therapy!

Rachel told me that medical science believes bipolar disorder is partly caused by an imbalance of brain chemicals called neurotransmitters, such as serotonin and dopamine. *Neuro what? Dopey who?* She said these neurotransmitters

affect our moods. Well, I certainly knew what a depressive mood was, but this other "manic" part was new. When Rachel explained the details, I gasped. She described me to a "T." *Mania? So that's what y'all call it?* You mean, there is a name for describing why I'm loud and talk fast and walk fast and feel like my brain is racing a million miles an hour? Is that why I rage, create drama, and speed when I drive?

Compulsive, you say? The incessant doodling, the endless braiding and unbraiding my hair? Impulsive? The arguing with people and storming off? Kicking shit, throwing shit? Yeah, okay, I guess all of that describes me, but . . .

Rachel broke it down for me because the concept of "mania" is sometimes more difficult to understand than the idea of depression. The American Psychiatric Association has the following definition:

> Mania: A distinct period of abnormally and persistently elevated, expansive, or irritable mood and abnormally and persistently increased activity or energy, lasting at least one week and present most of the day, nearly every day . . .

Whoa, whoa, wait a minute! "Abbie Normal"? Like in *Young Frankenstein*? I was uncomfortable and resistant, but I kept listening as Rachel talked about the symptoms that may occur during a manic episode:

1. Inflated self-esteem or grandiosity

Well, if I don't pump myself up, who will?

2. Decreased need for sleep

That's not me. I get at least eleven hours a night!!

3. More talkative than usual or pressure to keep talking

Yeah, I do sometimes feel like I just have to keep spouting off, or singing or cracking jokes.

4. Flight of ideas or subjective experience that thoughts are racing

Damn! Well, I guess I have sometimes felt like I can't catch up with the chaos in my brain.

5. Distractibility (i.e., attention too easily drawn to unimportant or irrelevant external stimuli)

I admit I've always had the attention of a fruit fly.

6. Increase in goal-directed activity

Look, I get things done! Something wrong with that?

7. Excessive involvement in pleasurable activities that have a high potential for painful consequences

Wait, what? So I like to drink a little, smoke a little, and get laid. Doesn't everybody? I mean, it's not like I ever did hard drugs.

Even though I resisted the definition of manic symptoms, I had to admit a lot of it described things I had been experiencing my entire life. Especially that last symptom about pleasurable activities. Rachel explained that people with bipolar disorder seek to relieve their depression or manic feelings by "self-medicating" with behaviors that temporarily may impact the balance of neurotransmitters in their brains. Actually, everybody does this. I mean, how many people do you know who smoke weed or drink wine every night when they get home? They do it to feel better. But because the brain chemistry of people with bipolar disease is out of whack, their relationship with their drug of choice gets out of whack. People with bipolar disorder typically self-medicate with gambling, food, drugs, alcohol, even overspending. Often it's a combination of several of these.

My addiction was sex. I was a high-functioning addict who needed regular orgasms in order to get those neurotransmitters flowing. I heard Rachel and knew she was right. All of this described my life, my moods, my behavior.

I began to realize that my hypersexuality was intertwined with my upbringing, bipolar disease, and my conflicted feelings about men. Just as alcoholism isn't really about the liquor, my addiction wasn't really about the sex. It was about the unresolved psychological problems that caused me pain. Sex was simply my painkiller.

By the time I entered therapy with Rachel, I had had more sex partners than I wanted to count. Therapy helped me understand why I felt compelled to have sex and how I used orgasms to prolong the joy and fulfillment I felt on stage. I

knew from a young age that orgasms brought me peace, comfort, and relaxation. Now I had insight about the psychological and biological reasons behind it all. I do not feel ashamed about my sexual history. I'm just amazed that I'm still alive and healthy.

Let me stop beating around the bush and share this little ditty:

ODE TO THE MEN

There was hunky Butch, Nasty Bruce, and silky sexy Lenier
The Ethiopian in Boston who had to put it in my ear

James had a tongue as long as the Nile
John was high yellow with the sexiest smile

Lenier was my first at the tender age of thirteen
Caught him with Phyllis—that sad Halloween

Dexter was my army boy, we did it on two chairs
Keep it down, fool, my mama's upstairs

There was Jessie, Jeffrey, Jimmy, and a dancer named
 Little Joe
Who lay me down, flipped me over, but didn't dent my 'fro

Gary pulled my hair and had me in the closet
Maurice served up a beer can, no return, no deposit

Sawyer, Sam, Gregory, Tucker, Eric, Adam, and Ken
In the words of Sly Stone, the butcher, the baker, the
 drummer, and then

On tour in Detroit in the middle of a blizzard so they had
 to cancel the show
He introduced himself as Scoobydoo. Scoobywho?
Scoobydoo, fuck it, let's go!

The businessman, the boxer, and the one in the sauna
I beckoned him with my titties, "com'ere baby—you, you
 wanna?"

On top the Empire State Building—yes even up there
Was anybody watching? Cha, please! I don't care!
Don, Ron, Tyrone, Tyrell, and I remember Rocky smoked a
 pipe
But it was Perry, ooh Perry, ooooh Perry was just ripe

There was a Mr. Gold, a Mr. Blue, and Mr. Green had lotsa
 dough
Had them in Minnesota, North Dakota, and yes, I confess
 Idaho

Phillip, Peter, Paul, oh yeah, and that crusty Brit
Was it Jeffrey? No Nigel. No Ed. No Fred. I'm gittin sick a
 dis shit

There were some STDs and pregnancies, and y'all know I
 didn't give birth to no kids
The recklessness, meltdowns, and chaos left me on the
 skids

This madness lasted throughout the decades of the eighties
I shared it in order to express to you ladies

Back then I didn't know my body was a temple—how
 precious and fragile we are
I was blind, crippled, and crazy—desperate to be a star

Oh, but I got up somehow, and scrubbed most of it away
Left a little funk on me—so I'd be stronger on this day

No shtick
Still love dick

I can joke about my sex addiction now. But trust me, there
was nothing funny about it. It was sick, compulsive, danger-
ous behavior. My discussions with Rachel about depression,
mania, and sex addiction were extremely painful. But Rachel
said that if I made a commitment to stay with the healing
process through the long haul, I could, in fact, become a joy-
ful person. Joy? I made other people laugh for a living, but
had never actually considered that I had a right to full-out
happiness myself.

Rachel suggested that I begin journaling. I told her, "Well,
you know, I've been keeping a diary all my life." Rachel said,
"Really? That's probably one of the things that has saved
you." Expressing my thoughts and feelings on paper was one
of the best habits I developed on my own. I wrote, doodled,
and drew in my journals, chronicling my experiences, sorting
out problems, writing my history. I could always be more ad-
venturous when I was alone. Every day was a different drama.
When you live in that drama, you stay in that drama. It be-
comes a habit. My journal entries were dramatic, but at least
they were honest. Now Rachel wanted me to process it all.

My sessions with Rachel transformed my journaling and doodling from pastimes into actual tools I could strategically employ to help myself through the difficult process of getting well. To write about my painful feelings, to illustrate them in many colors, would help me to experience them more deeply. Fully feeling and acknowledging my painful feelings could prevent me from acting them out—either toward others or myself. My journals from this period show how I was my own harshest critic. I contradicted myself at every turn. Being manic and crazy one minute, then grown up, realistic, and even wise the next.

> JOURNAL ENTRY: It's not so much stardom I want anymore as it is that I just want to feel better. Be better. I wanna stop trying to prove I am somebody and be somebody. I'm dramatic even as I write this. Let go baby. Nobody's gonna hurt you anymore.

Becoming a star was once my highest goal. My talent for entertaining people, making magic with my voice and my whole self as a performing artist, was the gift God gave me above everything else in life. I thought that if I worked hard enough, the challenges God gave me—poverty, abuse, lovelessness—would fade away.

I had been in therapy just a few months when Mama sent me a printed program from an event at her church. When I saw Pastor Heard's name, every cell in my body reacted. A numbing sensation engulfed me. I went out and bought a bottle of hard liquor. I got drunk. I held myself together enough to call

Mama and ask for Heard's number. She hesitated. So I said, "I want to ask him about a scripture." I knew that she knew his number by heart.

I called Pastor Heard.

"Hello."

"This is Jenifer."

"Hellooooo, Jenifer! We saw you on television! Oooooh, we're all so proud of you!"

"It ain't that kind of call, motherfucker."

He was silent.

"You still fucking with little girls in your church? Listen to me. If you hang up that phone, I'll fly there and kill you! Why did you do what you did to me?"

"When I kissed you, Jenifer, I was trying to show you what you might run into in Hollywood."

"You sick, twisted motherfucker. Do you realize that in those ten seconds that you touched my body, kissed me, and felt me up, you took everything from me? And you still call yourself a man of God? Just know if you hang up and don't let me get this out, I will blow your stupid, pathetic, little storefront church to pieces with you in it!"

"Am I allowed one word?"

"What, bitch?"

"Sorry. I am sorry."

I continued to attack him and wanted to tell him to go straight to hell, but strangely, I felt his remorse. His apology did not lessen my disgust for him or rectify the damage he had done to me. But, confronting him was liberating. My conversations with Rachel about the molestation became easier.

Ultimately, after many, many months, I was able to come to terms with the molestation, to acknowledge that it was evil, to feel my anger and sadness about it and to recognize that it was not my fault. Y'all, confronting Pastor Heard felt so good in terms of standing up for myself as a woman. I promised myself never to keep another secret. And I want other women to know they can stand up and must stand up to their persecutors. Feel the fear and do it anyway! We are all as sick as our secrets, y'all. Remember that shit.

In early December, I flew to Columbia, Missouri, to perform in a short run of *Ain't Misbehavin'*. When I picked up the phone in my hotel room late one night, it was Mama.

"Hello?"

"Jenny, your daddy's dead. When can you come home?"

I was devastated by the heartless way in which my mother told me of my father's demise. She had once told me she detested him. But it was me she hurt. He was my daddy and she was not respecting my feelings. I rented a car and drove the two hours to St. Louis for my father's funeral.

I've never known a funeral that didn't bring surprises. When I walked in the house, I recognized everyone in the family except one person: a ten-year-old boy who looked just like my father. My family had received him with open arms, and so did I. The funeral was sad. Having not really known my father, I was unclear about what I felt or should feel. Some of my siblings were closer to him, and I spent most of my time comforting them. My mother sat in the front row at the fu-

neral service, of course. Though they had been separated for thirty-three years, they never divorced. So there she sat in a full-length mink coat while the mother of the young son sat in the back of the church.

The morning of my father's funeral, Mark Brown called and told Mama that Quitman had died. Thank God Mama was merciful enough to hold the news until the repast after the service.

I went into the old bedroom that was once mine. I curled up on my old bed. Surprisingly, I smiled at first—God, help me—remembering every salad Quitman had made. Every piece of toast he had meticulously spread butter on, careful not to miss a spot. Every tight T-shirt he had squeezed his perfectly formed body into. I lay there and could still feel the deep compassion he showered on me when I'd burst into his apartment, wailing about some lost man, some lost audition, some note I couldn't hit, some lyric I had missed. But when my mind wandered to the last time I had seen him and those purple lesions covering my baby's face, I lost complete control and sobbed into the night.

Rest in peace, baby. They'll never tell you no again. Nobody will ever call you a nigger again. And all the suffering is over. I will love you into forever.

I returned to Columbia, Missouri, to finish the run of *Ain't Misbehavin'*. When the show closed, I went back to Kinloch and confronted my mother for the first time in my life. I had learned a few things in therapy: (1) to protect myself; (2) not

to let horrible things invade me to the point that I would lapse into a deep depression; and (3) to just tell the truth and get shit out on the table.

I used the courage therapy was giving me to confront my mother. She was washing dishes. I said, "The way you told me Daddy died was not right."

"It was the only way I knew to tell you."

I didn't feel that was apologetic enough and after months of working on myself in therapy, I was not afraid to let her know how I truly felt. I had come to understand that my fear of my mother was no longer necessary because she was the one who was really afraid.

As we stood over the kitchen sink, I looked her dead in her eyes and I said, "Mama, I am going to ask you: if something happens to one of my sisters or brothers, please tell me to sit down first. Or warn me that you have some bad news."

I don't think anyone had ever talked to Mama like that. And, frankly, she was not fazed. But after so many hours discussing my mother with Rachel, I understood that my mama could never admit that she had been wrong, 'cause then she would have to feel remorse. Her life, her circumstances, had mostly blotted away all feelings but anger or disdain. Perhaps it was survival. I tried not to judge her, but I had made my feelings known and could now choose to be my own self. I was growing up and went back to Los Angeles proud of myself.

Rachel suggested I try to resolve some of my issues by writing letters. "You don't have to mail them, but sit with your feelings. You can burn them afterward if you want."

I wrote everybody I could think of, avoiding my mother.

However, after several more sessions, I finally conjured up the nerve.

As Rachel had promised, putting my feelings in a letter was very helpful. A few days later, I read her the letter.

> *You worked very hard to keep us fed and clean. And I appreciate that very much, Mama. You sent me to school. But you never checked to see if I was learning anything. Where were you, Mama? I don't even remember you helping me with homework. Nor sitting and just talking to me about anything. You only demanded this, beat me for that, then went to your room. You just used us to serve you, to worship you. Like animals without souls. I had a soul, Mama. I was a child. You were supposed to love me, not beat me at every turn.*
>
> *I've been wanting to write you for a long time. Talking on the phone about these issues doesn't work for me because I slip into being a child. And the child in me is afraid of you. Because of the physical abuse and lack of compassion you imposed on me, Mama.*

I knew that what I had to say to Mama would hit her hard. Our instinct is to protect our mothers, but therapy had eliminated those blinders and allowed me to see that Mama had a responsibility to deal with the truth.

She hated that I used the word *abuse*. She didn't think of her tough love and no-nonsense discipline as abusing her child.

Our family had inherited Grandma Neil's rage, Grandma Small's rage—the ancestral memory of rapes, molestations, be-

trayal, theft, lies, and secrets. But, as Maya Angelou said, "When you know better, you do better." Or you should at least try.

The letter went on:

> *I have suffered unspeakable neurosis and psychosis. I've been a manic-depressive for years. Your rage made me unable to have healthy relationships with anyone, let alone a man.*

I questioned whether her motive for sending me off to school a year early was as much to get me out of her way as it was to assure that I would have a good future.

My words were harsh, but genuine. I saw her as a monster, and I used that word. I said that she "raised us like animals." I went there, and it was hurtful, but in my mind it matched how she hurt me.

> *Something horrible must have happened to you, Mama. What? I now know many things, and I assume other things I don't want to imagine.*

You buried us in the Baptist Church, I wrote. And I talked about Pastor Heard. *Surely if we'd ever had a mother, we lost you then. You poured your existence into this fucking man. Mama, did you know he, in different ways, tried to seduce or molest many of the girls at church?* I accused her of being so desperate *to be somebody to him and the church* that she overlooked what he was doing to the women in his congregation. *To this day you sit up in his church listening to this man refer to women as whores if they have sex before marriage. And yet.*

I told Mama she should have gotten help, suggesting that she was emotionally and mentally ill as well. I didn't consider that in the time and place I grew up, there was no mental health system, no social safety net. Even among educated people, psychiatry was suspect. Being mentally ill was something else you kept secret, if you could. If you couldn't, you suffered on top of the condition, being shamed and treated even worse by your family and neighbors. Nobody wants to be called "crazy" for real.

Then I shared something that she didn't know:

> *I became one of the biggest whores I could, Mama. I've slept with over sixty men. You see, I felt you gave me away to Heard . . . if you didn't care, why should I? I threw away my life. I blocked my childhood. I numbed out to survive.*

I told Mama that therapy had led me to an important realization about my career:

> *Every time I'd get close to success, subconsciously I'd sabotage it just to hurt you because my success would make you happy. Deep inside I hated you because I felt you hated me. Couldn't you see how unhappy we were? Can't you see it even now?*
>
> *I'm just now getting myself together to start living, not just surviving; laughing and not pretending, learning and not running away from my problems. This process is painful, Mama.*

I closed the letter with a plea for her honesty and respect. When I finished reading, Rachel said, "Good work. Now,

it's your choice if you want to mail it. This is your work, Jenifer. Your decision."

The letter was an incredible release, a breakthrough. I decided to send the letter. For more than two hours I sat in the parking lot at the post office holding seven letters: one for Mama and copies of the same letter for each of my siblings. We think we're going to kill our parents by confronting them. But people, including our parents, are often very much able to hear the truth. They may not take it well, but nobody dies from honesty.

T he first time Mama and I talked on the phone after she received the letter, she was subdued. She called back the next day and we wound up screaming at each other.

My siblings gave me varying responses. One sister didn't have memory of a lot of the behavior I described and was not having it. She didn't want anything bad said about Mama. A few of them agreed and were pleased I had led the charge because they weren't ready to. Ba'y Bro didn't want any drama and reminded me that "everybody got a beating in Kinloch." He said, "You leave Mama alone, Jenny!"

I actually expected harsher blowback because where I come from, you can't talk about people's mamas unless you're playing the dozens, and then you better be superfunny.

But at some point you have to tell the truth.

The letter did accomplish a few things: first, it ushered in a new level of respect among me, my siblings, and my mother. It opened new lines of communication and the family began

to have meetings to air out repressed secrets and emotions. I joined by phone. The letter was a big accomplishment for me, proof that I was learning to feel the fear and do it anyway.

Mama didn't change at all, but she did at least listen to what we had to say about the whole matter. Months passed before I was back in Missouri for Christmas. I was grateful that no one brought up the letter. I had relative peace in my mama's house during the visit. After all, how much can we all take at the holidays? They're stressful enough.

DISMISSING THE DIVA

Within the year, my sessions with Rachel increased to twice weekly. As the hours of therapy added up, I was becoming better at identifying and managing my feelings. My sex addiction lessened. When I'd begun therapy, my lovers were Tim, Adam, an actor named Sam, who, let's just say, liked it from the side, and Roger. I still enjoyed sex but felt less compelled to use it as a way to feel better.

I relished being more in control of myself. I had relapses. No trajectory is straight and we fall back on bullshit excuses, fear, and confusion. Rachel called it "dropping the ball." I would also throw the occasional pity party for myself.

JOURNAL ENTRY: I have no baby, no man, no show, fuck 'em.

On the other hand, I was determined to get well. As proof of my resolve, I kept my resolutions for the New Year. Starting in January 1991, I went 19 days without a cigarette and 167 days without sex. By the end, I felt hopeful. I was doing hatha yoga twice a week, playing racquetball, and doing aerobics at the gym. I worked on myself, but it was a circuitous journey. I still sobbed at night and had nightmares about Pastor Heard wanting to fuck me on a piano stool. Having Rachel in my corner made a huge difference, but it was clear to us both that I had a long way to go.

I went to a party at Marc Shaiman's house and got drunker than I had ever been. Bette Midler was there, and I sort of swaggered over to her and breathed red wine fumes in her face. Real loud, I said, "Why don' ya take c-c-care of yer Harlezz, Bette?" Needless to say, she left the party immediately. It was horrible. I was rude, loud, and ridiculous. I did a lot of apologizing the next day, to many, many friends, especially Bette. She definitely did not deserve to be on the receiving end of my acting out.

Living with my own bad behavior was painful enough, but then I was obliged to tell Rachel about the incident. Openness and honesty with your doctor is crucial to healing, but it can be so damn hard. "How much did you drink?" Rachel asked. I didn't admit to her how much I really drank at that party. I couldn't. She cut me no slack on what I actually *did* admit to her. She helped me to further understand how

to avoid a repeat of the situation; to recognize the warning signals. We discussed how I might shortcut my insecurities before they led me to do something I'd regret and dig myself into an emotional hole. I was so ashamed of myself.

I was pretty good to my body, eating clean, working out. As an actor, my body is my instrument, and with that in mind, I practiced a healthy lifestyle during the week. But I was challenged by the lack of structure a nine-to-five kind of job provides. Actors work long hours when we're working, but we have lots of time to fill between jobs, without always knowing how. Idle hours made room for too much drama, getting into everybody's and your own shit. You get in trouble. And when you find yourself in trouble and causing trouble, you still have to come clean and tell the truth to your therapist. Feel the fear, and tell the truth to yourself.

During the two years that I'd been in treatment with Rachel, she had shown herself to be a sensitive and compassionate person. Yet I was unable to look her in the eye when we talked. I had trust issues and fear. I was afraid that my wounds were so deep that no one, certainly not me, could heal them. I was slowly warming to her, but not completely. Some sessions were better than others.

On my good days, I was talking more and more, exploring issues of intimacy, or rather the lack of intimacy I had growing up. I was self-reflective. I learned that feelings of omnipotence and displays of grandiosity occurred because inside I felt unworthy much of the time. I pondered my pattern of selecting men to date who were really sad little boys. I guess the reason was that I was a sad little girl.

As I grew and learned, my inner diva was summarily dismissed and effectively humbled. My new reality informed the title for my new one-woman show, an autobiographical comedy and music show, *The Diva Is Dismissed*. There were never enough opportunities for me in the industry, so when they didn't call I wrote my own stuff. I wanted to work, tell my story, show what I could do. I enlisted the help of my brilliant and talented friends, writer-director Charles Randolph-Wright, Mark Alton Brown, and music director Michael Skloff.

The show was about the search for self, about removing the diva mask and becoming an authentic person. It chronicled my failed relationships, my journey from New York City to Los Angeles, and my difficulties transitioning from live performance to television and film. Ultimately, the diva character, who is me, acknowledges: "I didn't want to hurt anybody. I wanted to be somebody."

Lyrics for the show included *I got to climb this mountain. And it's big, scary, and tall. I don't want to fall. . . .*

We opened at Off Vine, a lovely, turn-of-the-century bungalow that had been converted into a relaxed, yet elegant restaurant in Hollywood. We chose a nontraditional venue because we wanted the show to feel sort of underground—something special, something different. It was a great success with audiences and critics.

After a few months, we took the show to the Hudson Backstage Theatre on Santa Monica Boulevard. We ran there every Sunday evening for about seven months. The production

would never have made it to a theater like the Hudson without Gay Iris Parker, one of the gentlest and purest people I'd ever known. Gay was a publicist for the Pasadena Playhouse. She saw my show at Off Vine and then pulled some strings at the Hudson. I was very grateful for what she did for me. Gay became a close friend, a confidante who loved my crazy ass through seventeen years of sisterhood until she passed away.

My one-woman shows have earned me my most loyal fans over the years, especially among my fellow artists. When Sidney Poitier saw the show, he said, "My daughter told me that you were wonderful. My dear, that was an understatement. You are fucking magnificent." Thank God someone was there to catch me when my knees buckled.

We sold out every Sunday night. People crammed into the ninety-nine-seat theater. There were nights when I heard the stage manager say, "They're fighting over the seats out there." I lost track of the many celebrities and actors who saw the show: Lee Daniels, Chris Callaway, Malcolm-Jamal Warner, Jackie Collins, Sandy Gallin, Mavis Staples, Sheryl Lee Ralph, Rosie O'Donnell, Bebe Neuwirth, Denzel and Pauletta Washington, Carol Lawrence, Bette Midler, Phylicia Rashad, and Bea Arthur all came out to see me.

Some of the show-business big shots who saw what I could do offered me work. Director Lee Rose was in the house one night and went on to cast me in three of her movies.

Seeing Lena Horne in the audience one evening, I didn't even exit the stage when I finished. I just ran into the audience and hugged her so tight! She whispered in my ear, "You are

the fucking best." *Hmmm*, seems the word *fucking* comes up a lot when people describe me.

My friend Attallah Shabazz, the eldest daughter of Malcom X and Betty Shabazz, brought Nina Simone backstage to meet me. Miss Simone was draped in what looked like a monkey coat. She extended her hand, and in her deep, rich tone said, "Hello, I am Nina Simone." I grabbed that monkey arm and pulled her close. "Bitch, I know your name. I know every lick on every fucking album you've ever made. I am you. You made me." Miss Simone drew back, and Attallah interjected, "It's time to go." I was deeply distressed, thinking I had somehow insulted this goddess whom I revered with my total soul. Later that evening Attallah called and said, "Nina praised your performance the entire way home and pledged that she would come out of her retirement and return to the stage because of what she had just witnessed." Wow.

Paula Kelly, who had starred in *Sweet Charity* with Shirley MacLaine and Chita Rivera, was in attendance one Sunday. As I started to sing a Stevie Wonder song, "They Won't Go When I Go," I could hear her humming and singing along with me. I looked at her in the audience and smiled. It was a cue to all the other gypsies and singers in the audience to join me. They knew I was singing about the many people we'd lost to AIDS. Never in my life had I experienced something so loving and supporting, so uplifting and beautiful. I was supposed to climb some stairs at the end of the song, and let's just say the audience's harmony made me believe I could fly.

In 1992, a horrible thing happened: *704 Hauser*. It was a late spinoff of *All in the Family*, about a black family that was

to occupy the row house the Bunkers had lived in. Television legend Norman Lear, who'd seen *The Diva Is Dismissed,* said he wanted to cast me in the lead role. I worked with Lear on the script and the character, even going to his home. I started to see him as a father figure; I just knew he was going to make me the next Maude. But lo and behold, he gave the part to Lynnie Godfrey, with whom I'd done *Eubie!* on Broadway. He offered me a small role, which I declined. It was a cruel Hollywood nightmare.

George C. Wolfe saw *The Diva Is Dismissed* in Los Angeles and invited me to do the show at the esteemed Public Theater in New York City. We opened in October 1994 to rave reviews. *Variety* wrote: "Jenifer Lewis could no more give up diva-hood than she could give away her big, rich voice." *Stage Review* said: "Lewis commands the stage . . . not only with her explosive personality and infectious humor, but with a glimmering jewel of a voice . . ."

This was an amazing time. Everyone from Morgan Freeman to Ashford and Simpson to Josephine Premice and Madonna—everybody showed up to see me at the Public. I won the NAACP Theatre Award for *The Diva Is Dismissed,* and I won an Ovation Award for the production later on.

Norman Lear heard about my success in New York and called to congratulate me. I proceeded to tell him, "Please don't ever call my phone again."

I would swim every evening before the show. My diet had to change completely in order to deliver the goods at the

theater. This was not TV or film. This shit was live and in person. You either step up or it will eat you alive. I thought about seducing the hunky lifeguard at the pool, but then I would have had to tell Rachel. Bitch.

I was throwing tantrums in my phone sessions with Rachel. I was getting tired of analyzing every goddamn thing I did. I was working hard on my abandonment issues during this time. The grind of *Diva* was taking its toll on me. I only had a few more weeks, but it was cold in New York and my voice was starting to go. And damn if I didn't catch an all-out flu. I slipped into a full-blown "woe is me" depression.

One day, I believe for the first time in my life, I just couldn't get myself together mentally, physically, or emotionally to get to the theater. It was really a bad day for me. I called Rachel from my apartment and told her, "I just don't think I can do it." She said, "Yes, you can." I walked out into the freezing cold. I had always walked to the theater at a fast pace to warm up my lungs. This time I walked two blocks and my legs felt heavy. My heart sad. My will faltering. Every three blocks I had to stop at a phone booth to call Rachel for more encouragement to keep moving and get to the theater and do my job. I knew better than anyone in the world that the show must go on. I applied my makeup through tears that evening. The standing ovation did not uplift my spirit.

New Year's Eve was closing night, and what a late Christmas present to have Ruby Dee and Ossie Davis attend! I apologized to Ruby that my voice had been hoarse. She said, in her fabulous Ruby Dee slur: "Well, I didn't have anything to

compare it to. I thought it was wonderful." I joined Phylicia Rashad and a few others and a few others for the New Year's Eve celebration at Café Beulah. I went to the ladies' room, and as I rejoined everyone at the table, I asked them, "Are you guys talking about the show?" Lynn Whitfield said, "Jenifer, I'm going to tell you like I tell my daughter Grace, 'It's not always about you.'" I looked at her and whispered, "Oh, yes, it is, bitch. And happy New Year to you, too."

B ack on the West Coast that spring, I was doing my act at clubs like Nucleus Nuance and the Rose Tattoo. In the early '90s, lots of New York gypsies had moved to Los Angeles to take advantage of the surge in black sitcoms. They all showed up for my shows.

The political climate got hot in Los Angeles. Rodney King, a black man, was beaten by police on video. It became international news. Riots broke out in the South Central area in the aftermath when an all-white jury acquitted the cops involved in the brutality. Like so many people, I was deeply concerned by what I saw on that video and how the authorities handled the matter. It was stressful to say the least. My urge was to do something to help. The horror of that incident and everything else I was going through in my life caused me to break out in hives. Even with all that itching, I was determined to go to South Central; it was the least I could do to volunteer to help clean up the rubble left by the rioting. It was me and five young white kids sweeping together. At some

point, a homeless man approached us and screamed, "You motherfuckers never come down here for nothing else!" I stepped to him and said, "Get the fuck on where you going." I felt bad. He could've been my own daddy.

I soon turned my attention back to my life and work. I auditioned for *I'll Fly Away*, and Regina Taylor got it. I auditioned for *Passenger 57* and Alex Datcher got it. My over-the-top-ness was still an issue. A big mouth and a deep backbend weren't cutting it in television. I auditioned for *Against the Law* and *Family Matters* and didn't get hired for either one. I wanted to win at show business, but toning myself down for work in front of the camera was difficult. Asshole.

I could go from zero to ten thousand in a minute and was still experiencing mood swings and rageful incidents, like when I was in a restaurant in London with my friend Thom Fennessey and the man next to us was speaking too loudly. I almost took the guy's head off.

Every now and then I would still fuck up with the people I loved the most. And they loved me enough to tell me when I did. My beloved Marc Shaiman invited me to an event. I showed up after it was over. I hadn't understood that it was a commitment ceremony with his partner, Scott Wittman. Hurt and furious, Scott read me the riot act the next day. All I could say was, "I am working on myself, Scott, and I am so fucking sorry." These were very close friends I had disappointed. I felt horrible.

Therapy became harder and harder. I was digging up memories, reaching down to rediscover the tough and tender stuff of my childhood. I threatened to leave many times.

Rachel recommended I see a psychiatrist who could pre-scribe medication to level off my extreme moods. I looked at her as if she were insane. "You aren't putting me on medi-cation! I am JeniferMothaFuckinLewis; you aren't going to turn me into a zombie!" I feared medication would take away my personality and restrain my ability to express emotions. Rachel wrote something down, and I'm sure she went to see *her* shrink right after I left.

My negative attitude toward pharmaceuticals was af-firmed by one psychiatrist Rachel sent me to. In his office, I saw a girl at the dispensary asking for her lithium. She looked out of it, fucked up. That stuck in my mind. I didn't want to be sluggish and dull like that. The psychiatrist said he didn't see anything wrong with my "edge," referring to my mania. "You need that to do what you do." He was right in the sense that performers are rewarded for being over the top, with boundless energy and extreme emotions. I decided against taking medication.

My point is that even health experts can have different opinions and come to different conclusions about the same patient. This makes it all the more important for us patients to take charge of our own health care. We have to seek varying sources of information and advice, and most of all we have to listen to our own bodies. You must pay attention to your symptoms and responses. It takes patience and diligence, but it is the key to helping your doctors help you.

I started to read more books about mental health and got back into spiritual books. *Women Who Run with the Wolves* by Clarissa Pinkola Estés touched me and many other women

deeply. The book presented ideas on the power and strength of women and puts the "wild woman" that is within each of us in a positive light. I, a self-proclaimed alpha woman, was attracted to that message.

Hillary Clinton wrote a book that impressed me as well—*It Takes a Village.* The book refers to an African proverb about what it takes to raise a child. But the idea can be applied to taking care of all people in general and me specifically. I was saved by the fact that I was surrounded by a "village" of good people, including my family, therapist, and friends—and of course the Boat. My family may have been dysfunctional in my youth, but we loved each other and were never far apart for long. My friends were not only brilliant and talented; they showed me love and support—even in my darkest times. When you are not at your best, surround yourself with good people.

In terms of my career, the better I understood myself and managed the bipolar illness, the more offers came my way, including *Undercover Blues* with Dennis Quaid and an HBO show, *Dream On.* Debbie Allen (oh fabulous one) swooped in and gave me a huge boost by asking me to become a regular on *A Different World,* playing Dean Dorothy Dandridge Davenport. That meant my name would appear in the opening titles and I would be guaranteed a minimum number of episodes during the season. Cree Summer, who played a character named Freddie Brooks, and I started hanging out a lot. The depth of our inside ridiculous humor cannot be described. Let's just say we were cutting the fool every moment we were together hiking in the hills.

The icing on the cake was that I did Johnny Carson's last

Tonight Show, with Bette Midler. I had always dreamt of being on Johnny Carson's show. I found it amazing that I was booked on the very last show, and with Bette Midler singing an upbeat rendition of "Miss Otis Regrets" (Ella Fitzgerald was known for her slower, mournful version). And our dear Marc Shaiman was on piano. Life was complete. I was so damn happy.

Robin Williams was on the show, too. I had always been a huge fan of his, but his behavior backstage is what I remember most. He was in an extremely manic state, and in that moment I saw myself. I became aware of how I failed to see anyone else when I was in that state. I felt unsettled. With all this good stuff going on, the rollercoaster of happy/sad, happy/sad became intolerable. I just got sick and tired of it. I finally told Rachel I was ready to begin medication. But even with medication, my depression lingered. I was trying to create more productive energy in my life; attending lectures on positive thinking and living in the moment. I had started meditating again and tried to stop smoking. (Rachel told me it revealed a lack of self-love.)

I auditioned for *The Fresh Prince of Bel-Air* and was hired to play Aunt Helen. I was excited to get a prime-time show that was already a hit. I had a blast working with the cast, especially Will Smith. One night I was backstage wearing a negligee. Will, with his big ears, saw me and said, "Oooh! You look good." As always, he had a bunch of groupies hovering nearby. I motioned at him and said, "Come here." I pointed to the young women. "You see all those little girls down there? You g'on and flirt with *them*, because if you flirt with me, *I'll*

fuck you." In typical Will fashion, his response was, "Uh oh, uh oh." And then he laughingly told everyone the story. It was a bonding experience and he became quite protective of me. Our mutual admiration for each other's talent made it a joy to work on the show.

I started hanging out with Janet Hubert, who played my sister and Will's Aunt Viv on the show. Let's just say that Ms. Hubert was not having any of it. From anybody. At any time.

I was coming from a Boat meeting one night, and some kids decided they would roll a grocery cart out in front of my little white Mazda 323. There was no way I could hit the brakes in time, but when I pulled over, it was a relief to see my car had only minimal damage. I wanted to report the incident to the police and walked toward the nearest home to see if I could use someone's phone. Just as I pressed the doorbell, I heard glass shatter and turned to see one of the kids reach in my passenger window, steal my purse off the front seat, and take off running. Damn, I was mad! But having been a little thief myself in my youth, I knew they only wanted the cash and would throw the purse away. The following day, I went back to the scene of the crime and put myself in the thieves' minds. Where would I have thrown that purse? I mounted a concrete wall to the back of an apartment building, climbed across the balcony, and up onto the roof. I retrieved my purse and took my black ass home. I saw a couple of other purses up there, too.

The next day, I had therapy and was then supposed to go to an audition for which I'd been studying for days. I told Rachel I planned to skip the audition 'cause my car window was broken and we were being hit hard by the rains of El Niño. She was not having it and told me I *would* be going to the audition. I drove all the way to Culver City with a plastic trash bag taped over the passenger's window. I auditioned for a twenty-four-year-old director named John Singleton, for his film *Poetic Justice*. After I finished my reading, I looked at John squarely. "Little boy, just give me the fucking part, will ya?" He said, "Yes ma'am."

I turned and walked out to the waiting room, grinning smugly at the three or four women waiting to audition. "Y'all might as well go home. I got this bitch." Like I said, therapy doesn't work right away.

Poetic Justice starred Janet Jackson and Tupac Shakur, the hip hop legend. I played the mother of Tupac's character. Of course I had been a fan of Janet's for years, but Tupac, and the whole rap thing were pretty foreign to me. Mostly, I associated the hip hop scene with guns and danger.

The day we were set to shoot our scene together, I walked to Tupac's trailer to rehearse. I could hear the music pounding before my knock was answered by an eighteen-year-old girl in hot pants and bikini top. As she opened the door, a huge cloud of weed smoke engulfed me. I entered the trailer and I swear, there must have been eight girls in there. The smoke was thick, the music was deafening and I felt intimidated by Tupac's thuggy bodyguards and their tattoos. I stood there a second, not knowing what to do. Then I guess

the contact high kicked in, because I shouted above the music, "You motherfuckers get the hell out! This son of a bitch has got to rehearse!" There was a moment of shocked silence, then Tupac said, "Ahh man, I love her! Y'all get the fuck outta here." We rehearsed, then shot our scene. Tupac was a total professional; a very impressive young man.

Nineteen ninety-three was one of the biggest years in my career. I was still filming *What's Love Got to Do with It* when the producers from *In Living Color* came to see *The Diva Is Dismissed* at the Hudson. They asked me to bring two of my characters from *Diva* to their comedy sketch show. My contributions to *In Living Color* were Snookie ("Who's a woman got to sleep with to get something to eat?") and Mrs. Sheridan ("That just proves my point!"). The Wayans brothers had left by then, so unfortunately I didn't get to work with any of them. But Jim Carrey, Jamie Foxx, and T'Keyah Crystal Keymáh were still there, and we had a blast.

I had steady work as a regular on *A Different World* and was filming *Poetic Justice*. I also had a small part in Robert Townsend's *Meteor Man,* and rejoined Whoopi as her backup singer in *Sister Act 2.*

Whoopi was in the middle of doing *The Whoopi Goldberg Show,* a late-night talk show that ran for about a year. She called me: "Come on down to the studio and hang out." When I pulled up to the studio, Eartha Kitt was leaving and Patti LaBelle was pulling up in a Rolls-Royce. Take a deep breath, close your eyes, and imagine: Eartha Kitt, Patti LaBelle, and Jenifer Lewis occupying the same space. When Patti LaBelle saw me, she said to Whoopi, "Ain't she the Dean?" It was a lovely day.

Whoopi got married on October 1. The celebs poured in: Steven Spielberg, Jeffrey Katzenberg, Richard Pryor, Mark Hamill, Ray Liotta, Jon Voight, and certainly most impressively, Jenifer Lewis. I went upstairs and zipped Whoopi into her pretty dress and we had a good laugh that she had had the words "fuck you" spelled out on her rooftop for the paparazzi.

Whoopi has always had my best interests at heart. I've been lucky, for the most part, in terms of the quality of my friendships. I believe the company you keep is incredibly important. I have surrounded myself with loving, giving people. And, of course, they have to be smart and talented.

One morning I went into Whoopi's trailer on the set of *Corrina, Corrina*. I was crying and I told her that I needed to get Ricky (someone I was dating and had allowed to move in with me) out of my house, and I didn't know how. The next day was per diem day. I went to Whoopi's trailer to rehearse the scene and saw $2,000 cash sitting on her coffee table. I said, "Girl why you got all this money sitting around? I'm going to steal this shit." She said, "You don't have to steal it, it's yours." I said, "What, girl, I don't . . ." She said, "Take that two thousand and get that Nigga outta your house before it costs you two million, like it did me."

M y success in movie and television roles allowed me to become a first-time homeowner. It was a huge deal for a poor girl from Kinloch. I bought a beautiful, spacious condominium in Studio City.

I had never lived in anything bigger than a one-bedroom apartment. The living room was huge. There were three bedrooms, two baths, a pool, and a tennis court. It seemed so cavernous. I'm not gonna lie to y'all, it scared me a little bit. I slept in the smallest bedroom for a long time.

I had a mortgage. I now belonged to the homeowners' association. I had two parking spaces; no more of that parking-on-the-street shit where somebody steals your car, takes it on a joy ride, and three days later, the police return it with Taco Bell wrappers in the back seat. Assholes.

I bought a new Camry. The only precious possession I brought with me from the bungalow to the condo was an upright piano. I had been sleeping on a futon and was looking forward to new, more grown-up furniture. My cousin Ronnie came from Kinloch to help me get the place together. I went antiquing with Whoopi in Santa Barbara. We saw a sofa I admired. The next day it was delivered to my house, a gift from Whoopi. I also employed my first housekeeper. However, once you've been a "have not," you're forever subject to moments that take you back. Gladys, my housekeeper, would bring her son along as she worked in my condo. Being with them made me melancholy and nostalgic, recalling the occasions when I went to work with my mother as she cleaned white people's homes.

JOURNAL ENTRY: Getting my ass kicked in Hollywood sometimes felt like getting my ass kicked in Kinloch. I've been trying to kill myself for thirty-three years. I awoke choking on my very crime.

I took a little vacation to St. Maarten with Deborah Dean Davis. She was always trying to get me to try new activities so I'd have something to focus on besides my career and therapy. This was the reason we lay, inappropriately, on the beach naked for all to see. I was thirty-five years old, a brick house in these streets: 36-24-36, with skin like a baby's ass, almond eyes, perfect nose, black-girl lips in full throttle, titties up (well, sagging a little), ass tight, and pretty feet. That's right, goddammit. Look at me and get your life.

> JOURNAL ENTRY: Stop waiting for something or someone to come and make you happy. Meditate daily. Breathe. Come on. You're okay. You have friends. Love them. Respect them. Go out and play. Learn to be alone.

I experienced a breakthrough in my psychological health when I got into a big argument with a makeup-artist friend named Sherry. It marked the first time a friend asked me to sit down and work through a problem rather than allow me or them to storm off. She was in therapy too—for an eating disorder. We both used the tools therapy had given us and processed our issues with each other. This was an important moment because it also showed how I was attracting more positive and adult people in my life. When I went to my next therapy session, I was proud to tell Rachel how I had worked through a disagreement with a friend in a healthy way.

Therapy is a bumpy bitch, but it continues to unfold if

you stick with it. I was starting to understand more of who I was taking into the audition rooms with me, and it allowed my career to grow. I stopped being so arrogant. I was dismissing the Diva, ripping off the mask to show my true self. But it sho' wa'nt easy.

TWELVE

KICKING DOWN DOORS

The artificial glitz of Hollywood is the least of living in Los Angeles. God spread her glory in this city, being generous with the bling of palms, golden sunshine, crashing ocean, and nearby mountains. And of course the purple jacaranda trees in May. Despite my moments of sadness, madness, and ambition, I aligned myself with nature like never before.

Mother Nature had a surprise for me. The violent shaking started around 4:30 a.m. on January 17, 1994. Tai chi and yoga had taught me to go limp in these kinds of situations. I was still sleeping on the low futon-style bed, so I had nothing to fall from, but I was thrown over the thing like a rag doll.

This was not my first earthquake, but it was the strongest I'd ever felt. The shaking seemed to go on forever. When it finally did stop, I was relieved to be in one piece, unhurt. I reached down and found the clothes I had dropped next to the bed the night before. There were matches in my pants pocket, and, foolishly, I did something you should not do in the aftermath of an earthquake—light a match. This could ignite any gas that had been released into the air. In the few seconds the match was aglow, I could see the ceiling had dropped a little and was about to crash onto my bed. Everything was broken and scattered about, and I felt the cool January air coming through the broken windows. I blew out the match, and in complete darkness, blindly felt my way toward the living room. My upright Yamaha piano had fallen over and there was a wall in my way, but somehow I squeezed through. My phone rang. It was my brother, Larry, calling from St. Louis. He was heading out early for his job teaching at Jennings High School when news of the quake came over the radio. "Larry, it's bad. It's real bad. Don't tell Mama. I'm okay, but it's so fucking bad," I whispered to him because the silence in the moment was so great around me, I felt compelled to keep my own voice low. Mother Nature had just kicked our ass.

I called Rachel. She lived just down the street. I was relieved to hear that she was fine. The phone went dead. I went outside into the corridor that opened onto a courtyard. Across the way lived an eighty-year-old couple. I went to check on them. They were shaken, of course, but alive. They had a flashlight,

which I asked for "so I can help these other people." I was now hearing screams for help. I went to open one neighbor's door only to find it was stuck.

Without hesitation, I yelled, "Stand back from the door!" It was as if my entire molecular structure suddenly recalled the moves I learned at the karate dojo when I lived with Miguel and his mother. I unleashed a powerful forward snap kick, which knocked open the door. A couple crawled out. I repeated the kick five more times that night. It was like I was in a Bruce Lee movie. Adrenaline, or some force greater, activated inside me.

I found my neighbor Tina underneath two curio cabinets that had collapsed over her head, forming a steeple in midair. Shards of glass stuck out from the cabinets, one just inches from Tina's neck. I said, "Don't move, Tina." I put the flashlight in my mouth and oh so carefully moved the shard away from her throat. Some young men appeared, and I asked them to help move the cabinets so she could get free while I went off to the next apartment.

In the midst of kicking down doors, I paused to look up. I saw stars in the sky like I'd never seen before. In the absence of electric lights, I saw the Milky Way in all its splendor. I said a prayer of thanks. Everybody in our complex had helped each other and made it out safely. We stood in the street together, crying, praying. When the sun came up, we learned the enormity of the disaster—the quake measured 6.7 on the Richter scale and fifty-two people died. I figured our building would be condemned, and a few days later, documents posted on

the front door made it official—FEMA would be placing us in temporary housing.

J ust a few weeks after the earthquake, I was asked to step in for disco queen Donna Summer at a fundraising concert for AIDS Project Los Angeles. The AIDS crisis was rampaging, and Hollywood royalty came out in droves that night. Whitney Houston, Elizabeth Taylor, Jennifer Holliday, Madonna, and countless more stars were there to honor entertainment idols whose lives were taken by the epidemic, including Rock Hudson, Robert Mapplethorpe, and Freddie Mercury.

Scott Wittman and Marc Shaiman directed the show. My performance recognized Paul Jabara, the brilliant composer who wrote disco hits like "Last Dance," "It's Raining Men," and the duet "Enough Is Enough," which was a huge success for Barbra Streisand and Donna Summer.

When I took the stage accompanied by a sixty-piece orchestra, three back-up singers, and a half-dozen dancers, I could see two of my biggest idols, First Lady Hillary Rodham Clinton and Barbra Streisand, sitting next to each other in the fifth row center. As one might expect, my performance was highly energetic and highly irreverent—my first words were "They couldn't get the bitch," referring to the fact that I was singing Donna's songs!

When I got to the part in the Jabara medley where I would sing Barbra Streisand's verse in "Enough Is Enough," I deliberately missed a note. Walking to the front of the stage to

address Ms. Streisand, I said, "Barbra, can you help me with this note, honey?" When I saw Barbra and Hillary turn to one another and laugh, my life was complete (and I got the first standing ovation of the night!).

At the after-party, Babs came over to me (alright, I pushed my way through so I could stand next to her). Now, everybody knows Barbra Streisand is a germaphobe, so when she placed her hand on my cheek, I was deeply touched. She said, "You are so special." Wow, I had been dubbed by the queen herself and never washed my face again.

Seriously, though, I must have been really "special" that night, because it just so happened that Rachel was at the show. At our next session she told me she wanted me to begin taking "add-on" medication to reign-in my manic behaviors.

Also, Rachel and I agreed I needed a focus outside of work and myself. Most entertainers spend a lot of time either being the center of attention or seeking to be the center of attention. We can lose perspective, thinking everything is about us. Fortunately, I had a strong circle of support around me; friends like Jeffrey Gunter and Kiki Shepard, Ron Glass, and, of course, Roxanne, helped me to stay on track. Plus, my cousin WiLetta Harmon had moved to LA from Kinloch and she was a steady, loving force.

While I was filming *Panther* with Kadeem Hardison, I arrived on set one day and Dick Gregory was there. What a wonderful surprise! Dick was a giant in the realms of social justice and entertainment, and like me, he's from Kinloch. I was eager to speak with him about nutrition. About ten years

earlier, Dick had created the Slim-Safe Bahamian Diet in response to the appalling health status of African Americans. The diet became a sensation in the black community because it reflected our culture and traditions around food. My conversation with Dick was a timely reminder of the importance of eating right for my mind and my body.

During the summer I went on a study tour of Egypt with acclaimed Egyptologist professor Asa Hilliard. Dr. Hilliard, who also was known as Nana Baffour Amankwatia III, provided an Afrocentric perspective on the history of this once-great empire. As we visited the Great Pyramid of Giza and the open markets in Cairo and viewed two-thousand-year-old ceiling paintings in the Temple of Karnak, Dr. Hilliard demonstrated that the roots of modern civilization lie in Africa, not Greece or Rome.

While we were in Cairo, I scheduled a massage. The masseuse was a young, and of course fine, Egyptian man. He truly worked out my knots. He was so good that I scheduled a follow-up massage, fully intending to fuck him. But I was conflicted. Rachel and I recently had talked about how others can't rescue you, so I tried to work through the situation by writing about it in my journal. After a couple of drinks, I called Rachel to talk me out of it.

"Jenifer, it's three a.m. in Los Angeles."

"I'm sorry, Rachel. But I'm going to have sex with this man."

"NO, you're not."

She hung up. Rachel was not suffering my foolishness, and I did not fuck the masseuse.

I returned to the States, only to learn from my answering machine that four friends had died from AIDS while I was away. I called my eternally wise acting teacher, Janet Alhanti, and said, "What do I do with this? How do you mourn four friends at once?" She said, "You live it. You just have to live it."

I was dealing with so much loss and so many abandonment issues that I couldn't comfortably be alone. I would hang out with the Boat or my gypsy friends as much as possible. I spent a lot of time with Michael Peters who had moved to Los Angeles. We had gone together to Joshua Tree National Park, where the Mojave and Colorado deserts meet. Amid the beauty of Joshua Tree, Michael told me he'd been suffering with HIV/AIDS for quite some time. To come home from Egypt and hear he'd made his transition was almost too much to bear. We celebrated him like the king of dance that he was.

At dinner one night with Marta Kauffman and Michael Skloff, the conversation of course turned to *Friends*, the sitcom Marta and her partner, David Crane, had created. Michael wrote the opening theme music and my friend Allee Willis wrote the lyrics—"*I'll be there for you!*" Naturally, I asked, "Is there anybody black on the show?" Ladies and Gentlemen, that's how I became the first black person on *Friends*. I played Paula, a chef working in a restaurant with Courteney Cox's character.

I was taking my medications regularly. There were side effects, including dry mouth and a loss of sexual appetite, which was a blessing. So much for my sex addiction. My psy-

chiatrist worked with me to adjust the dosage. It took patience, patience, patience to get the medication right. Don't walk into a doctor's office and think they're going to fix your shit overnight. You can't take a cocktail of pills and know immediately what the results are going to be. I feel fortunate that psychiatric medicines have become sophisticated enough that doctors can customize various kinds of drugs and dosages for each person. Please remember: I'm not pushing drug treatment. I am telling you my story, my song.

The best effect of the meds was that when the phone rang with bad news, I wasn't going to fall apart emotionally. My responses were no longer as extreme. No matter what big issue or catastrophe loomed, I could say, "bring it," feel it and move forward like an adult. I was better able to listen and be present and aware of the world around me.

I have learned that medication works best when you create a calm atmosphere for yourself. You have to slow your roll; give yourself quiet time and stop to smell the roses, thorns, and all.

At the New York premiere of the film *Waiting to Exhale*, Lela Rochon sat on one side of me and Loretta Devine was on the other. Whitney Houston was behind me on the right, sitting next to Angela Bassett, behind me on the left. I was surrounded by friends who starred in the film—the film that I had not gotten a part in. I came home insanely depressed but then felt very proud of myself because I actu-

ally got out of bed, grabbed my journal, and sat with my feel-ings as Rachel had suggested. Must've worked because I had a great time on *The Preacher's Wife* set the next day. Whitney and I took to each other like eggs and bacon.

Lordy, we laughed, sang, and acted a fool together! I loved Whitney, not only for her extraordinary talents, but for her warmth and humor.

The Preacher's Wife was shot mostly in Yonkers, New York, during terrible winter weather. One morning, I sat in the chilly hair-and-makeup trailer preparing for a scene with Whitney. Just as the stylist finished teasing my hair to the roof, I was notified that Whitney had phoned and would not be appearing for work that day. Therefore, I would have to shoot a different scene that required a completely different hairdo. I was furious. The stylist would have to wash and re-style my hair. I was already cold and the small heater in the trailer would never get the area warm enough for me to sit there with wet hair. After a miserable hour of shivering while my hair was redone, I called Whitney's private number.

"Hello?"

"Hi baby, it's Jenifer."

"Oh Mama, I can't come to work today. There is too much snow!"

"But you should have called two hours ago, Whitney! I had to sit in that freezing-ass trailer with a wet head because you called so late. I probably caught my death of cold!"

"But we couldn't even get the car down the driveway."

"Listen little girl. This ain't no concert tour. This is mak-

ing movies. This is teamwork. This is not the Whitney show! You have to think about the people who you are working with!"

"Please Mama, I won't do it no more. It won't happen again. Please don't be mad, Mama."

And how could I be mad? I knew she had heard me and was sorry.

It became more and more clear that Whitney carried heavy burdens. Later that week, we were shooting at a pier on the Hudson River. I could see that something wasn't right with Whitney that day. I didn't know what. She looked beautiful in her wardrobe, but she seemed troubled and disconnected. I said to her, "You know Whitney, I went to therapy to take care of my challenges, and baby..." Before I could say another word she whipped her head around and said, "Oh no Mama! My Lord and Savior Jesus Christ take care of me." She said it with such fervor and determination that I never brought it up again.

The next summer, Whitney invited me to Jersey and gave me the grand tour of her house. Her sweet little daughter, Bobbi Kristina, was swimming, so I jumped in. We had fun, but after an hour, I was ready to get out. She of course was not but nevertheless allowed me to wrap her in a big, fluffy towel and take her back inside to her talented mama.

Whitney and I stayed in touch off and on but we didn't see each other much. Years later, I was in Atlanta filming *Meet the Browns* and Whitney asked me to her home for dinner. When I arrived, she was "indisposed" and could not come down for the meal. I spent the evening with Cissy and Pat,

Whitney's mother and sister-in-law. Then, a couple of months before Whitney passed away she called me. She was very excited about *Waiting to Exhale 2* and said she was on her way to rehab so she would be in top shape to shoot the movie. "I'm going to do it this time, Mama! Don't worry, this time I'm going to do it for real."

I never heard Whitney's voice again, but I often recall the day we filmed the scene in the church where she sings. I was giving an interview in the back of the church and without moving my eyes off Whitney, I said to the journalist, "Her voice is the eighth wonder of the world, and that's all I have to say."

I went to a big birthday party given by Carrie Fisher and Penny Marshall, who directed *The Preacher's Wife*. It was a celebrity-filled affair. In addition to my castmates Denzel, Whitney, and Loretta, the crowd included Jack Nicholson, Jane Fonda, and Jay Leno. I was excited to meet Carrie, "Princess Leia" from *Star Wars*. She, too, lived with bipolar disorder and, similar to me, had turned her story and struggles into art.

Oprah Winfrey called, and I flew to New York again, this time to participate in a reading of Toni Morrison's *Beloved*. I was so excited. Oprah put us up at the Four Seasons, and that morning I ordered a $40 frittata. Disgusted at that, I was still happy it gave me energy to face a day with the likes of Samuel L. Jackson, Mary Alice, Thandie Newton, and Oprah. There were about twelve of us sitting around a long table, poised to impress the great one herself. Well, I for one had

studied my ass off. Now, before my big speech, Oprah and I had been trading side glances, teasing like regular girlfriends about Thandie Newton's character trying to take Sam Jackson's character away from Oprah Winfrey's character.

In other words, "Don't let her get your man, girl."

We were bonding, and I was very happy that Oprah was so down to earth and playful in real life. But then came time for my big monologue. I took a deep breath, slowed myself and delivered one of the finest performances of my life.

My speech had been so impressive that even the seasoned theater veterans started to applaud the delivery. Oprah clocked this exaggerated praise. Let's just say the "girlfriend bonding" shit stopped on a dime. I immediately knew I would not, under any circumstances, be cast in *Beloved*. It was Oprah's first starring role, and experience told me she was not about to let my happy ass upstage her even happier ass.

Thomas was back on the scene and he and I drove from Los Angeles down to Marc Shaiman and Scott Wittman's beach house in Laguna. We had fun, but we mostly fought. It was all because of that "I'm the man" bullshit. I'm sorry, baby. Everybody in the world knows I'm the man. How I am not a lesbian, ladies and gentlemen, is beyond me. But when you're a Dick Diva, you're a Dick Diva. He left for Detroit, and I flew to Hawaii to hang out with Bette Midler and her family, Marc Shaiman, Scott Wittman, and hallelujah, Mr. Bruce Vilanch himself. We had an insanely full-out, fabulous time.

When I returned from the trip, there was sad news from home. One of my favorites among my mother's eight sisters and seven brothers passed. Aunt Louise was the first of

Grandma Small's children to die. My first cousin Carol and her family were living in Compton, so I drove down to be with them. We had always been so very close.

That month I had a small meltdown because I hadn't had a job for a while. When you're in therapy it's often one step forward and ten steps back. But I didn't give up. There is no elevator to success in health or work. I was climbing the stairs against the winds of life. I responded by getting drunk, going shopping, and buying an electric-blue fox coat. Sorry, PETA.

Things picked up when, God help me, my new manager, Barry Krost, made a deal with Disney to do *The Jenifer Lewis Show*. A talk show. To make a long story short, I was basically incapable of asking other people about their lives without going on and on and on about my own. The show was a fucking train wreck and was never aired. I told y'all—yeah, I can sing, and act, and entertain, but apparently I just can't stop talking about myself!

Thank goodness the writer Lee Rose called, and I was off to Vancouver to film *An Unexpected Life*. In the cast were the great Elaine Stritch, Stockard Channing, S. Epatha Merkerson, Christine Ebersole, and RuPaul. I am under court order to never reveal stories about the carryings-on during that shoot. Ask Ru.

I won an audition for a role in an animation created by Eddie Murphy called *The PJs*. It was a cast of wacky and talented people. Phil Morris's fine ass was doing Eddie Murphy's voice, and even if you listen carefully, you can't tell the difference. I was fired from that job for reasons unknown. I think somebody was having sex with somebody and before I knew

it, somebody else had my job. But I didn't give a fuck, because I had fifteen other jobs. To this day, I don't remember doing *The Proud Family*. There was just a whole lot of shit going on, y'all, and I was in high demand. Thank you, Jesus.

The phone rang, and it was Suzanne de Passe inquiring about my availability to film a television mini-series called *The Temptations*. Before flying to Pittsburgh for filming, I took a side trip to the Optimum Health Institute in Lemon Grove, California. They should've called it Wheatgrass, California, 'cause these motherfuckers advised you to put wheatgrass in pretty much every functional hole in your body. Ear, nose throat and even the eyes. I was so green, I felt like Margaret Hamilton in *The Wizard of Oz*. You know she never got that green shit off her face, right?

I left the health retreat ten pounds lighter, feeling like I could conquer the world. Then I made one of the worst decisions of my life: I took myself off my meds.

Two days later, the mania had me zigzagging throughout *The Temptations'* base camp on a vintage Schwinn, with Suzanne de Passe running behind me screaming, "Get her off that bicycle!" Later, I got on the phone with Rachel, who knew immediately what was up with me. She asked if I was on my meds; I lied and said I had taken them. All the while I rattled on, excited about the cool 1960s cars they had on the set.

That night was, to quote James Weldon Johnson, "blacker than a hundred midnights down in the cypress swamp." At 1 a.m. I went down to a local bar and threw back a few too many. How I didn't pass out on the street walking back to

the hotel, I'll never know. As I fell face first onto the hotel bed and the room spun around, I had one thought only: I'm in trouble.

I turned over to reach for the old phone in that old hotel, in that old smelly room. As I reached, I fell out of the bed and wound up in fetal position on the carpet. The phone had also fallen, and somehow I dialed Rachel's number. It was midnight in Los Angeles. In what seemed to be my darkest hour, I prayed she would answer. When her answering machine picked up, I wailed over and over, "Rachel, I need help." She picked up. Thank God. I told her I was ready to admit I was sick. I told her I'd gotten off my meds and that I was out of control. I apologized to her for being so rageful in my sessions. I told her I wanted to be well, that I was tired of hurting myself. *"I'm ready now, Rachel. This time I'm really ready."*

It was a huge turning point in my life. Though I had been in therapy for a long while, I don't think I had been honestly serious about the whole thing. Well, now I was. That was the worst night of my life. It was also my proudest moment. I had to settle back into therapy with my newfound promise of being disciplined with my medication.

If the breakdown during *The Temptations* had not been enough, the call came that my Grandma Small had died. I flew to St. Louis to help comfort her fifteen children. Six sons: Robert, Walter, Roy, Charles, John, and Michael; nine daughters: Dorothy, Catherine, Rosetta, Jean, Shirley, Gloria, Janice, Margaret, and Mary. My aunt Louise had already passed away. There were two sisters as well: Ida Clay and Membry

Brown, and 79 grandchildren, 105 great-grandchildren, and 17 great-great-grandchildren.

I had written a song about Grandma Small for *The Diva Is Dismissed*. It was everybody's favorite:

Staring through the backscreen door
I finished my spaghetti plate
I sho' be glad when I'm all grown up
My Aint Rosetta is always late
(My Aint Rosetta is always late)
My mama is the oldest of sixteen kids
And I'm the baby of seven
Cat Johnny drove a Big Gray Cadillac
And everybody thought that he was in heaven
(Everybody thought that he was in heaven)
But my Grandma Small, she took care of me
My Grandma Small made cabbage for me
My Grandma Small took me in
Even when I didn't win
Somebody said the old house was haunted
So, I'd go there to play
I'd grab Billy Ray by his checkered shirt
It was a crystal blue sky day
(It was a crystal blue sky day)
What you want for your birthday, girl?
Just a brand-new bike
I was twelve years old, my daddy brought it in
Hey, Daddy, can't you stay for just one night?
(Can't you sleep over for just one night?)

But my Grandma Small, she watched over me
My Grandma Small was always happy to see me
My Grandma Small took me in
Even when I didn't win
One day after school
I was watching her work in her garden
She slipped and fell
So, I ran to help
She said, "No, child, I don't need to get up
If I can't get up by myself"
(By myself)
My Grandma Small, she took care of me
My Grandma Small, she was always happy to see me
My Grandma Small, took me in
Even when I didn't win
She took me in
Even when I didn't win

The next morning, I went to downtown St. Louis hoping I could sit on the banks of the Mississippi and do some healing. I walked over the grassy knoll and took in every majestic angle of the St. Louis arch, gateway to the West. I walked down to the muddy river, sat on the cobblestones—which had been laid there by enslaved Africans—and proceeded to have my own pity party. I knew I had to get it out. I cried like a baby. I remembered what my grandmother had said: "I don't need to get up if I can't get up by myself." So, I stood up and walked. I walked and I walked.

With the St. Louis skyline behind me, I realized the past

was just that, the past. I needed to get back to Los Angeles. Refill my prescriptions, get serious about pilates and meditate everyday, and take care of my health—mentally, physically, and spiritually.

My answering machine was full when I got home. There was Whoopi, inviting me to her birthday party, and Bette Midler asking me to do *The Roseanne Barr Show* with her. I learned I had been cast in *Mystery Men* as William H. Macy's wife, and Oprah's people called to invite me to the *Beloved* premiere. Life was good.

I thought the sky was the limit when I was asked to audition for *Cast Away* starring Tom Hanks. Tom fucking Hanks! Thank you, Mississippi River. I studied my ass off. I was getting this job. I was going to cross over into the A-list world. This was my big chance. I landed the audition like a 747 in these motherfucking streets. I was so pleased with myself that after I did the scene I tossed the script aside, slapped my hands down on the table and said, "Now, that was brilliant." The director, Robert Zemeckis, and the casting director, laughed at my sassy confidence. They called me right back and said I had the job.

It was thrilling to start shooting *Cast Away*. I had studied hard, was fully confident in my lines, and felt prepared to give Tom Hanks a run for his money. Before shooting my first scene with Tom, I was getting my hair done and decided to take a moment to look over the script for *Jackie's Back!*, the

movie for Lifetime that I would start shooting the following week. I was looking at the scene where a mink hat my character wore was taken and burned. My line was "Give me back my head, bitch." I heard the trailer door open, but didn't look up.

A male voice said, "Give me back my head, bitch." It was Tom, peering over my shoulder and reading the first line on the page. It was surprising to see him because big stars almost never come to hair and makeup with the rest of us. He had his own Gulf Stream trailer to dress in. "Is that in our scene? Oh, I'm sorry," he said, "I thought you were reading a scene from *Cast Away*." He sounded hurt. "Wait a minute . . . you were getting ready to do a scene with me and you're practicing for another project?" I was so embarrassed.

We got in rehearsal and I was nervous and over the top. He called me over and said, "Don't say it if you don't mean it." In the next take, I got myself together and proceeded to do the hell out of the scene. I played the role of Tom's boss at the FedEx facility where his character worked. In the scene, we'd gotten a call from Moscow that packages were not moving through to get to their destinations as they should.

We actors stood next to a conveyer belt. I heard "Action!" and said to Tom, "You go to Moscow." As I did, boxes came up the conveyor belt. Tom, who was poised to get my goat, picked up a box, tossed it in my direction, and said, "Here's your head, bitch!" Oh, we cut up on that set as if we had been raised on the same block. To this day, every time I see Tom, be it on the red carpet or at a restaurant, he teases me with, "Did you find your head yet, bitch?"

Filming *Cast Away* was mind-blowing. I learned so much working with Tom. And I realized that living in my show-business bubble, it had never occurred to me to think about how packages got from one place to the other. The operations of FedEx in real life are like a city, with ten zillion boxes, people, machines, and trucks. Who'd a thunk? I was blown away by that and by the fact that nearly all my scenes in *Cast Away* ended up on the cutting room floor.

THIRTEEN

JACKIE'S BACK!

I began taking writing classes for professional and personal reasons. I felt it was time for growth. I joined forces with my dear friends Mark Alton Brown and Dee La Duke to write a movie for me to star in. I shouldn't even say we wrote it. *Jackie's Back!* wrote itself. It was basically a compilation of the fevered, insane conversations we'd had for years. We came away with a mockumentary about Jackie Washington, a 1960s/70s-style R&B diva on the comeback.

The concept arose from Mark and I having watched a documentary about the singer Shirley Bassey called *Have Voice, Will Travel*. I love and adore Shirley Bassey. I pray every night to be able to hit the notes that bitch hits and I train my lungs constantly to hold notes longer than she does. Both are impossible.

In the documentary Shirley proclaimed multiple times that she was the greatest entertainer in the world. We wove that attitude, along with some aspects of my personality, into the Jackie Washington character. What distinguished Jackie from me most was that she would never doubt herself. She believed her own bullshit: that she was fabulous always and forever. I, on the other hand, might proclaim "I'm fabulous, I'm fabulous," but then pull back and cry myself to sleep wracked with self-doubt.

Barry Krost, my manager at the time, tried to sell the script all over town. Lifetime picked it up and the one and only Robert Townsend was chosen to direct. All y'all need to know is that during the first meeting with the Lifetime executives, one of them raised her hand timidly and, referring to the script, asked, "What does 'Cuth what? Thank you, say no mo' mean?" In his thick English accent, Barry replied, "Oh, darling, I honestly don't know what it means, but when Jackie Washington says it, it's quite clear."

I found that producing a movie is a whole nother thing, very different from creating a stage production for one actor. In producing, the bottom line is money. I was fortunate that my friends put me, not compensation, first. We rallied a long list of greats to make cameo appearances: The first person I called was Whoopi. Now, something you guys should know—because I had become the entertainer's entertainer, all the divas who love me sort of competed in claiming responsibility for my becoming a star. So, I was no fool. I played them against each other—with love, of course. I told Whoopi I had Bette. I told Bette I had Whoopi. I told Rosie I had Whoopi and Bette.

I told Loretta I had Whoopi, Bette, and Rosie. Barry Krost got Dolly Parton and JoBeth Williams. Robert Townsend got Don Cornelius. I snatched Chris Rock just walking across the lawn at the Beverly Hills Hotel. If you look closely and listen, he has no idea what he's talking about. What he's saying doesn't even make sense, but who cares? It was Chris Rock and he did it for Jenifer Lewis.

When they told me Tim Curry would be my co-star, all I could think of was him in that bustier and garter belt in *The Rocky Horror Picture Show*. I proceeded to levitate off the ground. The shit was set in motion. Robert Townsend took a crew to the set of *Girl, Interrupted* and got Whoopi in costume as a nurse. I had been up for that part. Bitch. They went to New York and got Liza Minnelli. Unfuckingbelievable. Then, when the head of Lifetime, Laurette Hayden, called and told me her mother had agreed to do a cameo, I proceeded to jump as high as the Maasai in Ngorongoro. Her mother was, of course, the legendary actress Eva Marie Saint, Miss *North by Northwest* herself.

Then Jackie Collins agreed to say that Jackie Washington had died from choking on a chitlin. We got Kathy Najimy, Kathy Griffin, and Sean Hayes. When Diahann Carroll proclaimed she had built herself from the ground up and was calling her lawyer to sue Jackie, whatever mind I had was lost. When Penny Marshall nasaled her way through her monologue, the gods came down from the heavens and blessed the entire production.

One theme of the movie is a corny double entendre. We named Jackie Washington's youngest daughter Antandre,

and then had Jackie ask her for a drink and make the obvious request: ya'll ready? "Make it a double, Antandre!"

The environment on the set equaled one word—laughter. My favorite scene is when Jackie comes out of the house, drunk, and tells the detective, "Wait a minute," so she can fix her hair for the cameras after stabbing Milkman, her husband, with an Afro pick. By the way, Milkman was played by the wonderful Richard Lawson, who later married Tina Knowles, Beyoncé's mama. I actually went on one date with him. Shit, had I known Tina would be my competition, I'd-a worn a lower neckline! But seriously, Richard and I were no Jackie and Milkman. We became more like sister and brother, which is very cool.

In the movie when you see that *Playboy* spread with Jackie's legs in a wide split, I just want y'all to know that's my real body. I am a yoga and Pilates diva after all. And let's not forget captain of the fucking cheerleading squad in high school.

On the day we shot the "Coco" scene, Rudy Ray Moore, portraying the main gangster, could not get the line right. He was supposed to say, "I will see you in the sequel, Coco!" But in take after take he kept calling her "Shakoan." Over and over again, "Shakoan, Shakoan, Shakoan." So in a looping session, I begged Robert Townsend to let me say, "Shakoan," for no good reason before Coco kicks ass in that scene. To this day, Mark Brown and I end every phone conversation not with "goodbye," but with "I will see you in the sequel, Shakoan!"

The day before shooting the scene with David Hyde Pierce, who played my deaf pianist, we had filmed a full-out production of "Love Goddess" accompanied by my high kicks over

and over again. The next day, at the piano when I had to kick over my head, it was impossible. That pain you see when I try to raise my leg was probably the most real moment in the film. Luckily, the genius of David Hyde Pierce masked it.

Isabel Sanford portrayed Jackie's play mama, Miss Krumes, who famously said, "White people smell like wet potato chips." Between takes, Isabel told me stories about Katharine Hepburn and Spencer Tracy on the set of *Guess Who's Coming to Dinner?* Apparently, Katharine was appalled that Isabel took the public bus to the set every day. She insisted Isabel be given a chauffeured car.

Marc Shaiman was an unbelievable friend to score the movie for close to nothing. He was in the midst of scoring *Ghosts of Mississippi*, so we worked on *Jackie's Back!* during his lunch breaks. His favorite lyric in the entire movie is in "Love Goddess": *". . . just like Aphrodite in her nightie. You're like Thor, I'm like Venus, something's got to come between us. Love Goddess!"*

Jackie's Back! was in the can and left with the editor. We crossed our fingers and something deep inside told me it was going to be good. When *Jackie's Back!* was finally ready, Barry Krost wouldn't let me see it until he threw an intimate party to celebrate. I wanted to kill him. I wanted to make sure it was good before anyone else saw it. I walked into the party wearing a hoodie under my coat and repressing the rage of a petulant five-year-old not getting her way. Inside I was yearning, hoping, and praying to God to please let it be good. I refused all hors d'oeuvres and drinks. I clutched up in a chair in fetal position, not making eye contact, and was silent. Silent? Y'all know I was scared.

During shooting, I had seen most, but not all, of the dailies. When the movie came on I stayed clutched up until Liza Minnelli, whose dailies I had not seen, came on the screen. When she said "I don't know much about the African . . . " the hoodie dropped, the coat flew off, and I came out of my body screaming in joy, "Somebody, break out the champagne!" *Jackie's Back!* was in fact the best shit I had ever seen. Humbly.

At the premiere, I spotted Rachel in the crowd. I could tell how proud she was of me; like a peacock strutting his beautiful plumage. Everybody was happy. Everybody was proud. A lot of people flew in, including Dr. Roma Little Walker, a friend I'd met on my trip to Egypt, Mrs. Butler, my high school counselor, and Ethel Rue, my "Fat Jackie" partner from Kinloch. My cousin Ronnie did cartwheels. We had a late-night celebration at Kate Mantilini restaurant in Beverly Hills.

A few days later, I left for New York, but I didn't really need the plane. I was flying high, heading to the city to promote *Jackie's Back!* on the *Rosie O'Donnell Show.* I had been dating a man named Terrence for about a year at this time, and brought him with me. When we landed back at LAX, Lifetime had sent a limousine for us. On the ride home, Terrence, who played a TV reporter in the film, spotted a huge billboard for *Jackie's Back!* with my face ten feet tall. We screamed and shouted while our heads stuck out of the limo's sun roof. The billboards were all over the city. The premiere of the film, June 22, 1999, was one of the happiest days of my life. Flow-

ers and gifts streamed in from Whoopi, Penny Marshall, Toni Braxton, The Boat, my sisters and brothers. Whitney and Bobby sent the largest roses I had ever seen. They were from Africa. Wow!

Unfortunately, the ratings for *Jackie's Back!* were low. I guess their Lifetime core audience was just not ready for my shenanigans. Fuck them if they can't take a joke. But the critics received it as they had received mostly everything I had done. Raves, raves, raves, raves. Life went on.

Over the years, *Jackie's Back!* has developed a cult following. All kinds of people—black folks, gypsies, soccer moms, the gay community—stop me on planes, in movie theaters, or at the mall when I'm bra shopping, and tell me they watch the movie over and over again. It even has its own holiday, Jackie Washington Day, which is celebrated on July 15. I've been to events where people dress up like characters in the movie and recite the dialogue right along with the actors. Just like the fans of *Rocky Horror.*

A fter the wonderful experience of *Jackie's Back!,* I got incredible news from Mark and Bobby. They had decided to become parents by adopting a child. They asked me to write a letter of reference to the judge for them. I was honored to do that. It was like an affirmation of our committed friendship. I was present with them when the adoption was confirmed.

I was the first to hold Ella Cesaria Brown after Mark and Bobby. They named her after Ella Fitzgerald. She was excep-

tionally beautiful. I remember saying to my own beautiful daughter, Charmaine, "She's got face," meaning she's has beauty and personality. Mark and Bobby adopted their wonderful son, Sander, a few years later. It has been a monumental pleasure for this here godmama to love and spoil them rotten.

FOURTEEN

MOTHER COURAGE

On screen I have portrayed Whitney's mama, Tupac's mama, Taraji's mama, Terrence J's mama, Gabrielle's mama, and Raven-Symoné's grandmother. I even played Angela Bassett's mama in *What's Love Got to Do With It* despite being just eighteen months older than her! Sometimes I think, "They're gonna ask me to play Miss Jane Pittman's mama next!"

Off-screen, I never thought of myself as "motherly." But God knows that I play with everybody's baby—in my family, among my fans, and even in the grocery store. I may be a high diva sometimes but nothing humbles my ass quicker than a cute little baby. When I was in love with Thomas, there was a point where I thought we would marry and have a baby. But, as time went on, having kids just fell off my to-do list.

When Rachel and my Boat sisters suggested that I consider being more active in the lives of children, I was surprised. They weren't saying jump into motherhood right away. They thought it would be good for me to start out by mentoring. I definitely had the energy for hanging with children, and had a sense of fun along with a desire to give back.

Several months passed as I continued to work with Rachel and on my own until I felt more confident about embarking on my new venture as a "Big Sister." Many of my friends supported my intention. Deborah Dean Davis wrote a letter of recommendation and Thom Fennessey was by my side from the start, going with me to the initial meetings with Big Brothers Big Sisters of America. I was in orientation with them to learn my responsibilities and their process.

I went to the community center to meet lanky, adorable seven-year-old Charmaine for the first time. She was balled up under a table when I first laid eyes on her. She reminded me of myself when I collapsed on the floor of Beverly Heath's friends' kitchen. My heart was drawn immediately to this pretty, skinny, long-legged little girl. She was very shy and when I finally made her smile, she revealed an adorable snaggle-tooth right in front.

Though I've never been shy a day in my life, the connection I felt to Charmaine was immediate, perhaps because I understood her circumstances. Charmaine's "normal" resembled mine as a child back in Kinloch: one woman, holding down multiple jobs to support multiple children, by herself.

It was my pleasure to share myself and my resources with this precious little girl.

Charmaine and I established a routine where I'd pick her up once a week. She was always anxiously waiting for me at her door. We'd go somewhere fun or just hang out at my place. At first, I had no idea what the hell I was doing. One day, not being able to reach any of my girlfriends, I was forced to call my agent from Whole Foods to ask, "What do you feed a seven-year-old?" The first time Charmaine opened the refrigerator all she saw was a bottle of champagne and a jar of caviar. I ate pretty healthy, but usually ordered in.

I loved every minute we spent together. It felt so good to do for Charmaine what had not been done for me. I'd take her to museums and movies and also made sure that she got outdoors and learned to enjoy nature. Plus, we went shopping a lot. Our first Halloween together, we spent an entire afternoon searching for exactly the right costume. At Toys 'R Us, I bought her Barbie dolls and books. In fact, I bought her everything I thought she might want. Well, as much as Big Brothers Big Sisters of America allowed. They had rules and regulations for everything. There was even a limit on how much time Big Sisters could spend with their mentees. I was around as much as possible, sometimes bending the rules. Charmaine had become more than a mentee.

The first time Charmaine slept over was Thanksgiving. I slowly and gently brushed her hair and then read to her from her favorite book, *The Eleventh Hour: A Curious Mystery*. When I tucked her in, her sincere little voice said, "Thank you, Jenny."

It was the first time she called me by the name that pretty much only my family uses. I was scared to death thinking of the million things that could go wrong. I kept waking up to check on her and finally, just watched her sleep peacefully.

I gave Charmaine lots of hugs, smiles, and laughter. I also found that, surprisingly, I drew from my mother's attitude that you had to toughen up children to prepare them for life. For example, I wanted Charmaine to build her physical stamina. So as we hiked the hills, I would walk very fast, pushing her lanky, mildly uncoordinated little body to keep up.

I think the day Charmaine had an asthma attack triggered by an allergy was the day I really understood what it was to be a mother. We were spending some casual time together and when Charmaine began to cough and gasp uncontrollably, I immediately put her in the car and sped to the hospital. She was fine, but sitting in that emergency room with her for four hours scared the shit out of me. I think I discovered that night what true love was.

A few weeks later, I took Charmaine with me to the Magic Johnson Theater to see *The Preacher's Wife*. I always loved watching my films with predominantly black audiences. In one scene with Denzel Washington, my character entered wearing a very unattractive outfit. A woman behind me shouted, "What the hell is she wearing?" I, of course, had gone to the theater incog-Negro, and Charmaine and I proceeded to laugh and laugh. She loved that her Big Sister was a "movie star." When I had a new movie coming out, Charmaine loved to stay up with me until midnight, when we'd rush to the 24-hour newsstand to read the reviews in the morning papers.

It was obvious that Charmaine was not the only one of us in need and we both benefited from our paths crossing. I monitored myself because I wanted to be a good example. I was motivated to "stay in my adult" and let Charmaine be the child (it didn't always work out that way). I got hypnotized to stop smoking, and after Charmaine came into my life, there was never another one-night stand. And, believe it or not, I made sure never to expose little Charmaine to my cursing (not counting road rage!).

I still had my issues, though. I was not in a relationship and was still trying to buy my mother's love, despite confronting her about her treatment of me as a child. But my progress was undeniable. I was learning to sit with my feelings instead of acting them out. Let's just say I was still the life of the party, singing, dancing and clowning around, but at least I wasn't doing it on top of the table or on top of somebody's head.

One night I was driving and feeling comfortable that I knew the road well enough to glance up at the moon through the sun roof. Bam! I hit the guard rail. My car went into a 360 spin and I ended up in a ditch. The driver door was smashed in. I pried myself out and crawled up the embankment in total shock. When I looked down at the car, my first thought was that my body was dead in the car and my spirit had floated out of it. I thought of Charmaine and how I wanted to be in her life always. Then, I thought "Damn! The headline tomorrow will be: 'Double D Cup Diva Dead in Ditch.'" The car was banged up, and so was I, but I felt that I could drive. It was a foolish decision, but I made it home safely.

Charmaine and I had grown extremely close, so it was dif-

ficult to tell her that I would not see her while I went to New York to work with Spike Lee on *Girl 6*. She didn't seem too disappointed, though, 'cause I sent her to Camp Hollywoodland for the summer.

In New York, I had a great time hanging out with my cast members Theresa Randle and Naomi Campbell. We'd go to the spa together, to dinner, and to parties. It was all very upscale New York, a 180-degree difference from my early days trudging to Gray's Papaya.

One morning, Naomi called and asked if I wanted to join her for breakfast in one of her favorite restaurants in lower Manhattan. She was dating some czar at the time and had just returned from Russia. As we gorged on fresh black sturgeon eggs, who walked in but John F. Kennedy Jr. My heart leapt, my legs moved, and I was in front of him within seconds. I know it's difficult to imagine Jenifer Lewis speechless but I just stood there like a sixteen-year-old in love. I wanted to say something intelligent. But the only words I could muster were "My God, you're beautiful." He looked me in the eye, took my hand, and said, "So are you." Had he kissed my hand, I would have been walking around with it filthy to this very day.

Charmaine's mom, LaRhonda, had more on her shoulders than any woman should bear. Not only was she the sole provider for her children, but she had been diagnosed with multiple sclerosis. We didn't become close friends, but we did sit down for long conversations. LaRhonda trusted me with all of her children. Charmaine's three sisters all had

Big Sisters, but I loved to scoop up all the girls myself and take them on special outings to the beach or Disneyland. But, there was tension among the siblings. It didn't help that I was a well-off celebrity and that Charmaine was somewhat the "runt" of her sisters.

As LaRhonda's health deteriorated, Charmaine came to live with me full time. Eventually, we all agreed that I would become Charmaine's legal guardian. It wasn't exactly adoption, but legal guardianship allowed me to assume all responsibility for the little girl I loved so much.

I promised LaRhonda that I would do my best for Charmaine, including getting her through high school and college. Immediately, I enrolled her in an expensive private school, because I wanted her to have the best.

JOURNAL ENTRY: Was my mother depressed everyday of her life? Is it what I learned? Can I live another way? I'm fighting so hard. These realizations and revelations mean nothing Jenny, unless you hold on to them and don't drop the ball. Don't drop the ball baby.

Becoming Charmaine's parent helped me to better understand my mother's predicament. I had just one child and could only imagine the pressure Mama felt trying to raise seven. Unlike Mama, I had the time and resources to focus on my child. I showered Charmaine with attention, listened to her, and encouraged her to talk about her feelings and what she wanted in life.

I saw that Charmaine felt pulled by the sometime oppos-

ing forces of her birth family and me. The life she led with me was the polar opposite of her family's struggle. Having grown up poor myself, I certainly understood the conflict she was feeling. Because LaRhonda had become too ill to care for her children, Charmaine's two older sisters had been sent to live with relatives and her younger sister, Angelica, had entered the foster care system. I think Charmaine felt guilty that she seemed to have lucked out in such an extreme way.

At first, as her Big Sister, I let Charmaine have her way on just about everything. She was quite artistic and when we made a birdhouse out of popsicle sticks, I let her stay up until midnight to finish it. I found out soon, however, that as Charmaine's parent, I couldn't always say "yes." I now had to say "no" sometimes. That was hard for both of us.

I didn't want to replicate my mother's superstrict approach and struggled to find the right balance between "big sister" and "disciplinarian." For instance, I grew up poor, but our homes were clean. My mother said, "When I get home, this house better be spotless" and we knew there would be hell to pay if it wasn't. But Charmaine's standards were different from mine and her refusal to clean her room to my liking resulted in my putting her on punishment. Worse, it caused anger and resentment between us.

My favorite cousin, Ronnie, who had become a professional hairstylist, came out to LA again to help with Charmaine. He was sweet as pie and so patient. He drove Charmaine to school, did the cooking, and styled Charmaine's hair (which of course, she loved). Ronnie could dance. He could sing. He only had a high school education, but he was smart,

fun loving, and a natural caretaker. It felt good to build a little family with Charmaine and Ronnie and the little apricot poodle, Cashoo, that I got Charmaine for her birthday.

Sheldon Epps, the brilliant artistic director of the esteemed Pasadena Playhouse, asked me to perform there in a play, John Henry Redwood's *The Old Settler*. My castmates were Christopher B. Duncan, Sally Richardson and the incomparable C.C.H. Pounder. *Settler* was the first straight (meaning non-musical) play I had performed in since college; I had done only musicals and concerts since. One night, after the final curtain, a young man peeped his head in my dressing room while I was removing my makeup. Oh, was he cute! I had taken a bite out of a Chinese pear, it was a juicy one. He said, "Can I have a bite?" Well, let's just say he came in and had a bite. For the next nine years we would continue to take bites out of that Chinese pear. God help me.

Enter Terrence Flack, my first boyfriend after a long dry spell. On our first date we hiked up Fryman Canyon, and he bent down to tie my shoe. I liked him on his knees. The rest, ladies and gentlemen, is history.

I dated Terrence for a month and a half before I actually slept with him. I was trying to be an adult and get to know somebody before I launch into bed with them. As you all know by now, that had not been my modus operandi in the past.

Over the months, I spent more time with Terrence. He was fun, he did not take my shit and he was not afraid of me. I could be myself with him and he made me laugh. Terrence

was well-read and a true lover of music. He liked to tease me, making fun of my dramatics by calling me "Groan Crawford."

There were some red flags, like his "woe is me" attitude, which wasn't that surprising, given his background. Of all the men I dated, Terrence had been the most abused. His mother was overwhelmed by her parental responsibilities and agents from the children's services bureau were trying to place her children with other relatives. With the agents on her heels, Terrence's mother bundled up her toddlers and headed for the Greyhound station. Just as she was about to board the bus, the social workers caught up with her. Little Terrence was sent to live with relatives who were far too strict. Terrence had survived, pretty much raised himself, graduated from college, and come to Los Angeles to pursue acting.

I wanted to take care of him. I wanted him to take my hand and I wanted us to win. I wanted two little black kids who had grown up in poverty to go around the world and leave it all behind. Oops. We take ourselves with us, don't we?

Ultimately, I introduced him to Charmaine. I felt proud for her to see me with an intelligent, creative man. Terrence was supportive of my relationship with Charmaine and as a trio, we had some good times together.

I was happy at work and in my off-hours. My relationship with Terrence grew and I realized I loved him when one morning I actually cooked for breakfast. In truth, he may have thought I hated him after that! In fact, when my sisters see me on screen playing somebody like Mama Rose in *The Temptations*, serving up platters of fried chicken, collard greens, and peach cobbler, they call me up: "You may be

fooling the audience, Jenny, but everyone in Kinloch knows you can't cook." When Charmaine went to summer camp, Terrence and I ran off to Paris. Late one night, we walked through the Pigalle area. He was a little ahead of me as we climbed a small hill. Terrence stopped, turned around and he reached both his arms out to me, pulling me up the hill saying, "Come on, baby." It was one of the most loving moments. I think that this night I felt surrounded by angels, and he was one of them.

I was becoming a woman of a certain age who was an endangered species in television and film. I felt especially grateful to have a vital career, including a schedule that allowed me to have a stable life at home with a child and a gorgeous man to love on.

My maturity did not cause a shortage of excitement and glamour in my life, though. I was thrilled to go to work on *Strong Medicine* every day. Tammy Ader and Whoopi Goldberg were the creators and producers. I loved and admired them both. *Strong Medicine* was more than good, it was making history in that it was dealing with women's health issues honestly. Plus it featured strong women who were breaking through the barrier of patriarchy. Girl power in these streets.

I remember episodes about breast cancer, and antiabortion protests. They even did an episode speaking to my own experience, in which my character, Lana Hawkins, became a mentor to a young girl who had come from hard times.

Terrence and I took another much-needed vacation to

Europe. His mood dampened the trip for me. He was often uncomfortable about me spending money on such luxuries. He felt it somehow compromised his manhood. We went to a fireworks display, in Monaco; it was the most beautiful thing I'd ever seen, with the music of Tchaikovsky playing in the background. I looked around and didn't see Terrence, who had been walking with me. He was sitting on the curb with his head down. He was overwhelmed. He felt unworthy. I had built this lavish life and he was thrown into it and apparently he was drowning.

He had his insecurities, I had mine. We got tickets for *The Phantom of the Opera* in the West End in London. At dinner I asked, "Do you think I'm beautiful?" It was one of the few times he looked me squarely in the eyes, answering, "Jenifer, you're so beautiful sometimes it's hard to look at you."

Looking to boost Terrence's self-esteem, I got him a job on *Strong Medicine*. He needed the money and we stupidly thought being together night and day would strengthen our relationship. Of course, it had the opposite effect.

JOURNAL ENTRY: I feel so foolish sometimes where Terrence is concerned. He could be playing me. Am I afraid of being alone? But I can't take being with him at work and at home. He's got to get the fuck out of Strong Medicine, it's killing us, I believe.

That's what I wrote, but it is not what I told Terrence. Instead our relationship sort of limped along, both of us wanting it to work, but neither willing to admit it wasn't. I was a bit

surprised when Terrence proposed—by nearly throwing the ring at me. Suffice it to say, the moment wasn't as romantic as I might have hoped. Ronnie was present. Terrence seemed detached during the whole thing. I was afraid to announce it to anyone. I didn't even want to tell Charmaine.

Terrance went with me to St. Louis for Christmas that year but I think he was stressing over whether he could handle marriage or not. We were still going on and off with our bullshit. Impulsively, we ran away after Christmas to Cancun to celebrate the new millennium. We said, "If the world does end, at least we'll be somewhere pretty and together." It didn't work. We fought like dogs the entire time.

As Charmaine entered her teens, everything changed. She turned into Regan from *The Exorcist*. We tangled—about homework, summer school, everything. She was secretive; of course I was frightened about drugs and was uncomfortable with some of the kids she hung out with. When Charmaine held a pool party while I was away, I lit into her and used the f-word over and over. I apologized profusely; I had been abusive and I was truly sorry. I felt even worse the next morning, when I had to leave Charmaine in order to fly to Florida to join Bette Midler and Kirsten Dunst at a campaign rally for John Kerry, the Democratic nominee for president. While in Florida, I got the call that my cousin Ronnie was in a coma in a hospital in St. Louis. I rushed home to sit by Ronnie's side and hold his hand. Though he could not hear me, I thanked him for helping me raise Charmaine and told him how much

we loved him. I hugged him and whispered in his ear, "You go on to sleep now, baby, if you want to. But hold on a minute, Ronnie, my hair looks like shit!" I knew he was laughing inside.

My dear, talented, sweet cousin passed away. Shame had prevented him from speaking about his illness and from getting treatment. Once again, I had witnessed how secrets destroy lives.

To help Charmaine, and myself, recover from Ronnie's death, we took a short trip to Hawaii. I wanted to show Charmaine that I trusted her, so I gave her freedom there to stay out late if she wanted. I was nervous though, and pretended to be asleep when she came home a little too late for my taste. (She still claims she was sooo not late!)

I received a call while in Hawaii that the role I wanted in *Lackawanna Blues* had gone to my friend S. Epatha Merkerson, who turned in a brilliant performance. When I got home, Glory Hallelujah, I was offered five movies, including *Nora's Hair Salon, The Cookout,* and *Antwone Fisher.*

In Charmaine's junior year of high school, she got herself into a not-so-good relationship with a pretty white boy. She was in emotional pain for nearly a year but couldn't find the strength to end it. To get Charmaine's mind on other things, I snatched her up and took her to Italy. This was the first time I'd taken her to a foreign country and maybe I was a little too protective. She was 18 now and I had to let my baby girl grow up. Damn.

We visited Florence, drove through Tuscany, and when we got to Pisa, I rushed her out of the car, shouting, "Come on!

Come on before it falls," as we laughingly rushed toward the Leaning Tower. In Rome, we went shopping around the Spanish Steps and I bought her two prom dresses. We were lucky enough to catch the last tour of the Vatican before it was announced that Pope John Paul II had died. We were scheduled to go home the next day, but flights had been cancelled because of the onslaught of people who had rushed to Rome for the Pope's funeral and selection of the new Pontiff. We even saw the smoke from the chimney.

Between having to stay a couple of extra nights and the long trip back to Los Angeles, I totaled four days off my medication, which triggered a manic episode when I got home.

That first morning, I took a spin in my car, still thinking about the wonderful trip to Italy, but happy to be back in our beautiful neighborhood which was awash in purple Jacaranda blooms. I turned a corner and found myself looking at a brand new tile-roofed home that reminded me of Tuscany. The house was beige with green shutters and in classic Tuscan-style, every window had a different shape. I had to see inside.

When the man who built the house walked me through it, I began to sing. The house matched what was going on inside of me. I was inside a manic episode and this house was as big as my feelings. The contractor, Joseph Aviv, brought his father, Moses, with him. Joseph and Moses—what an audience! I started singing "You Raise Me Up" by Josh Groban at the top of my lungs, ahh, the acoustics in an empty house! I fawned over Moses and asked if he knew the Ten Commandments and who Nefertiti was. Apparently other people were

bidding on the house, but Moses was entranced by my joy and told Joseph to sell it to me. Thus, in a highly manic state, and without due consideration, I bought the house. But when my manic mood subsided, one night I sat straight up in bed and thought, "How much did I just spend? What the fuck have I done?"

We moved into our new home a few weeks before Charmaine finished high school. She enrolled in college that fall, but dropped out two years later. I was terribly disappointed. She promised to return to college, and I set her up with an apartment, car, and an allowance. But when she told me she wasn't going back to school, our relationship hit a low point. Nearly three years passed, during which time LaRhonda passed away. When Charmaine and I finally reconciled, we talked about the great and not-so-great times. From her perspective, I gave her a voice in the way that I raised her, then I took that voice away. From my perspective, I encouraged her to have a voice, but when she used it to be disrespectful, I had to shut it down.

I wasn't the perfect mother, but I am grateful that Charmaine understands I did my best. Working through all this with Charmaine has helped me come to terms with my Mama; to see that she also did her best—even if I felt it wasn't enough.

After Charmaine moved out, I had time to face the fact that things with Terrence were pretty bad. For one thing, I realized I was getting a little tired of picking up the tab all the time. This has been a running issue in my life.

Though I've never minded sharing my success, we all must be careful of becoming a damn fool. Another thing was Terrence couldn't really talk about his deepest feelings. I realized that his horrible experiences as a child caused him to become emotionally disconnected. There was nothing mean about Terrence. Though intelligent, he was still just a scared little boy that had major arrested development.

But I wasn't willing to give up on us yet. I was asked to perform on a gay cruise to Alaska. But like a damn fool, I took Terrence with me. What came of that? Me threatening gay men left and right. When I thought I caught them looking at Terrence, I'd say: "this one's mine. Fuck with him and I'll sink this ship like the Titanic." They laughed, not realizing I was dead serious. (I love my gay babies!)

Ultimately, Terrence broke up with me. The first man who ever did that. It was usually me who ended my relationships. In a last-ditch effort to heal our relationship, we ran off to Japan—Tokyo, Kyoto, Kamakura, Osaka, and, dear God, Hiroshima, where the United States dropped the atom bomb at the end of World War II. As I entered the Hiroshima Peace Memorial Museum, I saw a banner hanging low. It was written in Japanese, but in my mind it read, "Look upon this shame. Look what you did to us." There was a concrete block that still had the shadow of a man who had been disintegrated in less than a second. There were photographs of children and families and animals that I cannot begin to describe nor will I try. Just know I vomited when I came out of the museum.

After nearly eight years together, Terrence abandoned me half way up Mount Fuji. We had taken the train out from

Tokyo one afternoon and then grabbed a taxi from the station to the base of the mountain. We did not realize the taxi driver took us to the wrong side of the mountain, leaving us at the path reserved for expert climbers and military training. Thus, not only was the trail of crushed lava rocks difficult to walk on, the angle of incline was extreme. Nevertheless, it was beautiful and the cumulus clouds gathering at the mountaintop seemed to call us upward. After about an hour of climbing, despite my athleticism, I was out of breath, drenched in sweat and knew that I couldn't go on. When I told Terrence, he half-heartedly offered to descend with me. I said, "Nah, you go on, I'll be okay," trusting he would, of course, insist on accompanying me back down, especially given my obvious physical distress. To my surprise, however, he was relieved. "That cloud is calling me," he said. "I want to go all the way to the top, Jenifer, so you go on and I'll meet you back at the hotel." I slowly and precariously crunched my way down the mountain. The temperature dropped a good ten degrees as the sun set. Within moments, it was damned near pitch black and I could neither see or hear anyone else on the trail. Okay y'all, my alpha ass was no match for Miss Mighty Mount Fuji. JeniferMothaFuckinLewis became plain old scared. Worst of all, I could not avoid acknowledging that "actions speak louder than words." Terrence's actions had shown me what he was not man enough to tell me: that he was no longer there for me, that he no longer prioritized my well-being, and that our relationship was, in fact, over. I managed to climb down the dangerous trail by myself and make it back to the hotel okay.

JOURNAL ENTRY: Help me God that I was ever with a man like this.

The bottom line is I was too much of a goddamn man myself. There was a part of me that chose men I could dominate. It wasn't my fault that I made more money than they did. Dumb bastards. Why couldn't they enjoy it and just be nice?

After appearing for six years as a regular cast member on *Strong Medicine*, the top-rated show on Lifetime, I got the horrific news that it was being canceled. There were many "what the fucks?" thrown around by me. I soon calmed down when Ruben Cannon called and offered me Tyler Perry's *Madea's Family Reunion*. I really needed this job, but the offer came in extremely low. I was disappointed, because I had already done so many low-budget, independent films for Ruben Cannon. I don't know where I got the balls from, but I said, "No." I was thinking to myself, "Fuck the mortgage. I want to be respected in this business." I've worked hard, worked hard on myself, and found the strength to just say "No."

Two hours later, Tyler Perry called and said, "Jenifer, what do I have to do to have you in my film?" I gave him my quote, and he said, "Yes."

Merry Christmas, bitches!

A few months later, I went to the premiere of *Cars*, in which I voiced a 1957 Cadillac named "Flo." The premiere was in Charleston, North Carolina, at a NASCAR event. Jesus Christ, what a scene; the roar of the car motors was deafening

and everyone in the stadium seemed to be eating fried turkey legs and drinking kegs of beer.

Around Christmastime, I was hired to sing at a private party in Beverly Hills. Norman Lear was there. He approached me respectfully. "I'd like to apologize to you, Jenifer. I'm so sorry you were hurt. You've grown into a beautiful woman." I felt so grown up when I responded sweetly. We went on to have a lovely conversation about our children.

Bertolt Brecht, a German born at the end of the nineteenth century, was known for stories steeped in history and told from the perspective of the poor and downtrodden. He wrote a play called *Mother Courage and Her Children* while in self-imposed exile from Nazi Germany.

Mother Courage was produced by the Public Theater in the outdoor Delacorte Theater in Central Park. I was asked to play the part of Yvette Poitier, performing opposite Meryl Streep. Before casting me, George C. Wolfe, the director, auditioned dozens of women. Every actress in the world wanted to work with Meryl Streep.

George's assistant told me that after auditioning about 30 women for the role, George put his head in his hands and said, "Who can I get to play Yvette?" She has to have classical training, be able to sing, and have enough presence to share the stage with Meryl and Kevin Kline." He suddenly flashed back to me, clowning during the run of *The Diva Is Dismissed* and entertaining the office staff by reciting Portia's mono-

logues from Shakespeare's *Julius Caesar.* George shouted at his assistant, "Get me Jenifer Lewis on the phone!"

I was thrilled to face the challenge of *Mother Courage.* I had my doubters. Artists are quickly labeled, and my label was "force of nature," not so much "serious actor." I didn't doubt that I could tear up the role. But, I was stressed and highly intimidated by Meryl Streep. Mark Brown named my condition "Streep Stress." I kidded with Mark that Ms. Streep would show up to the first rehearsal with one of her Oscars in hand. You know, just plop the gold statue on the table to establish the pecking order. That fool turned my anxiety into a monologue for a one-woman show the following year:

I walked into the first rehearsal of *Mother Courage* and planted my solid acrylic Ovation Award right in front of Meryl Streep.

"Murl Girl. You got one of these?" I said.

"No," she said.

"Okay Murl Girl, then we gonna be ah'iiiight."

"My name is Mer-yl."

"What now?" I asked.

"My name is Meryl."

"Yes honey, that may be," I said. "But Murl rhymes with girl. So, it's Murl Girl."

Meryl looked at the director, George C. Wolfe. He looked at the play's translator, Tony Kushner. They all looked at me, and I said, "Look, she may be playing 'Mother Courage,' but I'm the Mothafucka up on that

stage they'll be looking at." I was promptly shot in both knees and taken out.

In reality, despite my nervousness, I had the time of my life working with Meryl Streep. She was generous, brilliant, warm, and appreciative of my talents. She wrote me a note on opening night, calling me "the great one." It brought me to tears. In the few weeks we ran, more than three thousand people saw the play. Celebrities, average folks, and all my gypsy friends. I felt honored when Tom Hanks brought his wife, Rita, backstage to meet me.

The reviews of *Mother Courage* were good. I was honored when Ben Brantley said of me in *The Times* that "Her interpretation of Yvette's bitter song of remembered love is a stunningly calibrated blend of smoothness and harshness, of filigree irony and primal emotion, that suggests what Brecht was trying to achieve."

Another critic said that I was "the only one who could handle Brecht's dialogue." Meryl Streep may have been the draw, said critics, "but they're going to see Jenifer when they get there."

The only bad review I received was in *The New Yorker.* Flashback to a couple years earlier when I met with journalist Hilton Als to discuss his idea for a musical about a larger-than-life woman who was at the center of the party scene in Harlem. I was pretty underwhelmed by the idea and stated dismissively, "I don't want to be on stage with other people."

Turned out Als, who reviewed *Mother Courage* for *The New*

Yorker, got the opportunity to give me my comeuppance for my insensitivity about his idea:

"The only distraction here is Jenifer Lewis, as the business-minded whore Yvette. Lewis is not an actress but a personality. She plays the part like a refugee from the chit'lin' circuit. From time to time, her braying throws even Streep off." Some day I hope to meet Mr. Als in a dark alley where we can sit down and eat some chitlins together!

I was so happy when my four sisters agreed to come out to Los Angeles to see my wonderful new home. I wanted the house to look and feel special for them, so I ran around madly shopping for linens and home accessories. I called Mark Brown, rattling off all the stuff I needed to get. He let me talk until I ran out of breath. Then he asked where I was. "Bed, Bath and Beyond," I answered. Immediately, Mark knew I was in manic mode. He said, "No you aren't. You're at bipolar, bath and beyond." Well, of course that moment led to another one-woman performance piece called: *Bipolar, Bath & Beyond*. The show was about my turning fifty years old, surviving failed relationships, and, of course, therapy, as in the following monologue:

> I put in so much time on the couch, I've earned an honorary doctorate in human behavior. I can spot a disorder at fifty paces. I diagnosed my manicurist as having borderline personality disorder. I could tell by the way

she trimmed my cuticles. And the boy who does my hair, he's a motor mouth with a nervous tic—a dead giveaway—schizoid affective disorder. Sexual addiction, borderline personality, narcissism, oh yes, I call it like I feel it. I'm not judgmental about it. I support my charges in every way I can. I put my arm around 'em and say, "Baby you wanna borrow my drip?"

After one of the shows, an audience member introduced herself as a journalist with *Jet* magazine. She told me the show resonated with her because her brother had bipolar disorder. Naturally, I said yes to her request for an interview.

On closing night, after the piece ran in *Jet*, I got a phone call from Oprah—actually her producer, Jackie Taylor. "Miss Lewis, I am calling for Oprah Winfrey and we're doing a show on bipolar disorder. And Miss Winfrey was wondering if you would be a guest." I flew to Chicago.

I woke up at the famous Omni Hotel where all the guests of *The Oprah Winfrey Show* stayed. I was a nervous wreck. To compose myself, I looked in the mirror and said these words, "Jenny, today is not the day the diva meets the queen." This was some serious shit. I saw the show as an opportunity to perhaps help someone with bipolar disorder find their way out of the darkness. I felt it was my responsibility.

As the car drove us to Harpo Studios, I still had butterflies. To settle myself, as we got out of the car, I looked at my friend Gay Iris Parker and proclaimed, "I may be in her arena, but she's in my territory. I've suffered with this shit all my life and all I have to do is go in there, sit down, and tell the truth."

What I remember most about Oprah's studio was the enormous photograph of Nelson Mandela near the entrance. Mr. Mandela's commitment to humanity inspired me to give what Oprah later characterized as a "GREAT" interview.

Afterward, I called Rachel from the car and thanked her for helping me find the courage and the strength to be comfortable in my own skin. Going public with my mental disorder on *Oprah* led me to use my platform as a public figure to help others facing mental health problems. The following spring, I was asked by a pharmaceutical company that makes medicines used in the treatment of bipolar disorder to become a spokesperson for a mental health awareness campaign. I did nearly three dozen interviews with media from all over the country. The experience was amazing, and it contributed to my understanding of just how many people are affected by depression and anxiety. People are always coming up to me and telling me they appreciate the fact that I went public. Bottom line, y'all—Ain't no shame in my game. Like Mr. Mandela said, "Your playing small does not serve the world." If your "crazy" aunt never leaves the basement, or your friend is too depressed to go to work, play it "big"; reach out and touch somebody. I will be right by your side.

Stigma about mental illness stops people from seeking help. I believe widespread stigma, fear, and just plain ignorance about mental illness, particularly among African Americans, has taken a terrible toll on our families and communities.

I didn't have a name for what my condition was until I was thirty-three-years-old. We're each works-in-progress for

as long as we live, and I was no different. When you're in emotional distress, your life can feel like you're spiraling up or down at any given moment. If these ups and downs are extreme and chronic, they do damage to your mind, body, and soul, and your relationships with other people, including those who care about you most.

Recovery and healing require patience, something that is difficult for many people, and certainly was difficult for someone like me. But, I learned to submit to patience because it was either go step-by-step or die. Having patience means knowing that it is never too late to get well.

ON THE BACK OF A TWO-HUMPED CAMEL

What does an artist do when she gets a role bigger than she ever imagined? I faced this question when Dr. Elizabeth Stroble, the president of my alma mater, Webster University, called to invite me to deliver the 2015 commencement address. This was big; what could I possibly say to all those beautiful young graduates about to embark on their lives? What knowledge could I drop that would inspire them?

I panicked about the speech. I went straight to YouTube and watched a bunch of commencement speeches by people I

admired, like Michelle Obama, Hillary Clinton, Tom Hanks, Oprah Winfrey, and Jim Carrey, who also lives with mental illness. The speeches were amazing, but finally, I decided to just be myself and speak from my heart.

At the outdoor ceremony in Forest Park in St. Louis, I stood before more than six thousand graduating students. This was a homecoming. In the audience, I could see the beaming faces of all my siblings: Wilatrel, Vertrella, Robin, Jackie, and Larry. My late brother Edward was there in spirit. But my mother was not present. She had been rushed to the hospital the evening before.

As I approached the podium to deliver my speech, my heart felt heavy thinking about Mama lying in the hospital. Then I thought about how despite it all, if there was one thing Mama did, it was to instill us kids with a reverence for education and learning. I wanted to honor Mama and this grand responsibility before me, so I centered my speech on the three best nuggets of advice I could give.

Number one: the elevator to success is broken—take the stairs.

Number two: it is when you're hardest hit that you mustn't quit.

Number three: love yourself so that love will not be a stranger when it comes.

My speech brought to mind the words of the love of my life, Miguel, when he'd said, "Yenifer, joo have thees great ability to get zee attenshoon of zee people, but den, joo say no-thing."

Ah, my love, you'd be so proud of me now.

Toward the end of the speech, I blew the roof off (metaphorically of course) with an a capella rendition of "His Eye Is on the Sparrow." The crowd cheered my speech, my singing, and my jokes. The entire day is a glorious memory. Oh, and by the way—during the ceremony, I received an honorary doctorate. That's right, please refer to me henceforth as "*Dr.* Jenifer MothaFuckin' Lewis"!

My mother passed away the following September 11th. After her death, my sisters sent four large boxes containing what I thought were some of mama's belongings. I was speechless when I saw what was inside. It was scrapbooks of my life—every picture, every article, every report card, every review. I dug through the softball trophies, baby shoe and locks of my baby hair. At the bottom was a blue ribbon I had stolen so long ago. Mama had kept me with her, collected me, saved me from earliest childhood to right before she died. The scrapbooks brought me a recollection of Christmas some years earlier, when Mama came to Los Angeles. There she stood in front of my Christmas tree, holding Charmaine's little poodle. She was so small; so fragile; so vulnerable. In that moment, I realized my mother loved me; she just had her own way of showing it. Or perhaps not showing it. She did her best and my life was a testament to the values and determination she had instilled in me. I whispered to myself, *Let it go, Jenny. Let it all go.* And I did.

This year, I turned sixty years old and I am feeling pretty damn good about life. And y'all know I didn't come to

this realization because my journey's been easy. I overcame enormous challenges to have peace of mind and thank God, I have never forgotten from whence I come. Charity and "giving back" are constants for me, whether in the areas of mental health, AIDS, or young people in need. Even on a one-to-one basis, I love to help when people ask my opinions or advice about their lives. But I also know you can't help nobody who ain't ready to be helped!

But peace of mind and trying to do good deeds can't stop some fucked-up shit from coming around the corner right into your life. On the very day Mama died, September 11, 2015, I learned that a con artist had slithered into my life. He had been scamming women for twenty-five years and had spent four years in federal prison for fraud. Fortunately, I have surrounded myself with very good friends. When one of my girlfriends noticed that I was not acting like my usual self since I'd been dating this man, she took action and gave me proof that I was this man's latest victim.

Never in a million fucking years could I have imagined this kind of unspeakable evil finding its way into my life. Let me say this to you: there are sociopaths in this world. Please don't suspect the worst of people, but do pay attention, pay attention, people, pay the fuck attention! Listen to your instinct. If a romance or any opportunity, seems too good to be true, it probably *isn't* true.

It took months for me to come out of the abyss into which I fell on the day Mama died and, rather than mourn, I had to go to the police station to report that I had been the victim

of a con artist. That winter, as my numbness finally began to recede, a dear friend was diagnosed with HPV cancer of the throat. It pained me that work prevented me from being by her side through the ordeal. Fortunately, she is now cancer-free. Shortly afterward Charmaine's sweet little poodle, Cashoo, had a stroke, fell in the pool, and drowned. When the next year my best friend's young niece overdosed on heroin, I wondered whether my love was adequate to help him and his family cope with the loss.

This wonderful, amazing thing called life can take you through hell and back, but I've seen so many lights at the end of so many tunnels that my soul is full to the brim. Though I have been through the fire more than once, I know that coming out on the other side can be glorious and beautiful. With aging comes clarity; I see that had one man, one show, or one breakdown been different, I wouldn't be the woman I am today.

But all those flowery thoughts can't reverse the fact that aging can be a bitch on your body! Not long ago on the set of *black-ish*, my right knee, Arthur, went out. I screamed bloody murder! Ruby was taken down, y'all! At this point I had been a regular on the show for two years and had become an integral part of the Johnson family. Everything I had wished for that night on the Adriatic had come true; I was co-starring in a prime-time network show that tackles the issues of the day with gravity *and* humor, working with talented castmates, and portraying a character I could really sink my teeth into.

Over the past couple of years, I have sought to find Ruby

Johnson, to capture her flow and define the colors and levels of her personality. My favorite aspect of Ruby is her relationship with her daughter-in-law Rainbow, played by Tracee Ellis Ross. Oh, how the two of us love creating the Ruby-Rainbow battle for superiority in the Johnson household! I am so proud of Tracee. Not just for handling her role so beautifully, but also for her activism. She is a role model for so many young women.

Anthony Anderson, who plays my son Dre, and I are just damn fools together. I'll never forget the scene in the "Old Digger" episode when Dre fakes a heart attack when he encounters Ruby and her young lover in the hallway. As Dre lay on the floor and Ruby tapped his head demanding that the "devil come out!" I couldn't stop laughing, because Anthony kept bobbing his head in sync with my hand. Nothing like great chemistry; or should I say two happy fools in harmony! Thank you, Black Jesus!

The best thing about playing Ruby is that she loves kids as much as I do. It has been extraordinary to work with the four young actors who portray Ruby's grandchildren. Often working with kids can wear you out. But I am very happy that Yara Shahidi, Marcus Scribner, Miles Brown, and Caila (Marsai) Martin are exceptional in every way.

People often ask what it's like to work with Laurence Fishburne. Here is the answer: it's ice cream, cotton candy, and Christmas morning.

Black-ish is a happy set, thanks to the extraordinary leadership of its creator and showrunner, Kenya Barris. The entire

black-ish family—the crew, producers, writers, props and wardrobe teams, to the young production assistants, is amazing. And where would I be without makeup artist Martha Callender and hairstylist Tinisha Meeks, the two angels who are trapped in my trailer with my cappuccino-needing, crazy ass every morning?

Before I became part of the *black-ish* family, I would be recognized mostly by black people. In testament to the universality of *black-ish,* these days the fans approaching me are every shade of American. I am humbled when they compliment me on my portrayal of Ruby.

I am proud of Ruby. To me she is the exemplification of what "mother of black Hollywood" means. She represents how far we've come. I grew up watching black women play characters that, in some ways, stereotyped black womanhood—Hattie McDaniel in *Gone With the Wind,* Juanita Moore in *Imitation of Life.* Don't get me wrong: those actresses were well aware of their positions and were doing an honest job. My point is the heritage is real. Ruby incorporates the most positive parts of those characters and mixes in accurate representations of African American women, like those delivered by Cicely Tyson in *Sounder,* Diahann Carroll in *Claudine,* and even Pam Grier in *Foxy Brown.* Ruby brings it all into the modern world. Sure, Ruby's got the traditional, down-to-earth, God-fearing, outspoken (but always loving) profile that is usually attributed to black mothers on screen. But she also has her own life, has strong political views, and moves frequently and easily from braids to head-wraps to her 'fro. Plus, I would bet that Ruby,

God bless her, *always* checks the meat before getting her alpha wolf on with her newest sweet young thang!

After we wrapped the third season of *black-ish*, I decided to reward myself with another luxury trip. This time it was around the world by private jet for a month! I had been saving for this extra-special vacation for ten years. I was so happy that Marc Shaiman and his husband, Lou Mirabal, joined me.

The adventures we had traveling through Colombia, Easter Island, Solomon Islands, Tahiti, and the Philippines could fill a book! When we got to Mongolia, we spent time in a yurt visiting with a family of nomads. During one precious moment, the interpreter informed us that when a camel is giving birth, her herders sing a special song to her. I sweetly asked the man who owned the yurt to please sing that song. He was shy, but after a little Jenifer Lewis snuggling and carrying on, he began to sing. It was like nothing I had ever heard. His notes echoed, even in this tent made of cloth. It wasn't the acoustics; it was because his vocal cords were powered by the love that he felt for his camels. He held one pure, clear note as long as any prima donna could. His song wrapped my soul in grace.

Grace turned to "what the hell?" when I stepped outside of the yurt. There before me stood a two-humped camel, waiting for me to climb up between his humps for an afternoon romp in the Gobi Desert. It was a very bouncy, long ride. Upon descending from this ancient creature, I jokingly said to Marc

Shaiman, "I think I broke my pussy bone." He in turn, being the great songwriter that he is (and the funniest; okay, and the cutest!), went into action by writing a song. Wanna hear it? Here it go!

My pussy bone broke on the back of a two-humped camel
This ain't no joke
I heard it crack
On the back of that mammal
This ain't no time for a laugh
My pussy done broke in half
And next week we ride a giraffe?
God, help me and my pussy bone
I wish that camel had a microphone
So I could tell the world
My pussy bone broke
On the back of a two-humped camel.

I swear, the video got more than a half-million views on Facebook. Pure foolishness!

The trip continued through Uzbekistan, St. Petersburg in Russia, and Reykjavik, Iceland, where I sang "Amazing Grace" in a chapel inside a three-hundred-year-old glacier. Talk about acoustics!

I flew home to blue skies, my bichon Butters, and *black-ish*. Trust me, it don't get no better than that! As I stood at the baggage carousel, a young man leapt in front of me and began to sing in an accent I later learned was Kenyan: "I don't want nobody fuckin' with me in these streets!" I was sur-

prised. In 2016, when Brandy, Roz Ryan, and I recorded "In These Streets" while fooling around one night at my piano, we had no idea it would become an international viral sensation. The fuckin' Internet, y'all.

On the ride from the airport, I looked out the window, thinking about how different my life would have been without the ups and downs, the fabulous, and the terrifying. I was never one to wait for life to happen. I took a lot of risks, grabbed hold of opportunities when they came along, and even kicked down some doors when they didn't. I dared to dream and damn if the dream didn't come true—I became a "star." It happened on the day I realized that everybody is a star.

I asked myself a hard question of the type we ask as we grow older and more wise. For much of my life, I swore I would never be satisfied until I had it all—Grammy, Oscar, Tony, and Emmy. But I don't have any of those. Not yet. Perhaps not ever. So I asked myself, "What could I have done differently to get those awards?" The answer came easily: "Not a goddamn thing." I no longer need them to be happy, you see, because I am Jenifer Lewis, the Mother of Black Hollywood. It is an honor that eclipses all that other shit. And I wouldn't change it for all the world, y'all. Not for all the world.

A LETTER TO THE READER

Dear Reader,

I was pulling into my driveway after spending a Christmas, alone, in South Africa. I'd run off to get away from the pain of a broken engagement, or so I told myself. While there, I toured Robben Island and stood looking at the cell where Nelson Mandela had been locked up for twenty-seven years. Twenty-seven goddamn years, stuck in a cell. It was deeply moving. It wasn't until my car rolled into the garage of my home that I really took in the fact that while Mandela may have been in a cell for twenty-seven years, he had never been imprisoned. I, however, had no jail cell, but had been emotionally caged all my life—constricted by my own secrets.

I turned off the ignition, looked around, and thought, *I owe.*

Because I have survived, *I owe.*

Because I still have a smile on my face and am in good health, *I owe.*

Because I live with bipolar disorder and thrive, *I owe.*

Because I made it to the other side of sex addiction, *I owe.*

Because my generation has left behind a world of chaos and environmental deterioration that the next is being made to clean up, *I owe.*

Because while my role as the Mother of Black Hollywood started out as just that—a part to play—the platform has afforded me the opportunity to have so many young people come to me seeking answers to why, how, what, when . . . please, Miss Lewis?

I owe.

I owe it to the world to share what I have learned on my journey.

People love gossip.

I don't.

I know the pain gossip caused me and those around me. After all the shit I've been through, I now know no one is better or worse than anyone else. We are all God's babies.

It's the reason I chose not to write a Hollywood tell-all. *The Mother of Black Hollywood* is *a life* tell-all, an unburdening of secrets that have kept me captive for far too long. I've told you the truth, the whole truth, and nothing but the truth of my life as I saw it. As I felt it, tasted it, touched and smelled it. This is my story, my song. Yes, I've suffered, but no more and no less than anyone else. So, since we're all in this together, my prayer is that if any of you can take away even an ounce of comfort and joy by having read my story, then I will peacefully pass this plane knowing that I have stepped up, stood up, and stayed up, and done what I set out to do— help somebody because somebody helped me.

You have your own story, your own song to tell and sing. Don't sit back and hold it in. Secrets made me sick, stress held me back. I've witnessed fear ruin so many lives. Then we pass it on to our kids, and they pass it on to theirs, then on and ridiculously on until it's so big, it destroys us all. We can easily feel that even in this world of 7.4 billion people that there's no one out there who will listen. No one who has your back, even when you feel you had theirs.

I'll tell you like I tell my daughter—*we are never alone.* When I was young, I just knew somebody was coming to rescue me. A knight in shining armor, an angel, a guru, a priest, a director, a producer, a bird, a flower, a tree, a cloud, the moon—anything. And after all that praying and hoping and wishing, it came down to looking in the mirror, taking responsibility for my choices—every last one of them. And it wasn't until I asked, asked, asked—you have to ask—that someone *did* listen with a sincere smile and stood by my side and guided me gently. So, go beyond yourself and fight for it, damnit. Ain't nobody promised you a rose garden without painful-ass thorns. Go beyond yourself, reach out, and you will touch a hand that will lift you up. This kind gesture will give you the courage and strength to lift others.

Do your best and leave the rest. I want you to stand up in these streets, resist the forces that will taint this beautiful world, and immerse yourself in the experience, and sing the fuck out of that song in your heart. Be good to your body and your mind. If you need therapy, get it. If appropriately prescribed medication will help you, get the damn medication. Rest when you are tired, eat when you are

hungry. Go into everything with an open heart while being smart with how and with whom you share yourself. Above all, remember that we are all human. We will all grow old, we will all feel pain, and hopefully get laid. *Gotcha!!*

When I started writing this book, I told my editor, Tracy Sherrod, that if after I'm dead and gone, a little boy or girl is walking through some war-torn country and sees a tattered copy of my book on the side of the road, picks it up, and finds even one sentence that makes it possible to take one more step because of something I said, my life will not have been lived in vain. (Just hope they don't read the "Dick Diva" chapter first!)

Composing the *The Mother of Black Hollywood* was two years of blood, sweat, and tears—so many fucking tears—reliving all that drama and so many deaths. There's no foolproof recipe, y'all. You gotta live you. Make your own choices, build your own house, and set your own goals. I sincerely hope you find some tools in my honesty that will help you on your way. Don't let me have bared my soul for nothing! Ain't nobody got time for that in these streets!

Now, go get 'em, tiger.

Love,
Jenifer

ACKNOWLEDGMENTS

I started out trying to write each of you a personal thank-you. But there are just too many of you. So many of you. And all of you know what you did for me. And to me (MARC SHAIMAN—Asshole).

I used to say that when I won an award on television, I would begin my speech with, "I want to thank everybody everywhere for everything." So there you have it. Thank you all for every iota of your love and support over the years.

—Jenifer

PROFESSIONAL FABULOUSNESS

Tammy Ader-Green

Debbie Allen

Terry Apanasewicz

David Armstrong

Kenya Barris

Mel Berger

black-ish, entire Cast and
 Crew

Shirley Black-Brown

Brandy

Artie Butler

Clint Culpepper

Dominique Curtis

Tim Curtis

Chad Damon

Loretta Devine

Robert Ellis Studio and the Girls

John "Lypsinka" Epperson

Sheldon Epps

Ann Epting

George Faison

Valente Frazier

Jeff Friday

Trish Garland

Ron Gibbs

Whoopi Goldberg

Robyn Goodman

Dr. Pearl E. Grimes, M.D.

Joseph Hampton

Bob Harrington

Keith Harrison

Kevin Hart

Taraji P. Henson

Maurice Hines

Chad Hodge

Jonathan Howard

Lon Hoyt

Deborah Hyte

The Innovative Artists Team

Jackie's Back! Cameo Cast

Jenifer Lewis and Shangela, entire Cast and Crew

Eileen Knight

Maria Knupfer

Barry Krost

Dee LaDuke

Shirley Leflore

Tom Leonardis

Andrea & James Lopez

Dell McDonald

Bette Midler

William P. Miller

Roy Milton, II

Iona Morris

Linda Morris

Tony Moses

Niecy Nash

Ilan Nunez

Jack O'Brien

Rosie O'Donnell

Judi Pace

Will Packer

George Pennacchio

Dottie Peoples

Tyler Perry

D. J. "Shangela" Pierce

Arnie Preston

Richard Read

Charles Randolph-Wright

Kevin Reher

Roz Ryan

The St. John of Beverly Hills
Team

The Sara's Lingerie
Team

Tracy Sherrod

Malika Smith

The Sweet Butter Kitchen
Team

David E. Talbert

Jackie Taylor

Beverly Todd

Robert Townsend

Gabrielle Union

The WME Team; The
William Morris Agency

Robert Wachs

Michael Waddington

Julia Walker

Mervyn Warren

Camrin Williams

Oprah Winfrey

George C. Wolfe

David Zippel

Joanne Zippel

LOVE & SUPPORT (There are so many more of you who've been there for me but please take under consideration all memory was lost after I turned 169 years old.)

Malaika Adero

The Allan Jeffries Framing
Team

Joseph Aviv

Azhar

Cleo Babilonia

The Bechtel Physical
Therapy Team

Mary Lou Belli

Big Brothers Big Sisters of
America

Jasmine Blue Flowers

Bernice Bronson

Betty Ambrose Brown

Roberta Brunelle

Theresa Butler Long

Rudy Calvo

Victoria Carter

Ella Cesaria-Brown & Sander
Cesario-Brown

Robert "Bobby" Cesario

Jerry Cleveland

The Coffee Roaster Team

Deborah Dean Davis

Erin Diab

Deesha Dyer

Sherry Eaker

Dr. Neal Ellatrache, M.D.

Jose Enriquez

Evelyn, The Lowland
 Gorilla

Eytan's Jewelry

Lorraine Fields

Terrence Flack

Dora Frank

Carol Fulgrum

Jeffrey Gunter

Tess Haley

Terri S. Hashaway

Jill Hattersly

Charmaine Headspeth

Beverly Heath

Bea Henle

Sharon Hessler

Scott Howard

Temi Hyde

Ebony Jo-Ann

Virginia Justo

Freya Kay

Leniece Kincaid

The People of Kinloch,
 Missouri

John Lasseter

Butters Lewis

Roma Little-Walker

Toni Y. Long

Ann MacDonald

Reta Madsen

Essie Metcalf

Lou Mirabal

Dokhi Mirmirani

Sandra Mitchell

Mrs. Vera Mitchell

My Whole Family

Omolafe

Gay Iris Parker

Vicki Patman

Maria Perateau

Nita Whitaker-Perkins &
 Scott Perkins

Sidney Poitier

Erv Raible

Roxanne Reese

Jason Rice

Michiko Rice

Ethel Rue

Synthia St. James

Peter Sargent

Jill Scott

Dr. Douglas Sears, M.D.

The Sego Nursery Family

Mark D. Sendroff

Attallah Shabazz

Marc Shaiman

Hannah Shearer

Michael Skloff

Kira Tirimacco

Annette & Joseph Walker

Congresswoman Maxine Waters

Lance Williams

Medria Williams

Rose Wilson

Scott Wittman

Marita Woodruff

Don Zilbermintz

THOSE WHO ATTENDED THE ORGY—Don't deny you were there. Remember? It was at a Motel 6 in ancient Rome in AD 476, around the corner from the Colosseum.

Clare Bathé-Williams

Greg Bell

Mark Alton Brown

Bonnie Bruckheimer

Terry Burrell

Eric Butler

Martha Callender

Lee Daniels

Flotilla DeBarge

Brian Edwards

Thom Fennessey

Michael Goodall

WiLetta Harmon

Cheryl Hayes

Todd Hunter

Jon Imparato

Jeanne King

Billy Masters

Perry Moore

Brian Norber

Matthew Parker

Dean Payne

Beverly Jo Pryor

Laura Richter

Margie Rifenbark

RuPaul

Linda Saputo

Steve Semien

ACKNOWLEDGMENTS

Kiki Shephard

Ken Simmons

Michael Siplin

Louis St. Louis

Lee Summers

Lena Waithe

Nathan Hale Williams

Special thanks to Mark Alton Bown and Linda Morris for their amazing contributions to *The Mother of Black Hollywood*.

CAREER OVERVIEW

Broadway *
Comin' Uptown, 1979–1980
Eubie!, 1978–1979
Hairspray, 2008
Rock 'N Roll! The First 5,000 Years, 1982

Feature Films and Animation**
Antwone Fisher, "Aunt" (uncredited), 2002
Baggage Claim, "Catherine," 2013
Beaches, "Diva," 1988
Blast from the Past, "Dr. Aron," 1999
The Brothers, "Louise Smith," 2001
Cars, "Flo" (voice), 2006
Cars 2, "Flo" (voice), 2011
Cars 3, "Flo" (voice), 2017
Cast Away, "Becca Twig," 2000
The Cookout, "Lady Em," 2004

* More information at ibdb.com
** More information at imdb.com

Corrina, Corrina, "Jevina," 1994

Dancing in September, "Judge Warner," 2000

Dead Presidents, "Mrs. Curtis," 1995

Dirty Laundry, "Aunt Lettuce," 2006

The Exes, "Caren Dupree," 2015

Frozen Assets, "Jomisha," 1992

Girl 6, "Boss #1—Lil," 1996

The Heart Specialist, "Nurse Jackson," 2006

Hereafter, "Candace," 2010

Juwanna Mann, "Aunt Ruby," 2002

Madea's Family Reunion, "Milay Jenay Lori," 2006

Meet the Browns, "Vera," 2008

The Meteor Man, "Mrs. Williams, Lewis's Mother," 1993

The Mighty, "Mrs. Addison," 1998

Mystery Men, "Lucille," 1999

Nora's Hair Salon, "Nora Harper," 2004

Not Easily Broken, "Mary 'Mama' Clark," 2009

Panther, "Rita," 1995

Playin' for Love, "Alize Gates," 2013

Poetic Justice, "Annie," 1993

The Preacher's Wife, "Margueritte Coleman," 1996

The Princess and the Frog, "Mama Odie" (voice), 2009

Prop 8: The Musical, "Riffing Prop 8'er," Film Short, 2008

Red Heat, "Judge Jenifer Lewis" (uncredited), 1988

Redrum, "Therapist," 2007

Renaissance Man, "Mrs. Coleman," 1994

Rituals, Film Short, 1998

Secrets of the Magic City, "Aunt Valerie," 2014

Shark Tale, "Motown Turtle" (voice), 2004

Sister Act, "Michelle," 1992

Sister Act 2: Back in the Habit, "Vegas Backup Singer #1,"
 1993

The Sunday Morning Stripper, "Demetria," Film Short,
 2003

Think Like a Man, "Loretta," 2012

Think Like a Man Too, "Loretta," 2014

Undercover Blues, "Cab Driver," 1993

The Wedding Ringer, "Doris Jenkins," 2015

What's Love Got to Do with It, "Zelma Bullock," 1993

When Harry Met Sally 2 with Billy Crystal and Helen Mirren,
 "Retirement Home Waitress," Video short, 2011

Who's Your Caddy?, "C-Note's Mom," 2007

Zambezia, "Gogo," 2012

Television*

American Dad!, "Lessie" (voice), 1 episode, 2011

An Unexpected Life, "Camile," TV Movie, 1998

Bette, "Inez," 1 episode, 2000

Big Hero 6: The Series, "Professor Granville," 2 episodes,
 2017

black-ish, "Ruby," 56 episodes, 2014–

The Boondocks, "Geraldine/Boss Willona" (voice), 2014

Boston Legal, "Judge Isabel Fisher," 2 episodes, 2007–2008

* More information at imdb.com

The Cleveland Show, "Receptionist/Middle-Aged Woman/
Woman/Kevin Garnett's Mom" (voice), 2 episodes,
2011

Cosby, "Bernice," 1 episode, 1996

Courthouse, "Judge Rosetta Reide," 11 episodes, 1995

Day Break, "Elizabeth Hopper," 1 episode, 2007

Deadline for Murder: From the Files of Edna Buchanan, "Denice
Cooper," TV Movie, 1995

Deconstructing Sarah, "Betty," TV Movie, 1994

A Different World, "Susan Clayton/Dean Dorothy Dandridge
Davenport," 9 episodes, 1990–1993

Dream On, "Carolyn," 1 episode, 1992

Elena of Avalor, "Tornado," 1 episode, 2017

Family Affair, "Mrs. Summers," pilot episode, 2002

Five, "Maggie," TV Movie, 2011

For Your Love, "Mel and Reggie's Mother/Sylvia Ellis,"
2 episodes, 1998–2000

The Fresh Prince of Bel-Air, "Aunt Helen," 8 episodes,
1991–1996

Friends, "Paula," 1 episode, 1994

Girlfriends, "Veretta Childs," 7 episodes, 2002–2006

Grown-ups, "Melissa's Mother," 1 episode, 1999

Hangin' with Mr. Cooper, "Georgia Rodman," 2 episodes,
1992–1994

Happily Ever After: Fairy Tales for Every Child, "Hazel/Black
Widow Spider" (voice), 2 episodes, 1997–1999

In Living Color, "Various," 2 episodes, 1993

Instant Mom, "Delois," 2 episodes, 2015

It Had to Be You, "Reggie," TV Movie, 2015

Jackie's Back!, "Jackie Washington," TV Movie, 1999

The Jamie Foxx Show, "Josie," 1 episode, 1999

Last Days of Russell, "Aunt Yvette," TV Movie, 1994

Little Richard, "Muh Penniman," TV Movie, 2000

Living Single, "Delia Deveaux," 1 episode, 1995

Lois & Clark: The New Adventures of Superman, "Mystique,"
 1 episode, 1994

Meet the Browns, "Vera Brown," 5 episodes, 2009–2010

Moesha, "Mrs. Biggs," 1 episode, 1999

Moon Over Miami, "Aurora Tyler," 1 episode, 1993

Murphy Brown, "Sales Person," 2 episodes, 1990–1991

New York Undercover, "Medina," 1 episode, 1995

The Parent 'Hood, "Linda," 1998

Partners, "Detective Lancy," TV Movie, 2000

Piper's Picks TV, "Herself," 1 episode, 2012

The PJs, "Bebe Ho," 36 episodes, 1999–2001

The Playboy Club, "Pearl," 7 episodes, 2011

The Ponder Heart, "Narcissa Wingfield," TV Movie,
 2001

Promised Land, "Queenie," 1 episode, 1997

The Proud Family, 2001–2005, "Aunt Spice" (voice), 1 episode,
 2003

Rebel Highway, "Amanda Baldwin Cooper," 1 episode,
 1994

Roc, "Charlaine," 1 episode, 1993

Shark, "Ellie Broussard," 1 episode, 2007

Shattle, Rattle and Rock!, "Amanda," TV Movie, 1994

Stat, "Felicia Brown," 1 episode, 1991

State of Georgia, "Patrice," 1 episode, 2011

Strong Medicine, "Lana Hawkins," 131 episodes, 2000–
 2006
Sunday in Paris, "Taylor Chase," TV Short, 1991
Tales from Radiator Springs, "Flo" (voice), 2 episodes, 2013–
 2014
The Temptations, "Mama Rose," 2 episodes, 1998
That's So Raven, "Vivian Baxter," 1 episode, 2004
Time of Your Life, "Joss's Mother," 1 episode, 1999
Touched by an Angel, "Queenie," 1 episode, 1997
Young Justice, "Olympia," 1 episode, 2017

Video Games* (Voices)
Cars, "Flo," 2006
Cars 2: The Video Game, "Flo," 2011
Cars Mater-National, "Flo," 2007
Cars Race-O-Rama, "Flo," 2009
Disney Infinity, "Flo," 2013
The Princess and the Frog, "Mama Odie," 2009
Sorcerers of the Magic Kingdom, "Mama Odie/Shenzi," 2012

Social Media Videos
Amazing Grace. YouTube. Marc Shaiman. May 31, 2017
An Artist's Duty (aka 50 Million of Us), with Brandy and Roz
 Ryan. Instagram. jeniferlewisforreal, January 16, 2017.
Brandy, Roz Ryan, & Jenifer Lewis Perform "In These Streets." You-
 Tube. ForeverBrandy. May 6, 2016. Retrieved from https://
 youtu.be/Ud2E6TSfJ0M

* More information at imdb.com

How You Gonna Call SOMEONE ELSE #Legend, with Brandy and Todrick Hall. Instagram. jeniferlewisforreal. October 6, 2016.

Jenifer Lewis—Carnegie Hall "Shaiman/Wittman" Tribute—"I Know Where I've Been." YouTube. Shangela L. Wadley. April 29, 2014.

Jenifer Lewis and Marc Shaiman Preview "Black Don't Crack" and More! playbill.com.

Jenifer Lewis and Shangela: Ep. 1: Doo Doo. YouTube. Jenifer Lewis and Shangela. September 4, 2012.

Jenifer Lewis and Shangela: Ep. 2: Recognition. YouTube. Jenifer Lewis and Shangela. September 12, 2012.

Jenifer Lewis and Shangela: Ep. 3: Gold Earring. Jenifer Lewis and Shangela. September 18, 2012.

Jenifer Lewis and Shangela: Ep. 4: Mouse. Jenifer Lewis and Shangela. September 25, 2012.

Jenifer Lewis Performs Last Dance at APLA Commitment to Life Event. TheJeniferLewis. June 21, 2011.

Jenifer Lewis Gives Powerful Speech at Baggage Claim Premiere. YouTube. TrueExclusives. September 20, 2013

Jenifer Lewis Gives Webster University Commencement Speech. YouTube. Webster University. May 12, 2015

Jenifer Lewis' Get Your Ass Out and Vote. YouTube. TheJenifer Lewis. November 8, 2016.

Jenifer Lewis on Oprah. YouTube. TheJeniferLewis. May 8, 2011.

Josh Gad Impersonates Jenifer Lewis on the set of The Wedding Ringer. YouTube. Sony Pictures Entertainment. January 14, 2015.

"Pussy Bone." YouTube. Marc Shaiman. May 23, 2017.

Social Media Handles

Facebook: http://www.facebook.com/jeniferlewisforreal
Instagram: www.instagram.com/jeniferlewisforreal/
Twitter: @jeniferlewis